CHIEM VAN HOUWENINGE

DOUBLE TROUBLE

Writing and Filming

Edited by
THOMAS ELSAESSER
ROBERT KIEVIT
JAN SIMONS

AMSTERDAM UNIVERSITY PRESS

CIP-DATA KONINKLIJKE BIBLIOTHEEK, DEN HAAG

Double

Chiem van Houweninge
Double trouble: writing and filming / ed. by Thomas Elsaesser, Robert Kievit,
Jan Simons. – Amsterdam : Amsterdam University Press.– Ill.
With biogr., filmogr.
ISBN 90-5356-025-4
NUGI 925
Subject headings: Houweninge, Chiem van / Screenwriting.

Colophon

Editors
Thomas Elsaesser, Robert Kievit, Jan Simons

Translators
Murray Pearson, Karen Pehla

With thanks to
Blue Horse Productions

Coverdesign and lay-out
Kok Korpershoek (KO), Amsterdam

© Amsterdam University Press, Amsterdam, 1994

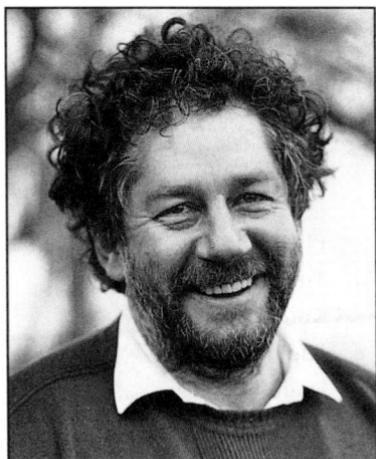

CONTENTS

I

IMAGINATION IS LIKE A MUSCLE: YOU HAVE TO GIVE IT DAILY EXERCISE

An Introduction

THOMAS ELSAESSER

It was a memorable moment, when Chiem van Houweninge came to give his first master-class on screenwriting at the University of Amsterdam. I was nervous, for after all, here was a real professional, taking time to talk to our students. He was nervous, too, I think he had told me on previous occasions how he certainly was no scholar and probably too impatient to be a teacher. The buzz in the corridor, as the students broke for lunch, made it clear we need not have worried. Excitement had infected the building, felt even on the stairs, all the way down to the coffee corner in the hall. When Chiem came to join us for cakes in the staff-room, he was beaming. The actor, the showman and entertainer in him had discovered a new dramatic genre: the seminar. He took to it with gusto and dedication.

For the next three months, Tuesday was the highlight of the week for the 30-odd students assigned to one of his two groups. When at the end of it, Chiem agreed to answer questions in public, the lecture hall was packed. What came across was a man who not only loved his craft and took pride in it, but who took television seriously. In fact, he took the business of writing comedy very seriously, one of the hardest things, as he said, to do as a writer. A joke does not have a second chance to make a first impression. When comedy fails, it fails absolutely, not like drama, where dead moments are just waiting periods. Nor can you say, well, maybe the audience is not in the mood for it tonight. Or, it's meant to be art, and they are too stupid to appreciate it.

In Chiem van Houweninge's view of his profession, making popular television, there is no room for either snobbery or cynicism. One would expect a television writer-and-producer, and a successful one at that, to have a big ego. But one is not prepared for the humility and generosity of mind that animates a writer who works for the so-called 'general public'.

Having made listening to others a habit, so he can speak to them in their own words and feelings, a maker of popular television would appear to be an ideal teacher. And so it was with Chiem: he relished what he could pass on to students, but he also seemed to enjoy it when students came to him with writings or scripts of their own, when he could treat them as the professionals of the future.

The idea for *Double Trouble*, then, came from wanting to preserve, or at the very least document something of this two-way process, but also catch a little of the general buzz and excitement brought by his presence. Perhaps the book can even prolong the moment beyond the brief period Chiem van Houweninge could teach face to face, while allowing some who were not there to share and benefit from his experience. Robert Kievit attended the seminars throughout the twelve weeks, took notes, and then put together, in a slightly more formal presentation, Van Houweninge's basic principles and good practice in the art of script-writing: *The Writer at Work*. Since the classes were held in Dutch, of course, and spoken rather than read, the translator was asked to keep the sense of the spoken word alive in English. I am greatly obliged to Murray Pearson for acceding to so arduous a request, and managing to invent a voice he had never heard.

One of the special strengths of Chiem van Houweninge's teaching was that among the many examples cited, he could also rely on extracts from his own work to illustrate salient points. It seemed natural, therefore, to include two of these extracts, one from a situation comedy, the other from a police series. They allow readers to 'see for themselves'. In addition, it seemed useful to introduce the scenes, in order to provide a generic and historical context, and to highlight the way Chiem van Houweninge works within the rules of the genres: a prerequisite for the professional television maker. Yet his particular talent may well be his use of the rules in order to break them, and to situate himself *Between the Genres*, while at times *Transgressing the Boundaries*, discussed in Chapters IV and VI.

It also seemed a good idea to let Chiem argue and debate with fellow professionals, such as scriptwriters, script-editors and directors, and to convey something of the practical context in which television writing, producing and filming take place today. The discussions covered a wide range of subjects and raised questions about the autonomy of the writer and the place

of the script in the collaborative but ultimately very hierarchical business
which is television. The particular craft of working on a television series
also allowed the participants to focus on the limitations and opportunities
that come from writing for a national audience, while under pressure from
the international programme makers and hit manufacturers of Hollywood.
The discussions took place before an invited audience at the Nederlands
Filmmuseum and is here reproduced in edited form, organized around the
topics that emerged in the dialectic *Between Writing and Filming* (Chapter VIII).

At one point in the discussion, Chiem van Houweninge gallantly
rises to the defence of academic film and television studies. A recent convert,
perhaps, he is prepared to concede it might have its uses, where others
among his colleagues appear distinctly sceptical. In the line of fire is the
Dutch practice of assigning a university-trained 'dramaturge' or script-editor
to a programme, but jokes are also made about those University research
teams who set out to track down the secret of success in comedy series like
SAY AH, only to return with the fool's gold of truism and commonplace.
Van Houweninge remarks that film studies is a young discipline, which may
be more the case in the Netherlands than elsewhere.

What is undoubtedly the case almost everywhere is that writing
about television has yet to acquire a tradition, and that television as well as
the academy could benefit from more frequent encounters. Television makers
might offer much to students, as our experiment with Chiem van Houweninge
proved, but television makers in turn may well derive some benefit from, once
in a while, becoming more self-reflexive about their own work: seeing it in a
wider context, away from the day-to-day urgencies and emergencies, or
looking at what they do, from the kind of distance a historical or comparative
perspective can add.

We therefore commissioned a number of essays by critics and
scholars from the younger generation, trained in the disciplines of film
studies or theatre studies. We asked them to comment on aspects of the
work of Chiem van Houweninge. Perhaps not unexpectedly, they chose to
concentrate on his work in comedy. Viewing it from different angles, they
– fortuitously, but happily for the sake of overall coherence – at times echo
each others' findings, and even once or twice cite the same examples.
Rather than eliminate these overlaps, we preferred to think that they might

strengthen the points made, a decision we hope the less didactically inclined reader will be able to forgive. In these essays, SAY AH stands at the centre, inevitable considering its popularity. But given the fact that the series has now ceased to be, the essays combine homage and commemoration, although as Ernie Tee reminds us in his article, Double Trouble is pleased to celebrate an anniversary: Chiem van Houweninge's quarter of a century in television.

Tee is the first to strike a chord which others take up, namely the very close contact Van Houweninge's comedies have always sought with social reality. SAY AH in particular, might well serve as a chronicle and barometer of more than a decade of Dutch society. Clara Overduin analyzes the tension in situation comedies between stereotype and genre on the one hand, and individualized character and realism on the other. Having recourse to a typology first worked out by British theorists of situation comedy, she makes a convincing case for the view that Van Houweninge and his co-writer, Alexander Pola, increasingly addressed the challenge of how to make popular television socially and politically relevant, without needing to pontificate or moralize. Instead, they tried to deepen the humanity and humour of their characters. Marja Tutert, finally, takes upon herself the somewhat thankless task of categorizing different kinds of humour, and to investigate whether it is possible to establish the conditions under which audiences laugh at situations, word games, or the gestures and mannerisms of the characters. Many of her suggestions seem intriguing enough to deserve being developed further, as do the comparisons she makes between SAY AH and American sit-coms, which confirm both the context-bound nature of Van Houweninge's work – its rootedness in a particular 'national' experience – and his distrust of sit-coms that consist of a string of one-liners, especially when written by a small army of writers, dividing up the characters between them. Van Houweninge hates the idea of writers hunched over their typewriters, inventing funny lines for granny to say in THE GOLDEN GIRLS, or teams sweating all week to come up with those devastating repartees of Bill Cosby's. This is not the way Chiem van Houweninge sees sit-coms, nor 'dramady' or 'krimidy'. There has to be an organic situation, a lived context; there has to be some movement between people, not verbal machine-guns with wisecracking Rambos mowing down whatever gets in their way. Sit-coms have to grow around the interaction between characters held together by bonds stronger

than profession or pastime, and ties as thick as blood: the family, as the real, imagined or nostalgically remembered core that gives meaning to things and flavour to existence.

But what exactly is a sit-com, or rather, why is it so attractive to millions of viewers all over the world? Is what defines a sit-com the tension between the mechanics of laughter, the fireworks of jokes on the one hand, and the accuracy of social reality, the ordinariness of the characters, or the topicality of the themes on the other?

Life is a pain. You bicker with your wife and hate yourself for it. The kids are growing up, and when they don't ask you for more pocket money, they ignore you or – if by chance they're in a good mood – they mercilessly poke fun at you. You work and slave, mostly for others, but it's taken for granted. The plumber, come to mend the sink, has obviously overcharged you, and why is the dog always peeing on the doormat? Nothing but aggravation, nothing but misunderstandings, and in your heart of hearts, you know it's going to be like this forever, day in day out, year in year out. You are about to contemplate suicide, or think of going out to get a pack of cigarettes, never to come home again. But suddenly, you view it in a different light: what a moment ago seemed unbearable, so pointless it wasn't even tragic, has become funny, hilarious, or at any rate, poignant. You've stopped looking at it from your own point of view. The miracle has occurred. You have discovered another mode of being, nothing short of metaphysics: the family sit-com.

This, too, may be a way of approaching the secret of sit-coms' success, and it is how I sometimes allow myself to imagine Chiem van Houweninge's move from dramatic actor, playright and writer of film scripts, to becoming the writer-producer of some of The Netherlands' most successful prime-time television sit-coms. Of course, none of the above is literally true. Not with an adorable family like his, a wife, Marina de Vos as co-writer, two children, both gifted and enthusiastic, and a father who observes the family scene with dry irony and acerbic wit. Indeed, the conclusion one is tempted to draw is that Chiem's sit-coms are autobiographical in the opposite sense: a week in the Van Houweninge household delivers more funny situations, comic encounters and witty repartees than can be crammed into a half-hour television show.

But my sense is that the secret of Van Houweninge's success has

also to be sought elsewhere: in his classical training, his theatre work. I am
not suggesting he has taken Mien Dobbelsteen from Shakespeare, or the
squabbles between her and Koos from Aristophanes. Rather, I think a not
altogether hidden source in Van Houwninge's work is Anton Chekhov.
The kind of gentle and humane comedy Chiem likes and practices strikes
me as guided by the insight that were Chekhov alive today, he might well
be writing sit-coms, or if we turn it around, what we still find irresistible and
inexhaustible in Chekhov's plays is also what draws us to our favourite sit-
coms – the experience of tragedies and disasters of life, but looked at under a
different light, from a different vantage point, where they seem moving,
touching and absurd, without making us altogether forget that they could just
as well be devastating, crushing and irredeemably oppressive. What emerges
for me from Van Houweninge's work is, oddly enough, quite a double
personality: the socially conscious crime stories and situation comedies deal
rather more with hurt and aggression than appears at first sight, and they
regard the world, if not with stoicism, then with a certain remarkable fortitude
which knows that all the while, the cherry orchards are being cut down.

Chiem van Houweninge's strength, it seems to me, is not only that
he can pick up a *faits divers* from the papers, or a topic from the news bulletin.
I have seen him go to where there is nothing, look at it, take it between his
teeth, make a story out of it, breathe warmth into it: in short, bring it to life.
That, of course, makes him the artist he is.

It is only fitting, then, that *Double Trouble* should conclude with a
brief *catalogue raisonné*, where the work solicits comments from the author,
and the pictures create their own story which is both less and more than a
biographical sketch. Marina de Vos has been an invaluable source in putting
this section together, as indeed throughout she has unstintingly given of her
time. My thanks go to Chiem van Houweninge himself, of course, for sub-
mitting graciously to the many questions and requests, and also to the
contributors, who have been generous with their labour and patience. Last
but not least, special gratitude goes to my two fellow editors, Robert Kievit
and Jan Simons, who have been an inspiration, and a model of perseverance.

Amsterdam, October 1993

Chiem van Houweninge

II

DRAMA, COMEDY, REALITY

In Response to the Comedies of Chiem van Houweninge

ERNIE TEE

II.1 Introduction

In The Netherlands, the name of Chiem van Houweninge, has
become almost synonymous with SAY AH (ZEG 'NS AAA). As its creator and
scriptwriter, Van Houweninge (together with the late Alexander Pola) has
been largely responsible for this immensely popular comedy, the most
successful in the recent history of Dutch television.

But the name of Van Houweninge is just as closely associated with
'television drama', because although Van Houweninge also wrote scripts for
feature films, he primarily made his name with his television plays and series.
Here we have a small anniversary to celebrate. It was 25 years ago that Van
Houweninge started his work for television with the script for COME CRY ON
MY SHOULDER (HUIL MAAR EVEN BIJ ME UIT). Originally a piece written as Van
Houweninge's second year final project at the theatre school, it was eventually
broadcast in 1968 by VARA and BRT. Van Houweninge's subsequent script-
writing produced a steady stream of plays and series, some of them written
for German television, including several episodes of the crime series TATORT.
His work for Dutch television covers original drama as well as adaptations of
plays, but his most outstanding contribution is to original drama, especially
to the genre of the television series. Among the series in which he has been
involved, SAY AH and DOUBLE TROUBLE (OPPASSEN!!!) – measured in broadcast
time – are the most ambitious projects. SAY AH was finally wound up in the
1992-93 season with episode number 212, while DOUBLE TROUBLE, still part of
the current VARA programme, is nearing its hundredth instalment.

Moreover, these two series, SAY AH and DOUBLE TROUBLE, define
the realm of the specific qualities of Van Houweninge's work: the scripts find

their inspiration in reality (whether based on events taking place in Van Houweninge's immediate surroundings or taking aboard social developments in general), while the dramatic material is further enlivened by comic aspects. This tie between private and social realities is not only discernible in comedies like SAY AH but also in feature films like Frans Weisz' THE BURGLAR (DE INBREKER), for which Van Houweninge wrote the script, and in his work on German crime series. As for the fusion of drama and comedy, Van Houweninge himself has patented a term hitherto lacking in our vocabulary: *dramady*, a term that can refer equally to comedy in dramatic form or to drama in which there is room for the comic.

This text will focus on Van Houweninge's work for television comedies. In particular, I would like to have a look at how he dramatizes events taken from social reality and how the resulting drama is interwoven with comedy. I will refer principally to SAY AH and DOUBLE TROUBLE not only because they provide strong support for my overall argument, but also because of their easy availability, or perhaps one had better say because of the general inaccessibility of television material, since the earlier series are simply no longer there to be got hold of. But at least from my point of view, his later scripts are a good example of the characteristics particular to Van Houweninge's work. I will primarily be concerned with the work, not with the author. When all is said, the best way to get acquainted with the author is through his work.

II.2 **Everyday Reality**

Chiem van Houweninge, I asserted, makes extensive use of events that occur in his immediate environment as well as events that take place in a larger social context. This does not mean that Van Houweninge does not write original stories, but that he takes his inspiration from reality, social reality. In interviews, he has pointed out that the material for SAY AH grew from the countless sessions he had held with Alexander Pola. In those sessions they covered a wide range of events, from simple domestic incidents to actual political, social and cultural developments taken from sources such as newspapers and the evening news on television, but also from stories provided by friends and acquaintances. As Van Houweninge puts it: 'I look for actual

occurrences that engage me as a starting point for a script. Then I invent the story, and only after I have written it do I show it to experts in the field who can judge the script for factual accuracy. I don't work the other way round since that would simply amount to dramatising newspaper articles. I try to work from my own imagination and only then do I look whether it corresponds to reality.'[1] The reference to real events is thus crystallized during an initial stage and returns in the winding up of the creative process: the facts provide the seed sown over the fields of Van Houweninge's imagination, the full-grown crop being more thoroughly processed at harvest time. Between these two moments, the storm rages in the author's head.

 The reality represented in SAY AH consists of the household and the general practice of the medical family Van der Ploeg/Lansbergen, with the Dobbelsteen house serving as a second location. In DOUBLE TROUBLE it is the household of the family Bol/Buys which is managed by two grandfathers. In the course of time, the material for SAY AH was located more and more in the immediate, domestic environment. Van Houweninge explains: 'I try to create something nice within the context of the daily life of a family. That works. I believe one of the most important things is to look at issues close to home'.[2] The starting point of DOUBLE TROUBLE is a situation that could have been taken from the daily life of the author, whose children were often in their grand-fathers' care. The plot situations and even some of the jokes may well have had their origins 'close to home' in Van Houweninge's life.

 His preference for everyday reality makes Van Houweninge's work ideally suited for television which, after all, is mostly about social reality. Generally, the television audience experiences the medium as transparent, which is to say, television is assumed to presents things as if they were 'real'. Numerous studies in communication research have shown again and again that people place considerable trust in whatever is announced on television. Being their most important access to the outside world, the television set has become, for large parts of the population, their main source of knowledge. However isolated we may be from everyone and everything, 'the telly' makes us feel like a living part of this world. Even in the close intimacy of our private homes, television gives us the feeling of being a social individual. In short, television, on top of the information it supplies, exercises a pervasive reality effect which provides an important connection to external, social life.

 If we approach the scripts and writing of Chiem van Houweninge

from the point of view of everyday reality and the distinctive features he gives to the concept of *dramady*, does this imply a reduction of his work's multi-faceted nature? One could, for instance, also approach the work with the rules of model script writing in mind, but Van Houweninge himself has stated over and over again that he feels little affinity with the standard norms set out in the obligatory screenwriter's handbooks. His ways of working (whether on his own, or as a team, together with associates, such as Alexander Pola, or currently with his partner Marina de Vos) do not follow slavishly the paths smoothed out for us by American scriptwriters touring Europe, and talking about script structure. Van Houweninge is a craftsman in the classical sense of the word. Without receiving a formal education as a scriptwriter, he mastered the art in the process of practicing it. His long experience as an actor certainly must have served him well in matters of judging the effectiveness of dialogue or assessing the adequacy of the tempo and rhythm of certain scenes. For the rest, he can probably do without notions like *plot points*, or *points of attack*. Van Houweninge usually comes into a scene simply at the most appropriate moment and leaves it when he feels the time is ripe: 'What I have discovered to be a law is that there must always be a plot, supported by an alternative plot, and that every scene must be brought to a conclusion and that you must not make scenes too long. You must avoid too much talk, you must get on with writing a good story. What is important is to always look for the conflict. Where is this conflict?'[3]

In these candid remarks Van Houweninge shows innocence as well as good craftsmanship. Maybe they are the very qualities that have made SAY AH so popular: the episodes never moralise, certainly not the later ones, and moreover, the stories run smoothly, as though 'oiled', assuming one can say this of a screenplay. If there is any resemblance with the notion of the standard script in Van Houweninge's work, it is not so much the fruit of deliberate construction, but rather the result of an unconscious and organic 'infection' with the 'standard virus' creeping in, which in this case, turns out to be a healthy script.

Plausibilities

We can well leave the standard norms of a screenplay as they are. We do more justice to Van Houweninge's work by considering it in the light of experienced reality and the characteristic features of *dramady*. For these two aspects are what has really become important to Van Houweninge's scriptwriting practice.

Reality, of course, is a slippery concept. But we can make some headway if we place Van Houweninge's work in the context of two kinds of 'plausibilities'. The first is determined by the relation between the work and lived reality. This plausibility depends on conjuring up characters and actions in TV series such as SAY AH and DOUBLE TROUBLE that emphatically refer to characters and actions which we also observe in our daily lives. Characters like Lydie van der Ploeg (Sjoukje Hooymaayer) and Mien Dobbelsteen (Carry Tefsen), Willem Bol (Ben Hulsman) and Henry Buys (Coen Flink) can therefore be judged by the spectator as 'real', as part of 'reality'; or rather, they are part of what is generally experienced as 'reality'. But because of the quite obvious truism that we can only speak about 'reality' by referring to a 'general' level, since every individual experiences reality in his own, unique and peculiar way, we had better reformulate the idea of 'plausibility': it is determined by the relation between the fictional world represented in a tv series and a 'general concensus'[4], made up of the prevailing conceptions of what is real and unreal, possible and impossible, rather than by a specifiable relation between the series and some absolute 'reality'. The 'general consensus' is the framework, then, within which the characters of the series, their surroundings, their actions and motivations are construed as 'plausible' and therefore real.

Especially in the early episodes of SAY AH, there was an obvious intention to deal as much as possible with actual issues which because of their topical interest were experienced as part of contemporary reality. Almost an extension of 'current affairs', the episodes encompassed common sense cultural values, and they expressed political views, attitudes and patterns of behaviour typically found among the majority of the population. Its concern for framing and reframing this consensus makes SAY AH a virtual chronicle of its time, on which a future historian could confidently rely in order to distil the essential spirit of the eighties. Most spectators will certainly remember the endless verbal battles Renee Soutendijk as the feminist daughter had to fight

with her younger brother Gertjan (Hans Cornelissen), who took his common sense opinions from the conservative circles of the Leiden University student corps. And no doubt, just as many people will remember how in the middle of the opening scene of the very first episode, an announcement is made about a militant Unmarried Mother having a baby. The right to abortion, single motherhood, equal status for women at work and in the home – one could easily reconstruct from SAY AH the cultural and political shifts brought about in the first half of the eighties by the second wave of feminism. Many other topical issues were introduced in the series: the housing problems of young people in the inner cities, the squatters' movement, alternative health care, acupuncture, homosexuality, modern parenthood, educational problems, unemployment, the culture of 'liberated youth'; they all got an airing on SAY AH. Because each of these issues was carefully identified with individual characters, the spectrum of different roles also broadly reflected the socio-cultural scene of the time.

There is, however, another axis along which plausibility in Van Houweninge's scripts can be defined. This second 'plausibility' is determined by the relation of programmes like SAY AH and DOUBLE TROUBLE to other television productions and series. It constructs itself mainly from the tacit conventions and rules that operate 'behind' the television screen. SAY AH can be judged 'plausible', not only because the series clearly refers to existing situations and existing characters, but also because it conforms to certain rules that have developed within television over time. As long as a programme does not deviate from these rules, it appears 'plausible' to us. This plausibility is what Christian Metz has described as the 'effect of a corpus': in this case, that of series which preceded SAY AH and are similar.[5] The series thus forms part of a greater whole, of a system with its own rules that have to be observed if the individual programme is not to come across as implausible (even incomprehensible).

This plausibility can also be considered the effect of a very specific corpus with its own specific rules: what we usually mean by 'genre'. SAY AH and DOUBLE TROUBLE can be seen unproblematically as examples of situation comedy. In general, this genre can be identified by certain of its external characteristics: it has a half hour format, it is narrative and the comic aspects are dominant. Formally, it follows the principle of repetition-with-variation, which is typical of the series format in general. Sometimes additional content-

oriented criteria are called upon, such as typical representation of the family and the domestic sphere.[6] But this would give too much prominence to the American model (of which I LOVE LUCY is the mother) and marginalize the more absurd English comedy examples. I am thinking of earlier English sit-coms, such as HI-DE-HI!, situated in a fifties holiday camp, or the more recent THE YOUNG ONES, in which four culturally rather disparate youths attempt to run a common household. Rowan Atkinson's BLACKADDER also belongs to this species of series that cannot be accommodated in such a content based categorization. In fact, these programmes have even been called 'anti-sit-com' sit-coms.[7]

SAY AH and DOUBLE TROUBLE can best be classified among such sit-coms as THE DICK VAN DYKE SHOW, THE COSBY SHOW, THE FRESH PRINCE OF BEL AIR, LEAVE IT TO BEAVER, MY THREE SONS, FATHER KNOWS BEST, THE BRADY BUNCH, HAPPY DAYS, FAMILY TIES, MARRIED WITH CHILDREN, ROSEANNE and of course, I LOVE LUCY and THE LUCY SHOW. In other words, I am referring to the subgenre of the domestic or family sit com, in which the predominant location is the domestic hearth and the characters all belong to the same family. The shift

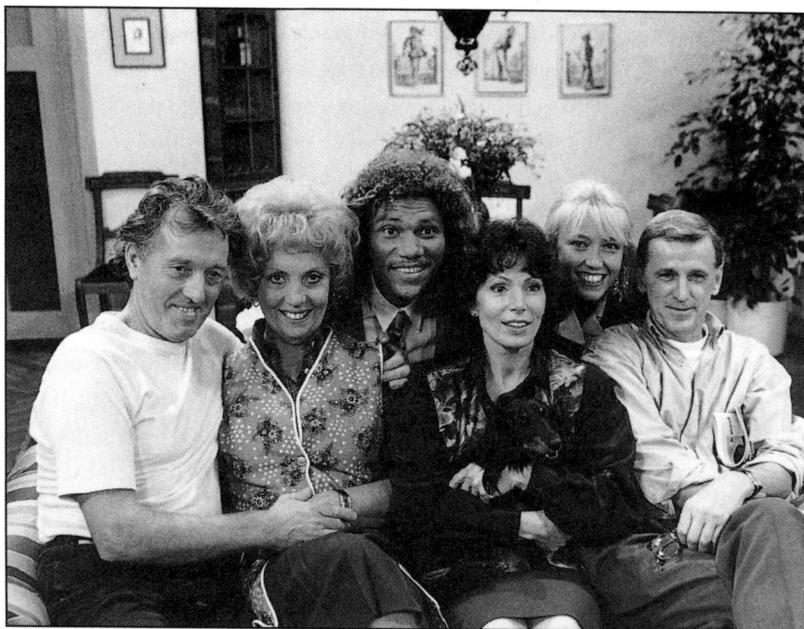

SAY AH (ZEG 'NS AAA): *the cast*

observed in these American sit-coms, where the nuclear family of father, mother and two or three children has given way to damaged families or anomalous family connections are also evident in SAY AH and DOUBLE TROUBLE which are also lacking 'normal' nuclear families. In the doctor's family Van der Ploeg, for example, the father figure is absent from the start. Doctor Lydie van der Ploeg's new partner, Hans Lansbergen (Manfred de Graaf) may at certain moments act as 'head' of the family, but since he is a newcomer in the family nucleus, he is more of a comrade to Gertjan, the son, than a paternal authority. The other household of SAY AH, that of Mien and Koos Dobbelsteen (John Leddy), also has a striking 'anomaly': the Dobbelsteens are childless. As a result, family issues are restricted to the 'better' social class of the doctors, where matters of upbringing and education play no role, and in turn are not mirrored in the working class culture of the Dobbelsteens. In DOUBLE TROUBLE the anomaly consists of the presence of two grandfathers, who have taken upon themselves the parental responsibilities in the household of the Bol-Buys family (father, mother and two children). In particular, Grandpa Buys, a retired major, acquits himself splendidly of his duties, ruling the kitchen rather like the formidable housekeeper in THE BRADY BUNCH.

Of the two plausibilities sketched above,[8] it is the first that pre-dominates in Van Houweninge's television comedies, plausibility that depends on correspondence with general beliefs about 'reality'. Genre conventions are less prominent in Van Houweninge's series because his attitude towards them is as relaxed as his attutide to the norms and standards of script writing. No single sit-com model is imposed on the scripts. Rather, the only motto Van Houweninge has consciously adopted from the sit-com is to 'make 'em laugh'.

Contrasting with his lighthearted approach to genre is the serious-ness of Van Houweninge's approach to reality. According to Van Houweninge's steady working partner, the late Alexander Pola, reality was an authority for this writing duo. 'In EACH TO EACH (IEDER ZIJN DEEL) [the first comedy series that issued from their working partnership] we discovered to our cost that we must never invent things that weren't possible in reality. We had a factory director marry a lion-tamer. We thought it was plausible but it turned out to be such a miserable performance. Kitty Jansen, who played the liontamer, didn't manage to crack her whip. We don't contrive things like that any more.'[9]

Totally unreal situations are rarely found in the Van Houweninge/ Pola comedies, unlike many other situation comedies where unreality runs amok. SAY AH and DOUBLE TROUBLE differ from many other comedies because of their explicit intention to present a plausible world to the spectator, a world that is sufficiently rooted in our everyday experience to be immediately recognizable.

This intention fitted in perfectly with the policy of VARA, the company that commissioned and broadcast these series in the eighties. VARA wanted to reach the public with 'socially responsible' fiction. Among the fiction output, drama series should be the most easily recognizable, which meant plausible situations and identifiable characters. Although the terms 'plausible' or 'realistic' remained largely undefined, they permitted programme makers to decide without much difficulty what could be a VARA-programme and what could not. When presented with a series such as MIAMI VICE, Marcel van Dam, the VARA chairman at the time, immediately reacted negatively, since in his view the two detectives, Crockett and Tubbs, were not remotely realistic.[10] The required 'plausibility', undefined as it might be, nonetheless helped to provide an answer to the question of what might be meant by 'quality for a large public', the phrase employed by VARA at that time in defining its programming standard. Quality drama was drama that represented everyday situations as realistically as possible, with characters as 'normal' as the average viewer.

II.4 The Comic Aspect

From the perspective of 'plausibility' as the 'effect of a corpus', SAY AH and DOUBLE TROUBLE are most closely affiliated with sit-coms in respect to the one feature that binds them all together: emphasis on the comic. Getting the laughs is, after all, the only firmly fixed goal of television comedies. Whatever they are about, whatever sort of characters they present, in the end their purpose it to make the audience regularly burst into laughter. Without the comic aspect, sit-coms would simply merge with all other genres that deal in domestic drama or follow the fates of a number of interrelated characters. What, then, defines the comic aspect of tv sit-coms?

First, comedy is connected with surprise: it plays on the unexpected.

Since the comic effect is generally short-lived, it achieves its maximum impact when it comes with a short, sharp shock. Young children, for example, can be surprised by small gestures or quick noises made by adults to entertain them. Without any logical or narrative support, those gestures and noises are experienced as comic. That is why the comic aspect always carries with it a *subversive* element, since its unexpected character temporarily disrupts the system in which it is imbedded. From the point of view of the system, the comic aspect is unpredictable and unimaginable.

This disruptiveness is the mark of comedies, but the disruptive effect can be established within two different frames of reference. '*Crazy comedy* tends to articulate order and disorder across the very mechanisms of discourse, producing incongruities, contradictions and illogicalities at the level of language and code, while *social (situation) comedy* on the other hand, tends to specify its disorder as the disturbance of socially institutionalised discursive hierarchies'. This distinction is made by Stephen Neale[11] who distinguishes two kinds of disruption: one at the linguistic level, the other at the level of social reality, or in the words of John Ellis, 'a formal and a social disruption'.[12]

Because of the comic aspect and its associated subversiveness comedy might be called the 'genre of disruption', or the 'genre that disrupts all genres', to quote the definition of Jean-Paul Simon.[13] The comic aspect, in fact, can be inserted into various kinds of genre, capable as it is of transforming a western, a musical, a police film or whatever into a comedy. Situation comedies, too, lean comfortably against various other genres. The comedy show CAR 54, for example, was constructed round two clumsy agents from a New York police station in the Bronx, whose comedy derived from police and detective films. Similarly, M*A*S*H connected with the genre of war films, while the characters in the family of THE MUNSTERS walked straight out of a horror film; and GET SMART!, a comedy built round two spies, Agent Maxwell Smart and Agent 99, both from the secret state organization C.O.N.T.R.O.L., was intended as a parody of a James Bond film.

Does comedy, then, as the 'genre that disrupts all genres', have any specific form at all? Terry Lovell introduced the concept of the 'comic mode' which she correlated with narrative structures found in situation comedy. 'If comedy cuts across classification accroding to genre, then we should expect to find comic forms which correspond at some level of

description to all the various genres of narrative. For the moment it may be preferable to speak of narratives in comic or non-comic mode, rather than attempting to identify narrative structures specific to comedy.'[14]

Thus Lovell abandons a possible essentialist definition in favour of a 'comic mode of narration'. This 'comic mode' is typically realized by an obstruction in the narrative. According to Lovell, narrative development in comedy is constantly impeded, deferred, postponed: 'The characteristic comic disruption is not, as in other narrative forms, that which initiates the narrative, sets the story going, but on the contrary something which holds it up and interferes with it.'[15]

Although all situation comedies are more or less narrative, the story itself can hardly be seen as the dominant structure. The logic suggested by the story rarely constitutes a system: rather, comedies are constructed as a succession of loose events, independent sketches, self-contained actions. The disparate character of comedy prevails, and the irregular but necessary eruptions of the comic aspect tend to push the calm logic of the story into the background. From a narrative perspective, comedy is therefore unsystematic, fragmented, incoherent. This in particular, makes TV comedy a direct relative of the old music hall or variety show, entertainment forms of pure spectacle in which comic numbers and absurd performances follow each other without being constrained by any particular structure. Just like variety shows, comedies are concerned with immediate humorous effects and are less interested in complex intellectual games of reference and presumption. What counts in comedy is what is shown and expressed, putting the emphasis on the literal or the physical, rather than making us search for a refined plot or hidden moral.

In many ways, television sit-coms, too, want to be taken above all as spectacle. This is evident in the way they are recorded, with the cameras always shooting from one side of the scene. This holds for SAY AH as well as for DOUBLE TROUBLE, just as it did for I LOVE LUCY (which I suggested earlier was in some respects the mother of all sit-com programmes).[16] The arrangement of the SAY AH set is revealed at the end of the very last (212nd) episode, when Mien Dobbelsteen invites the public to leave their seats in the audience and join the cast on the floor to celebrate the end of 12 years of SAY AH. For the first time the cameras turn towards the public as they descend from their seats, showing the 'reality' of the decor: the carpentry, the dividing walls, the merely roughed in backs of the sets, etc.

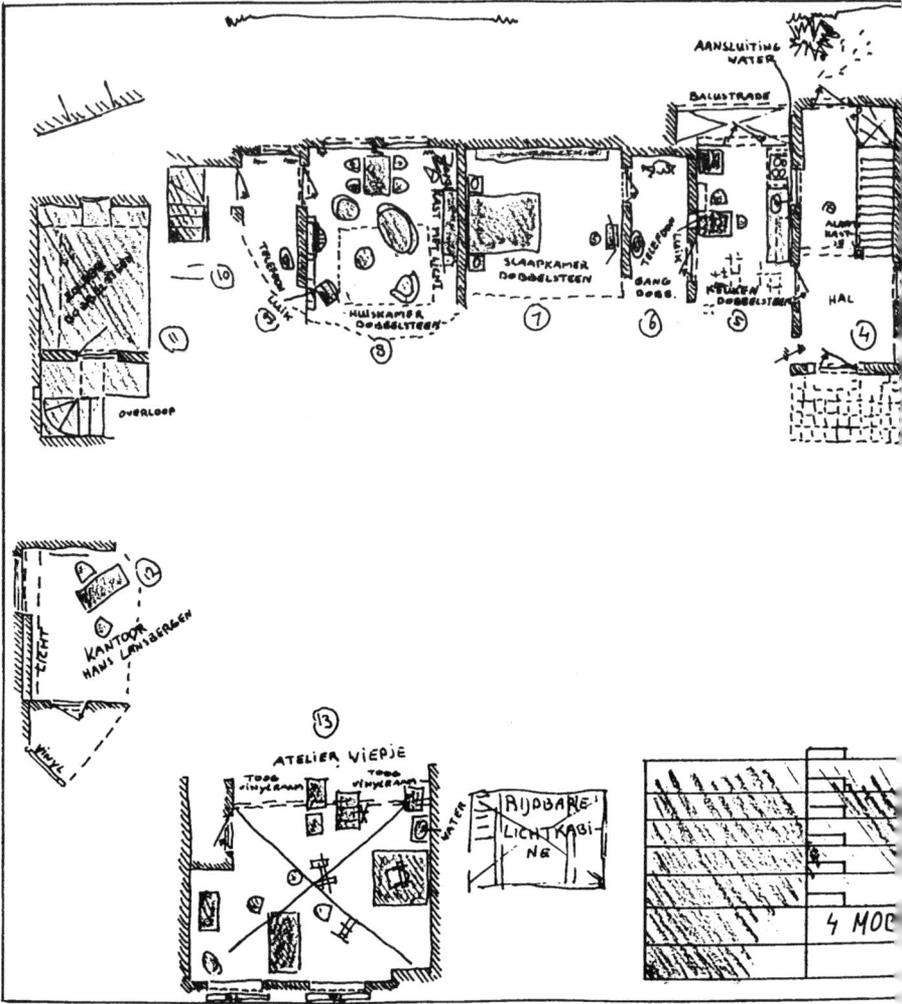

SAY AH: *the floorplan of the studio*

SLAAPKAMER
LYDIE & HANS

KLEED

KLEED

KEUKEN
LYDIE

SALON LYDIE,
HANS

KAMER JAAP / VOORM.
SLAAPKAMER
GERTJAN & RIEN

S TIJDENS

AMES MET PUBLIEK

TOEGANG
UITGANG

Foto van			Werktitel	ZEGHS A I	SCHOLEN	Opnamedatum
1 Gewijzigd			Regisseur	NICO KNAPPER		Projectnummer
2 Gewijzigd			Ontwerper	JAAP DE GROOTE		dd opname
3 Gewijzigd			Getekend			tel.
			D.PL.			tel.
		Schaal 1:	Maten in			©
		Studio				

The image we are given of the space of comedy-drama is comparable to the stage in a theatrical performance, where the scenic space is an undivided whole. As in the theatre, the fourth wall is never shown, but separates the spectator from the scene. We watch the comedy space from a certain distance, without literally being led *into* the scene, as is the case with cinematic space. This makes television comedy a pure succession of comic acts, more or less spectacular. Comedy deals with immediate representation, and does not delve into the laboured and complex game of the imagination.[17]

American sit coms provide the clearest examples of this mode of 'television spectacle-plus-comic-numbers'. There, the comic effect is brought about by the gags that follow each other at a mad tempo. As spectators, we find ourselves in one comic situation after another, assaulted by a continual barrage of jokes. In I LOVE LUCY and THE LUCY SHOW almost every utterance by the characters was turned into an absurdity, and almost every action into a comic sketch. Lucille Ball's shows, absorbing spectacles with a high comic density, also set the pattern for more topical sit-coms such as CHEERS where the comic effect is based on sharp dialogue. The same pattern recurs in THE COSBY SHOW, almost wholly dominated by the humorous performances of its central character, Bill Cosby. Although there is always the suggestion of a certain narrative development, THE COSBY SHOW is in fact nothing more than the hilarious unwinding of a succession of absurd acts which star the performer Bill Cosby, ably assisted but never upstaged by his fellow actors.[18]

In this respect, we come across the same phenomenon already previously noted: the comic aspect can make its appearance either at the level of social reality (a joke which we recognize as such from our experience of reality), or at the level of the formal conventions which belong to the discursive system we call television, and our repeated exposure to it as viewers. However, according to Stephen Neale, the comic effect in situation comedy must primarily be sought at the social level[19]: that is, its comic effects are social, 'realistic' and recognizable. This holds for series such as SAY AH and DOUBLE TROUBLE, and for many other Dutch comedies such as IN DE VLAAMSCHE POT, NIEMAND DE DEUR UIT, VREEMDE PRAKTIJKEN, HA DIE PA! and the immensely popular VRIENDEN VOOR HET LEVEN.

Terry Lovell calls series such as these *comedies of social realism*. The 'order' that is disrupted here refers less to the specific discourse of situation comedy, and rather to a discourse situated somewhere beyond the world of

comedy as well as beyond the world of television. She comes to the conclusion that in these comedies the comic effect is not constructed, but rather asserts itself as something already there in our daily reality.[20] Here the comic effect converges, as it were, with the reality effect which makes us forget that the joke presented to us is actually a deliberate construction. In the 'comedies of social realism' the awareness of the fictive origin and the 'constructedness' of the gag is largely obliterated. For us, the television viewers, these comedies seem totally transparent; their jokes come from our daily lives.

II.5 Comedy and Life

Following Terry Lovell, we must classify SAY AH and DOUBLE TROUBLE as fully fledged members of the class of 'social-realist' comedy (a term which, of course, in this usage has little in common with social realism as we know it from literary genres, such as the novel). To return to the point made earlier, we might say that in these comedies the mode of plausibility which refers to the world, pushes the mode of plausibility of the genre into the background. The comic effects of these 'comedies of social realism' follow naturally from the first plausibility. It is as if the comic effect emanates effortlessly from the situations and characters, with television appearing as a medium that confines itself to the mere act of registering. It functions as a neutral agency presenting reality 'as it is', making itself so transparent that it seems invisible and becomes merely a form of recording.

But humour, of course, never comes about by itself. It is, after all, one of the most artificial, one of the most carefully constructed forms of human interaction. Events in real life are, rarely funny in themselves, just as people in our immediate surroundings rarely provoke regular bursts of laughter by their very existence. The comic performances recorded by television are constructions that, however much they refer to reality, have constant recourse to the proven figures and techniques which process these references to reality, shape and transform them, in order to produce the comic effect. In these comedies, a clever and intelligent game is played with reality. But this inevitably brings us to a fundamental question that underlies our approach to Van Houweninge's series: how to make comic effects out of a reality which is in itself a serious matter?

In fact, comedy and real life are two closely related categories. Comedy is neither an innocent amusement, nor an antisocial phenomenon, but invariably a comment on the problems with which we are confronted in real life. As Henri Bergson put it: 'Comedy therefore stands closer to real life than tragedy (...). The more sublime, the more it blends with life. There are scenes taken from real life that are so close to high comedy that they could be transposed to the theatre without changing a single word'.[21] Perhaps he insists too much on the relation between comedy and reality (only reserved for the 'sublime' form of comedy) but nevertheless the reality-quality of comedy is perfectly expressed.

On the other hand, comedy seems emphatically distinct from life since it frequently presents things as the very opposite of alive, namely as mechanical. Just as a child experiences pleasure with a toy that for her or him can assume the form of a human body, or of an animal, but is itself a self-propelling mechanism, so we enjoy the mechanical movements of a clown or the wooden gait of a character (such as Charlie Chaplin moving through his films, or the jerky stride of Tati). Mien Dobbelsteen owes part of her success in SAY AH to an 'unnatural' body posture, her head screwed into her neck, her exaggerated posterior, and her feet taking the smallest of tripping steps. These characteristics make hers the most physically comic performance in the series. She thus conforms to the image of a 'female comedian'.[22] The comic aspect therefore seems to be a combination of something that is alive, something that is human, but at the same time also inhuman, or rather, de-humanized, mechanical: 'Comic is any treatment of actions and events that give us the illusion of life together with the clear sensation of a mechanical construction '.[23]

According to Bergson, the mechanical in the comic and the comic's comment on life go hand in hand. The question we need to answer is: what is so funny about the mechanical? Why do we laugh when living beings surrender to a mechanism, to an automatic gesticulator or a mechanical system?

The rigid mechanism that we, from time to time, discover as an intruder in the living continuity of human existence has a very particular significance, since it can be considered as something that withdraws from life (...). Comic is a person who seems like a thing. Comic is that aspect of human events which, because of the inflexibility possessed by this most

peculiar genre, imitates a pure and simple mechanism, an automatism, a movement without life. The comic thus expresses an individual and collective deficiency which demands immediate correction. That correction is the laugh. The laugh is a particular social gesture that underscores and suppresses peculiar or unusual deviations of people and events.'[24]

The woodenness of numerous characters in situation comedies, expresses, if we refer ourselves to Bergson, a deficiency to which we can only react with hilarity. This applies, for instance, to the character of Lucille Ball. The humour of her shows always depended on the terrible clumsiness with which she tackled the most disparate situations. In this respect Lucille Ball did not possess the least flexibility, nor the least control over her own way of behaving. In almost every episode she finished up – sometimes literally – in the ditch. As a result, the reaction of her employer Mr. Mooney (Gale Gordon) was also characteristic, for whenever Lucille Ball (as Lucille Carmichael) announced another of her initiatives, he would go: 'Ooooooh Nooooo Mrs. Carmichael!'

What holds for characters also holds for situations: we are only amused by a situation or event if it also displays some element of the non-organic, or better, a certain deficiency inherent in the organic. Precisely here

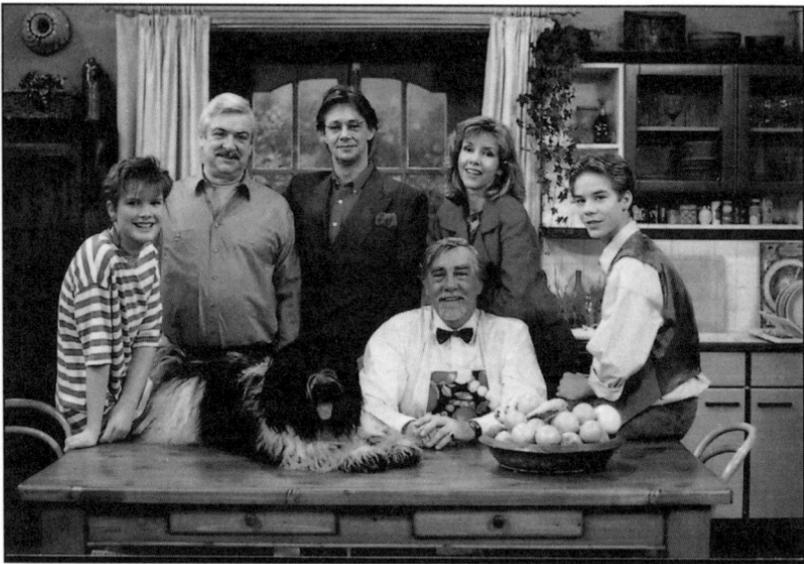

DOUBLE TROUBLE: *the Dutch cast*

a problem arises in the comedies of social realism: how to express the many 'deficiencies' of social reality? Or rather: how to provide social life with a comic appearance?

In series like SAY AH and DOUBLE TROUBLE the answer to this question is perhaps that situations are regularly presented which seem to lack a certain common sense, or in any case are open to discussion. Situations regarded as 'hot potatoes' in the public domain are transposed into the fictive world of the sit-com, where they are once again declared 'hot potatoes'. 'Exactly as in reality' these issues become topics of conversation at the dinner table in the Van der Ploeg household, or at the kitchen table of the Bol-Buys household. The 'deficiency' thus manifests itself here as a 'deviation', as an aberrant form of human life about which no consensus can be reached, rather than as a 'disruption' in the 'world' represented by the comedy.

From time to time SAY AH strives for direct treatment of such social 'problems', where many other comedies do so in a less explicit manner. At first glance, for example, social pretentions appear entirely absent from THE COSBY SHOW, where the humour seems restricted to the protected world of the Huxtable family. No great political themes, nor public debates seem to enter, and the laughter is concentrated on the intimate relationships between the children and Ma and Pa Huxtable. But this insistent stress on family life and the issues of school and education have their own external reference, so that – to its primary audiences – THE COSBY SHOW does reflect extremely topical problems of the eighties and nineties, most notably, how to represent family life when the family has definitively lost the illusion of inner coherence it had in the sixties, the brave face it put up to the outside world which it had in the seventies, and shortly thereafter, the status it still enjoyed up to the eighties. This is in fact the painful problem concealed underneath the warmth of the Huxtable family, but brought to the surface in, for example, THREE'S COMPANY, where one man and two women (John Ritter, Joyce Dewitt and Suzanne Somers) attempt to develop an alternative household.

Chiem van Houweninge's series raise questions like these explicitly. I already mentioned several 'hot potatoes' that engaged the characters in SAY AH, such as alternative medicine and homosexuality. Again, it should be remembered that at the time SAY AH was introduced on television, raising issues that were on the agenda for social and political debate was a policy entirely in tune with the outlook of its commissioning broadcaster, VARA,

which wanted to adapt some of the original, enduring objectives of social democracy to the vicissitudes and demands of modern times. VARA, together with its 'natural supporters' among Dutch society at large, was looking for a way of making these 'hot potatoes' generally acceptable, and by introducing them into a series such as SAY AH, a certain social 'solidarity' could be evoked.

II.6 Superiority

Nevertheless, it should be remembered that the world of SAY AH comes to its audience in the form of comedy. The shifts in society are presented neither in a documentary frame, nor as serious television drama (which was typical for VARA prior to the eighties), nor even as docu-drama, but in the guise of a situation comedy. The question this raises is whether a sit-com can articulate social issues in a responsible way?

If it is true that laughter serves as a 'corrective gesture', as Bergson puts it, then the effect of a joke does not necessarily conform with the politics social-realist comedy strives for. All the issues raised within comedy, researched and tested as they may be, are subject to eventual adjustment by our laughter. It is the audience that controls, neutralises and adjusts the comedy by its reaction. Every element supposed to constitute the comic in a comedy (whether it is a character's traits or actions, or the situation represented) is always threatened by dissolution into shallow laughter and innocence. Especially in the case of issues that concern non-conformist, dissenting forms of contemporary human life, touch on controversial matters, or take up developments not yet accomodated within a publicly agreed consensus, a situation comedy would seem to be an extremely delicate vehicle. Our laughter by no means always testifies to an unqualified acceptance, but very often acts as a defence mechanism against what is felt to be the strange, uncanny or even unacceptable.

The delicacy of comedies is enhanced moreover, because the comic effect not only presupposes a certain 'deficiency' in the object of laughter, but also an awareness of the audience that they are in some respects in a superior position with regard to the 'deficient' object of their laughter. Situation comedy thus presupposes an asymmetrical relationship between the subject and object of laughter, which allows little room for the warm feelings of

solidarity which the VARA type of 'socialist-realist' comedy strives to call upon.

The superior position of the public is itself the product of a careful construction of the comic 'object'. That is, the 'deficiency' manifested by the object is always the result of a certain amount of work in advance, thanks to which we are able to detect a 'deficiency'. If one wants to provide a proper (social, humane) position for the audiences of sit-coms, a strategy is required that takes into account the audience's (structural) position of superiority.

Here, the question of whether the spectator is provided with information about the story or is kept in ignorance becomes important. Among the most commonly available strategies for managing knowledge, both surprise and suspense are at the disposal of comedy.[25] Humour can be played out in two ways. If the public knows or ignores as much as the characters do, new information can be revealed by surprise. If the public is one step ahead of the characters and knows more than they do, the audience can be kept in suspense. The latter strategy is, according to Robert Escarpit, to be considered as the primary form in which comedy tends to manifest itself.

It is also possible to exploit the audience's ignorance by providing the relevant character with more knowledge and thus putting him in a superior position with regard to the spectator. This figure results in what Escarpit calls 'humour in the second degree'. It is a strategy not practiced very often, because it rests on a very dubious premise: it aims at making the audience laugh at its own stupidities, its own mistakes.

The most effective strategy for soliciting a humorous reaction, then, rests on maintaining the superior position of the audience vis-a-vis the comic object. According to Bergson, this feeling of superiority is confirmed in the corrective action the audience is allowed to perform towards the comic scene. Laughing permits the audience to control and direct the 'deviant', the 'strange' that is laid before it. According to Escarpit, we speak of tragedy whenever a feeling of sympathy and solidarity with the unwitting character is evoked in the audience. But we are dealing with comedy when the audience has the feeling of being superior to the character who is led into actions precisely because of ignorance.[26]

In a comic situation of 'the third degree', this relationship is reversed. Mostly it is felt as a form of misplaced humour; it is the character who laughs at the public rather than vice versa. Humour functions at its best when the comic character gets into trouble because of his or her innocence

and ignorance, and thus becomes the object, the 'victim' of the joke.

This is where comedy reveals its social nature, according to Bergson, for whom comedy is seldom a form of inconsequential or uncommitted amusement. It confronts a society with its 'deviations', 'oddities' and 'marginalities'. But in the very same process, comedy allows a society to test and control its 'deviations'. These two conditions constitute the social or ethnographic dimension of 'canonical' comedy. They define the model from which other forms of comedy are derived.

Constantly shifting relations between laughing subject and comic object are also typical for SAY AH. SAY AH sometimes makes use of humour by revealing information that the audience could not possibly infer from the plot. In an early episode of the series for example, comic effects are drawn from a misunderstanding about a romantic affair which eventually turns out to be entirely unfounded. The misunderstanding is allowed to arise in the viewer as well as the characters. The characters speculate among each other about a possible love affair, and the audience is led toward the same mis-understanding by, for example, the information given in a skating scene between Hans and Thea. In this scene, Hans and Thea have an exchange which, indeed, provides food for thought. 'If I did not have you', says Hans, after Thea has given him a number of coaching tips. 'I mean it' he goes on, 'you give a person confidence in himself.' And Thea says, 'you give me the same feeling too.' And finally Hans says: 'Do you know what it is? We're just lucky to have each other.' And arm in arm they skate away from the camera. The scene ends with Hans' offer to take her home, accompanied by a meaningful look: a scarcely mistakable scene, in fact.

The comic aspect makes its appearance at the end of the episode when it turns out that Thea is a lesbian and that Hans and Thea are just good friends. Everyone turns out to have been badly mistaken. The denouement consists of revealing information not provided by the plot. Here, no mis-understanding results from the part of the ignorant 'comic object'. The clue of the episode is rather the revelation that Thea is a lesbian. This information is, strictly speaking, irrelevant to the structure of the episode. She might as well have confessed a preference for men with moustaches, in which case a relationship with the clean-shaven Hans would have been equally unthinkable. Everything in the build-up of the misunderstanding and the sudden revelation depends on the *how*, and any motivation of the point by

some social content is arbitrary, or at least superfluous (except, of course, insofar as a preference for a partner of the same sex is more socially charged than a preference for men with moustaches).

II.7 Double Address

The most effective form of comedy assumes a risible 'object', and a laughing 'subject'. But the deficiency of the 'object' and the concomitant superiority of the laughing subject will be a major source of inconvenience for comedies of social realism, as SAY AH and to a lesser extent DOUBLE TROUBLE prove. Constructing a deficiency will inevitably do injustice to the social phenomenon, which will somehow be made to appear ridiculous, wooden, or (as Bergson has it) mechanical. Moreover, precisely because of its superiority to the comic object, the public by definition will not be sensitive to *solidarity* and warm sympathy since, with the laugh, one feels oneself raised above the 'object'. To quote Bergson once more: 'The laugh is for everybody a correction, which must, since it is expressed in order to humiliate, cast the person who is the object of the laugh in a disagreeable light (..) The laugh could not achieve its aim if it wore the badge of sympathy and goodness.'[27]

The solution Chiem van Houweninge has found for the problems articulated here is as simple as it is ingenious, and it gives a special significance to the hybrid concept of dramady which he has invented. The meaning of dramady does not lie in a blending of essences – the essence of drama, which is to say the tragic, mixed with the essence of comedy, laughter – but rather in the pluralistic way in which the public is addressed.

This pluralism becomes immediately clear in SAY AH in the open flirtation with several milieus: the doctors' milieu of Lydie van der Ploeg and the working class milieu of the Dobbelsteen couple, although this initial situation was clearly adopted as a strategy to attract a pluralistic viewing public. The same could be said of the series DOUBLE TROUBLE, where, although only one household is involved, the various members of the Bol-Buys family have nonetheless such a broad range of interests that they cover several different milieus. At one end of the spectrum we have Grandfather Henry Buys, who in his active career has graced mayoral office, his daughter Simone, an actress, and her husband Victor Bol, a representative in the European parliament.

At the other end we have Victor's father Willem Bol, handyman and collector, and through him we have access to the milieu of market stall holder Harry and to that of Gunez, who is of Turkish origin.

But the pluralism intended here concerns above all the double appeal that emerges from the way in which the drama involves the spectator while at the same time assuming the distance and malevolence of the comic. This 'disobedience' vis-a-vis genres and rules distinguishes Chiem van Houweninge's series from American sit-coms, in which there is scarcely any doubt about the invulnerably superior position of the spectator. In SAY AH and DOUBLE TROUBLE, the spectator is, on the contrary, tossed back and forth between drama and comedy, between social engagement and superiority, between serious involvement and laughter. Out of this anomalous relation with the spectator emerges the specific character of Van Houweninge's comedies.

Thus, it is ultimately a certain quality of freedom that is at stake. In the freedom to be entirely and wholly a 'television-viewer', assuming the heterogeneity, continuity, and irrevocability that this medium offers, the spectator addressed by Van Houweninge is able to occupy several positions at the same time. Offering a certain 'freedom of access' to the social, without the limitations of formula and genre, while not abandoning altogether the security of superiority that television comedies promise their viewers, Van Houweninge's work in this field has, for the last 25 years, consistently tested the boundaries of the possible.

Notes

1 *Het Nederlands Scenario*, no. 1, 1990, p. 82.
2 *Het Nederlands Scenario*, no. 5, 1991, p. 20.
3 *Ibid.*, p. 18.
4 As defined by Tzvetan Todorov. See *Communications*, no. 11, 1968, p. 2.
5 Christian Metz, 'Le Dire et le Dit au Cinéma', *Communications*, no. 11, 1968, p. 22.
6 That's why this subgenre is called *domestic sit-com*.
 See: Steve Neale and Frank Krutnik, *Popular Film and Television Comedy*, London: Routledge, 1990, p. 233.

7 *Ibid.*, p. 245.
8 These two plausibilities cannot always be clearly distinguished.
See: Eric de Kuyper, 'Enkele bedenkingen bij de Genreproblematiek',
Versus, no. 2, 1985, pp. 51 ff.
9 *Het Nederlands Scenario*, no. 5, p. 12.
10 Ien Ang, Ernie Tee, 'De Kwaliteitsomroep van Marcel van Dam',
De Groene Amsterdammer, no. 20, 13 may 1987.
11 Stephen Neale, *Genre*, London: BFI, 1980, p. 24.
12 John Ellis, 'Made in Ealing', *Screen*, vol. 16, no. 1, 1985.
13 Jean-Paul Simon, *Le Filmique et le Comique: Essai sur le Film Comique*,
Paris: Albatros, 1979, p. 19. Simon calls it the *genre de la transgression*.
14 Terry Lovell, 'A Genre of Social Disruption?',
BFI Dossier 17: Television Sitcom, London: BFI, 1982, p. 21.
15 *Ibid.*
16 See Bart Andrews, *The 'I Love Lucy' Book*, New York: Doubleday, 1985.
17 See Ernie Tee, 'CHEERS, A Situation Comedy', *Skrien*, no. 140,
February/March 1985.
18 See Ernie Tee, 'THE COSBY SHOW, een Geruststellende Komedie',
Skrien, no. 146, February/March, 1986.
19 *Genre*, p. 24.
20 'A Genre of Social Disruption?', pp. 22-23.
21 Henri Bergson, *Le Rire*, Paris: Quadrige/PUF, 1983 (1940), p. 104.
22 See Eric de Kuyper, 'De Vrouwelijke Komiek: Het Lichaam en de Lach',
Versus, no. 3, 1987, p. 73.
23 *Le Rire*, p. 53.
24 *Le Rire*, p. 67.
25 For a more detailed discussion of the regimes of knowledge in narratives,
see the essay on 'Trangressing the Boundaries of the Detective Genre'
by Robert Kievit, Chapter VI.
26 Robert Escarpit, *L'Humour*, Paris: PUF, 1981 (1960), p. 105.
27 *Le Rire*, p. 150.

Chiem van Houweninge

III

CHIEM VAN HOUWENINGE

The Writer at Work

ROBERT KIEVIT

III.1 Introduction

Chiem van Houweninge held a seminar on scriptwriting at the department of Film and Television Studies at the University of Amsterdam, where he also gave a number of lectures and was interviewed by Jan Simons. During these sessions, Van Houweninge formulated his understanding of scriptwriting. Robert Kievit, who attended the sessions, gives here his edited account of them.

The theory and the practice of writing screenplays are treated in an integrated fashion, using examples both from the work of others and from his own work. The writer at work on a screenplay is followed systematically from the initial idea to the final script.

First, a number of starting points for writing a screenplay are cited, after which Van Houweninge considers the path leading from this basis to the plot. From there he discusses the central role of the conflict and how that conflict is worked out at different levels. The next section deals with the way a screenplay is constructed, from the exposé, via conflict stage, to climax and resolution. He looks at the question of the shaping of characters and the accentuation of dialogue, and then rounds off his account of the path from idea to finished script with a consideration of the way the main strands of a script are drawn together in the scenes.

Finally, he sets forth two essential principles which serve, in his view, as a basis for the construction of good scriptwriting.

Starting Points for Writing Screenplays

A Screenplay Is a Story

Stories, in my view, are preeminently suited to the playing off against each other of different interests and viewpoints. A number of people from my generation have not always agreed with this, alleging that a story is of no importance. If film were nothing more than telling a trivial story, then I would be in perfect agreement with them, but I look at the significance of stories rather differently. Fortunately, however, I find support for my position these days coming from modern philosophers and other thinkers, who point out that many questions which concern human life, or deal with the value of human existence, cannot in fact be treated theoretically.

What this evidently means is that a revolution or reversal has occurred with regard to the recent past, when the significance of stories was undervalued. Currently, many people are saying that there are a number of essential questions that can only be handled in the form of stories, since it is precisely in a story that the struggle of conflicting interests is articulated in words.

In addition, there is the great power of a good story to affect people. A good story or screenplay seizes the public rather like the Trojan Horse. If you make a remote documentary about illegal adoption, then all the viewers are going to switch channels. But if you make a good story about illegal adoption, as I tried to do in CUDDLIES (KUSCHELTIERE), then you involve people. They get angry over the injustice done to these children. The 'Trojan Horse' is brought inside by viewers, the 'theme' is released and in so doing it appeals directly to their feelings.

The classic screenplays are also constructed on the basis of a good story. Ton Lutz, a well known Dutch director, said in the Publiekstheater that *Electra*, with all its Greek traditions and language, should be played as a Western. Not only thrillers or horror stories, but also really great themes such as handled in *Electra* need a plain story base, like a peg to hang it on. Without a story, the script rapidly becomes abstract, or a formless background. Devising a good film without a good story as a backbone is incredibly difficult, which is why in my view you must base a film on a story. This of course immediately raises the question of how you actually write a screenplay with a good story line.

Scriptwriting Is a Powerful Subject Properly Worked Out

To write well does not mean that you have to come up with some terribly important or psychologically profound problem with an abstract conflict which you struggle to get on paper, only to realize that you are inadequate for the task. Such great themes require a giant of a writer. Nor does good writing mean devising as complex a construction as possible; but rather that you work up a strong subject as well as possible. A good rule is: the simpler, the stronger. Therein lies the key. Good writing consists of giving shape to an essential, simple problem in a brilliant way. Roald Dahl, for instance, is a master of this. One of his terrific ideas, a script that he worked out simply and beautifully, is the story of a woman who kills a man with a frozen leg of lamb. The policeman eats the corpus delicti, destroying the evidence as he feasts on the lamb.

A story is told about Robert Mitchum, who, while shooting a film in Yugoslavia, received a request from L.A. to play the lead role in a Western. He telegraphed back: 'Send me the script.' A day later he got another telegram which read: 'Man rides into town.' Nothing else. 'I'll do it', he replied. Write something simple. If it's brilliant, the talent will shine through. Write a screenplay on a problem that you are equal to as an author. The theme or problem is important, but what is more important is how you, as author, give form to that problem.

A Screenplay Is Structured Imagination

Writing screenplays is like learning a language. You can learn words and grammar, but if you don't learn to speak a language and thus learn to communicate, then there's no point in it. The way of handling a language, speaking and writing, has to do with musicality, rhythm, in short, with talent. This speaking or writing ability determines your power of communication.

The techniques of scriptwriting can certainly be imparted, but imagination is something you have to develop, and is not to be learned out of a book. You have to train the imagination, day in and day out. If you write each day, you can master it sufficiently to write a script. It's a lot of work. So far, I have written something almost every day, though I've thrown away a great deal of it. A first rule is that you should practice your trade every day, but apart from that, you have to feed and stimulate your imagination.

You have to be interested in the things around you, though you don't have to put down everything you see.

I once compared writing with baseball. If a really good pitcher, who is absolutely accurate every time, falls ill and as a consequence doesn't pitch for three months, then his pitching will no longer be perfect when he returns. He has to begin all over again. So, too, with the development of the imagination. Just as somebody who spends the whole day in fitness training develops huge arms, you will acquire a huge imagination if you spend the whole day training it, the imagination needed for writing screenplays. It's a matter of releasing the imagination and then capturing it on paper. What is required is to give free rein to your imagination, but only as free as you want it to be. In other words, if we compare the imagination with a frisky racehorse, you also have to remember that you need a good jockey to be first at the finishing post: a precarious balance between an unbridled imagination and the reins of technique. Once technique and imagination are integrated, you acquire structured imagination. A good script is structured imagination.

III.3 Foundation and Plot

The Foundation and the Writer
When I was first asked to write a synopsis for TATORT, I went completely wrong. I had written something which I thought ought to be the basis for a good, really bizarre, amusing thriller. But alas, it was immediately rejected. It was a completely fictitious subject: a ventriloquist wants to kill his boss by using a doll, with all the attendant complications. In short, it was a complicated story without a leg to stand on.

The essence of the rejection was that no one was interested in contrived stories and atmospheres, and even less in a story in which someone kills his aunt for a pearl necklace. What was required was a screenplay with a plot rooted in society. I subsequently set out to write from an idea in which I myself was emotionally involved, illegal adoption, and wrote a synopsis which was approved. For some time I had been incensed over the fact that it was still possible in The Netherlands to order a child for adoption as though it were a business transaction. For 30,000 guilders you could buy a child with all the necessary documents. In indignation, I suddenly realized that this would

make an excellent basis for a screenplay, and that was the screenplay I wrote. It was not something concocted, but something I wrote because my heart was in it. And because I was so strongly involved, I was also able to handle the discussions with script editors.

I consider the foundation as one of the most important elements of a script. A writer must get excited over something, and have something to report, an underlying motive that will make him want to write. Whether it's a comedy or a thriller makes no difference; the writing comes out of that foundation. As long as it originates in a theme that moves the scriptwriter.

Foundation and Story

Further, the foundation must be given form in such a way that it comes across to someone else, to the viewer. In most cases then, I look for an arresting story. It is very different, however, if a story goes much deeper than the level of the superficial story, if the foundation, the idea the writer had about a social event, or a view of the world the writer wanted to express, speaks from that story.

To my mind, it is terribly important that you construct a story as a vehicle to get across that idea. Without a story, in my opinion, the idea becomes vague, so that you will never get it across succinctly. For this reason I am a strong devotee of the story, and for the same reason I use this figure of the foundation that you as writer have, the concrete block that is yourself. The foundation determines the house (the story) that you want to build on it.

From Foundation to Plot

A plot is simpler to analyse than to write. It is the backbone of your story. When writing the plot you must always keep an eye on the foundation. It is the clarity of the plot that mainly determines the power with which you give shape to your basic idea. The more involved the conflicts are, the more interesting the characters and the clearer the plot must be. The plot is the hand that leads the innocent viewer through a new world, either abstract or concrete; and if the hand is limp and indecisive, then the viewer is soon lost. He remains, perhaps, standing beside a striking event or place of interest, but he does not arrive 'home'.

There are two different approaches to constructing a plot. The first begins with something alive in the writer's imagination that he wants to get

onto paper, whereas the second is based on wanting to use the medium of film or television. Ninety-nine percent of people active in our business want to make a film and are looking desperately for something they could make that film about, but in my view the foundation of the plot has to be a living idea.

To use a simple image, the construction of the plot can be considered rather like a coat stand. The trunk (the idea) supports the rail (the story with its main thread) on which the various coats (characters and scenes) can be hung. How those elements are hung demands a high degree of precision.

After an idea has formed in the imagination, originating from within yourself, from an emotion for example, the next difficult step is writing a plot from which the characters and scenes are developed. The main line of the story must contain building blocks for the imaginations of people who will sit and watch it.

Premise and Foundation

In various American handbooks, the starting point is given as the premise: the basic idea of a film can be summarized in three words. From this premise you should be able to develop the entire screenplay, and anything else you might think of that does not fit the premise deserves to be cut out.

This premise more or less corresponds with what I have called the foundation, yet I would formulate my foundation rather more broadly than the three words allowed by the premise. Too rigid an application of a rule like this could easily result in a script devoid of all imagination. As scriptwriter you must find a balance between, on one hand, giving free run to the imagination, and on the other hand, restricting the imagination and concentrating on the premise. If it is too closely tied to the premise, the story becomes thin and unimaginative, whereas if imagination is given too much rein, the screenplay drifts out of control.

I find it more important myself to have a strong idea of what it is you want to say. If you know this, if you have found that foundation, then you must, of course, subsequently tie in everything you do to that idea.

If a writer comes to me to ask my help, I can point out in which particular scenes he has drifted too far away from the basic conflict, and my advice is always to take those scenes out since they add nothing essential. Reading scripts, it often strikes me that a great deal of superfluous ballast should be discarded and that essential matters of characterization and the

line of the premise must be introduced. Many American scripts often stick to this line very well, and in these scripts the coat stand is strong and clear. On a coat stand like this, however, you have to hang your garments in balance. If you hang a red coat, a fur coat, two parkas, a hat and an umbrella on one side, and nothing on the other side, then it will fall over. Similarly, a screenplay must be constructed in a balanced fashion.

In the exposé, which sits below on the foundation, and from which the coat stand is able to grow, you become acquainted with the characters, and usually at the same time a problem in which all the building blocks for the conflict lie ready and waiting. Here you construct the script which via the conflict, climax and resolution gives form to the premise, and by means of plot, brings the characters and dialogue to life.

To show how these sometimes rather abstract concepts fit together I want to give a concrete example by describing how I wrote a film script about heart transplants, called CROSS MY HEART (HARTEDIEF). The *foundation*, the idea, is that someone, because of his fear that he could be psychologically changed as a result of a heart transplant, pays such careful attention to himself that he is changed anyway: the principle of the 'self-fulfilling prophecy'.

CROSS MY HEART (HARTEDIEF)

When the man realizes that he has undergone a heart transplant, he sets out to investigate the life of his donor. Since he has re-entered a life that is totally different from his own, he becomes afraid. How does a person deal with his fear and what will he do if he finds out that he has been given somebody else's heart? This theme pre-occupied me after Christiaan Barnard carried out the first heart transplant in 1967.

In the *story* the man is a professor of Egyptology who discovers that he has been given the heart of a murderer. He learns this via a journalist working for a tabloid newspaper who was tipped off by the police. As a result, the man wants to know where the murderer lived. He goes to the newspaper office in search of the address of the man who killed his wife and then died of a fractured skull himself after falling out of the window. He looks through the papers in the office until he finds the address. He then goes to the house where the man lived, and interrupts two burglars who are conducting an investigation of their own. They have turned the entire house of the donor upside down in search of a roll of film. The man who has undergone the heart transplant is at once seized by these two since they think he knows something. He can, in fact, escape, but for the first time the man finds himself involved in something that he has absolutely no knowledge of. He gets drawn in even deeper. The further the man descends into the life of his donor, and the more he comes to learn of his life, the more powerfully the world of the donor works on him. Because he gets so ensnared in the life of his donor, the man is able to establish that it was not the donor, but someone else who killed the woman. That is the story, the coat stand's support rail.

How everything happens, however, is how the coats are hung. The story for example is amplified by the fact that the man is a professor of Egyptology, for the Egyptians believed that the soul dwelt in the heart for four thousand years. This soul could take on any shape and even live in another body. During the operation this information is conveyed to the viewer.

The Story as Train
I sometimes compare a story with a train journey. As a writer, you have to keep a very close eye on the basic conflict, which lays the track on which your train is going to run. The train travels towards its destination and through its movement, through that manner of thinking, it sucks up other apparently irrelevant elements in its wake. This is the case with a regular

narrative film, but also in a more difficult abstract film. If you have no story as a starting point, but instead work from some other logic, then you have to stay within that logic, and the elements sucked along by the onrushing train must be of sufficient quality to ensure that the journey is interesting. In that case the outcome need not be so tangible, the conflicts can be more abstract, somewhat more subterranean and difficult. To write something of that kind, you have to be incomparably good. For example, Fellini's SATYRICON was not made without effort, just like that. Conflicts which at first glance seem to have little to do with each other, fit together to form a strange jigsaw puzzle. Once such a train is on the track and rushing ahead, then you are in for a fantastic journey.

On the other hand, many screenplays keep much more strictly to the rules. There are many police series which simply unwind in a specified timetable. You have station A – the problem or crime is discovered, and eventually you have end station Z – the solution. The only question is how you get from A to Z. On this trip there are various obstacles thrown up by B through Y which only serve to delay the alert sleuths in their arrival. In the end, however, the entire story is directed toward the journey to the terminal station.

You will often see a trajectory like this in series such as DERRICK, which is all about the solution of the case. Derrick himself almost never has any personal conflicts, he always feels like working, he has no wife, only his work. He is like a case-solving machine.

If you put this beside TATORT, the following differences are immediately striking. The TATORT train makes quite an arduous journey, but it goes through a certain landscape that you as traveller can look out on, a landscape that is sometimes more interesting than the track. That landscape through which the train travels is my personality, an imaginary landscape shaped by just those little personal conflicts which I invent in order to populate it. The more interesting you make those people, the richer in colour the whole case becomes. The more imaginative you make the case, the more exciting it is, and the more the viewer is involved.

What matters is that the train stays on the track, even though there are obstacles. There should be false trails, but the main line, like a steel thread, the plot, must hold. It is difficult to make such a story. But if you succeed in putting together an exciting story out of the conflict that you discover in yourself, then you make a film that everyone is going to watch.

In CUDDLIES (KUSCHELTIERE), I invented a story for a television film starting from the foundation. The story is put together so that people can understand it easily. I take them by the hand so that they can readily follow the journey for which I have built the track. A well constructed story takes good care to carry the viewers with it. But if you want to go from A to Z, and if you want to captivate the people you carry with you, then you must strike a chord with the viewer. What you want to tell must be given form in a conflict; but you can only make the conflict clear if you have a good story.

Contriving a good story is tricky and therefore you hear rather often that a story is unimportant, as for instance in the 'difficult' abstract film. If in an abstract story the scriptwriter does not stick with the logic he himself has traced, then he loses the public. If that logic is indeed consistent, then they will be sitting on the edge of their seats, and when they emerge from the cinema will say that they have seen a strange yet wonderful film.

The Plotline as a Circle

I have indicated on the one hand the importance of a well constructed story, based on its premise or foundation that should be honed by cutting out all superfluous material.

On the other hand, I have been pleading for a rich imaginative landscape that is at least as important as the rails on which the story travels. The scriptwriter moves between these two poles. Here, plotline and circle are central concepts.

Certainly, if you begin writing screenplays, it is important to exploit the line of the plot fully within a radius of action that you have created. You must follow a very clear line, and along that line you must exercise your imagination to the full. If you visualize the story as a circle in which everything happens, then you have to stay within the action radius and not construct larger circles around it. You have to ensure that during the writing you do not invent yet more elements in order to give the plot shape. You must not stray too far from the main story by interrupting the plotline with other sidelines, but rather strive to give shape to proceedings from within, and so keep the plot within its own circumscribed limits. Each scene should be exploited in such a way that a new scene arises quite naturally from it, with every scene contributing something essential. The viewers' attention will then stay riveted.

Plotlines and the Length of a Film

According to the length of a film, a script will need more or fewer plotlines. A film of thirty minutes for instance needs two plotlines, while a forty-minute film requires at least two strong plotlines, and a fifty-minute film needs at least three.

Of course, the number of plotlines depends very much on the issue at stake. The problem of illegal adoption that was so central to KUSCHELTIERE is hardly a problem to be dealt with in half an hour. You need 92 minutes for that. In half an hour, you can at most dramatize the conflict.

From Synopsis to Screenplay

How should you submit a script to interest prospective buyers? First, you should prepare a page with a general presentation of the *idea* of the piece, in which you set out what it is about and what you want to do with it. The basic conflict on which the foundation is constructed is indicated here, and should be formulated in an arresting way.

With a single play, a film of thirty to fifty minutes, after the general presentation comes the *synopsis* of the story, followed by the screenplay itself. This synopsis is most important, and if not sufficiently interesting then nobody will bother to read the script. The synopsis must give a taste for more, must make the reader curious about the screenplay. It is also useful for the script-writer to write a synopsis, since by making the screenplay more compact it becomes clear whether or not the line of the script fits.

With a series, after the general presentation comes the 'coat stand': the basic idea for a great many episodes. It is important for the screenplay idea that you give an assessment of financial feasibility. Further, the mutual relations between people should be central to the idea, and not the environment. A screenplay idea must be about people in their surroundings. I will give an example. With DOUBLE TROUBLE (OPPASSEN!!!) I had one sentence: 'I would like to make a series about two grandfathers who bring up their two grandchildren, a boy and a girl, while the father and mother pursue their careers.' That idea was the basis for a series from which I could certainly pro-duce 150 episodes, since it contains the seed of countless conflicts. After this comes the choice of a set where the series will be realised: its environment. However, a series grows as a process in which not all the details have to be clear in advance.

I shall go further into the differences between a single play and a television series in the discussion of characters.

From Basic Idea to Plotlines

Glancing back, I want to list the central elements once more. The writer has an idea that he wants to tell, a foundation that will form the basis for the plot. The construction of the plot is linked closely to the basic conflict which is fundamental. The plotlines must be developed and honed on that nucleus, without forcing this to happen in a rigid manner. Room must also be provided for the capricious nature of the imagination, though without ever letting the main thread out of sight.

Depending on the length of the film, a screenplay requires more or less plotlines. Although the number of plotlines depends mainly on the central issue at stake, this number can vary from two (in a thirty-minute film) to more than three in a film longer than fifty minutes.

The essence of the screenplay is reproduced in the synopsis. The foundation is formulated in as arresting manner as possible, and a sketch is given of the plot construction. With a single play, an idea is given of the entire plot; with a series, the basic idea for various episodes is sketched, in which the relations between the characters are placed centrally and not incidental to the narrative context. The point here is also to sketch the way the basic conflict, the foundation, is to be worked out in plotlines.

III.4 The Conflict

The Central Role of the Conflict

Conflict plays a central role in a screenplay. This conflict is not only to be found in the foundation which I discussed, but also forms the basis for the plot, for the characters and their behaviour. Besides, a conflict is indispensible for writing sharp dialogue, although I wish to postpone the question of how conflict serves to sharpen characters and dialogue until later. I first want to concentrate on other functions of conflict in a screenplay.

Conflicting Interests in THE KENNY CASE

The major conflict in a screenplay must carry a conflict of interest within it. The moment there is no conflict of interest, there is no tension. Without a strong counterforce, the story has no muscle, and therefore, you must always look for conflicting interests in the writing.

If a scriptwriter works out a conflict, he or she is bound to look for that counter force, both in the conflict of the main drama and the smaller conflicts that play a part in each scene. The conflict, the basis of your story, must be translated into a scene, but it must not be uttered. It has to be developed throughout the scene, in the acting and the 'mise-en-scène'.

The main conflict is closely linked to the plot treatment. In order to explain this and as an illustration of conflict at different levels, I will use THE KENNY CASE (DE ZAAK KENNY), my screenplay about genetic manipulation.

The background story is as follows. At the Institute for Exceptional Scientific Research, Willemien, a gynaecologist, and Johan, a microbiologist, have implanted a number of chimpanzees with fertilized human eggs: that is, a human egg cell fertilized by chimpanzee sperm is now carried by a chimpanzee. One of these implants is successful, so that the egg fertilized in vitro is now an embryo developing in the ape's womb. When the experiment becomes public knowledge, a row follows in the parliament over whether such experiments are ethically permissible. The gynaecologist is called on to terminate the pregnancy of the chimp, but instead she falsifies the necessary paperwork because, like the microbiologist, she wants to know what the end result of the experiment will be. She goes to her parents' house on Schiermonnikoog, a Friesian island, taking the ape from the research institute with her, where she allows the child to be born. She brings up the child, a lad called Kenny, until he is sixteen. That is the background.

The moment the conflict gains form, Kenny is a pleasant sixteen-year-old who has had problems because of a pronounced tailbone and exaggerated canine teeth. These teeth are pulled and replaced with teeth of normal human proportions. He can run tremendously fast, and is immensely strong, which causes a number of problems at school. If he hits someone, it would be a terrific blow, and for this reason he has to be treated for his excessive bursts of anger. Otherwise everything is going well.

The film begins – and this is the basis of the major conflict – at the moment the microbiologist returns from California, where another mutant

The Kenny case (De zaak Kenny)

such as Kenny has been developed and is just about to be born. Willemien and Johan realize that their project will lose all its glamour if they don't proceed now with publication. The gynaecologist is caught on the horns of a dilemma. She has to choose between her ambitions as a scientist and her responsibility as somebody who, by caring for the child for sixteen years, has become a mother. She says she and Johan agreed to raise him as a normal child until he was eighteen. Johan comes in from time to time as a pleasant avuncular figure, interested in his progress, whereas she has invested sixteen years of her life in the boy. Furthermore, she thinks that Kenny could not survive if he learned that both his father and his surrogate mother were chimpanzees. She is afraid, in fact, that issues far more dangerous than they had foreseen might now come up and prefers to 'let sleeping dogs lie'. The question is in fact to whom Kenny belongs. He was, after all, 'made' under the aegis of the Institute for Exceptional Scientic Research.

When the man enters, they have a row which, although a minor conflict in itself, foreshadows the major conflict. Who can decide the fate of the boy? The mother, who has meanwhile consulted a lawyer, declares that no one can own a person, let alone give a person back to a research institute. The conflict escalates to the point where the mother must prove before the judge, on actual rather than philosophical grounds, what a human being is. That is the basis, and naturally I tailored the plea of the Public Prosecutor accordingly.

I let Kenny himself say what he thinks in the screenplay. When the judge asks what he thinks about the difference between people and animals, Kenny says, 'Art'. Everyone laughs, not comprehending. He says: 'I can hang a photo of a banana above my bed, a chimpanzee can't.' The conclusion follows from that sentence, the essence from which I constructed the entire conflict: there is one thing that distinguishes human beings from animals; a human can choose his future, whereas an animal cannot.

Eventually, as the trial winds up, judgement is pronounced. After considering all the pros and cons, the judge can only use the tools the law provides, and the law offers no provision for this matter. He proposes that it is high time provision was made in the law, but nevertheless, he can only say that Kenny seems so human that he cannot be returned to the research institute.

Although everybody is tremendously pleased by this judgement,

the judge, in his verdict, gives an addendum which prohibits any crossing of the races of apes and humans. He forbids further experiments with Kenny and orders Kenny to be sterilized to prevent introduction of ape genes into the human gene pool.

With this, Kenny's existence is effectively denied. The screenplay ends on the island with Kenny sitting in a tree beneath which his surrogate mother is buried. He shoots himself, but before he dies he says: 'I am a human being. I can choose. I do not wish to belong to the human race.'

What is demonstrated here is the way the major conflict is very strongly related to the plot, and why therefore, given the extreme consequence of the conflict, I made the dramatic solution in THE KENNY CASE equally extreme.

When writing fiction and making up stories, one of the most important things to remember is always to be on the lookout for the counterforce.

The Levels of a Conflict

In order to give shape to a conflict, I must both use and structure my imagination. The conflict plays on various levels, and if I am to get a gripping screenplay then it has to be strongly worked out at all these levels.

In my account of THE KENNY CASE it emerged that the conflict plays an important role at the level of the coordinating plot, and this makes itself felt both in the conflicts between the characters concerned and also in a character's internal conflicts. But of course, the conflict also plays an essential role at the lower levels of individual scenes.

On the basis of the screenplay KUSCHELTIERE, taken from the TATORT series, I would like to point out the various levels where there is a conflict of interests and how I worked it out.

The Conflict at the Social Level

KUSCHELTIERE is about the issue of illegal adoption. Schimanski, Thanner and Hänschen are notified that the body of a girl has been discovered in a river. The girl is found to have come from the Third World and has died of typhus. She has been buried in a wicker basket with toys and white flowers. Since the girl had typhus it becomes a case of culpable death, given that nobody has informed the health authorities of any typhus case, and typhus, after all, must be reported to the doctors. Because of this a suspect is being

CUDDLIES (KUSCHELTIERE)

sought, guilty of culpable homicide and here the police begin their work. The trail leads to The Netherlands, since at that time one could book a trip with child included through a travel agency: for 30,000 guilders one could go to Thailand and fetch a child with valid passport and all the necessary documents. In view of the fact that such adoption is illegal in Germany and other countries, many Germans exploit this route through The Netherlands. Inquiries there produced problems for the German commissioner, since such an adoption was not a punishable offence in The Netherlands.

My concern with illegal adoption and with the Third World served here as my foundation. The social pillar of the conflict has to do with the following forces. In Western society it is difficult to be able to adopt a child; it is a lengthy and complex process. There is a conflict within society, a society where, in order to protect such a child, laws are made for adoption, and

people must appear before a commission. Waiting lists for adoption are drawn up where people have to wait so long that they become too old to raise a small child. As a result, people who still want to adopt a child frequently reach a stalemate, and so society seeks other ways and means to obtain such children quickly. A smart organization gets round the problem and ensures that people are able to adopt a child by illegal means. And here enormous problems arise. People who suddenly have a child, without being properly prepared for it, without having been able to talk it over calmly with someone, are additionally forced into illegal action, unable to step away from their problems, since their illegally acquired child could, after all, be taken away from them again.

The root of the problem is that the Third World has to satisfy the demands of the rich Western World. For me, the conflict arises there.

The Conflict at the Human Level

I try to make the enormous conflict set out in such an episode of TATORT tangible by translating it into human proportions. In the screenplay I let this conflict play itself out within a family which has illegally adopted twins. A wave of problems follows. The woman becomes house-bound. All at once the man finds himself getting no attention from his wife. The grand-mother starts to interfere. But to make matters worse, one of the twins falls seriously ill, and for fear of being discovered they dare not take her to a doctor. The child turns out to have typhus, and dies. They are unable to give the child a normal burial since everything would then come to light and as a result they would loose their other child.

In essence these people do nothing wrong. They want a child. But all the same they do something forbidden by the state, they adopt a child illegally. They fear the penalty of discovery and therefore dare not fetch the doctor when the girl becomes fatally ill. That is the great conflict that I sketched, and from this I sat down and wrote the script. I began to make the coat stand, the story of KUSCHELTIERE.

The Inner Conflict and the Conflict Between Characters

Schimanski, investigating this affair, gets involved in the issue and as a result finds himself in an inner, emotional conflict.

At the same time, there is a conflict among the regular characters

of TATORT between the non-conformist Schimanski and the more conservative Thanner. These conflicts, in a certain sense, are interwoven. To realize this, the two characters Schimanski and Thanner are divided, such that Thanner wants to investigate the matter correctly, while Schimanski wants to push ahead and if necessary undertake partially illegal action in order to expedite the resolution of the affair. If this conflict is played out, the script gains tension.

Conflict and Building up Tension

'The tension mounts' is a good indication. But the question is, how does it happen? From time to time, a script lands on my desk in which there is a scene where between inverted commas is written: 'This scene has still to be worked out to make it exciting.' Then I send the script back with the comment: 'Indeed.'

An indication such as 'the tension mounts' would not be out of place in a book. In a film script, however, you must bring in the actual building blocks with which the tension can be created.

How do you build up tension? You as the writer must invent the building blocks, and as dramaturge you have to work out in which elements this tension lies. One of the most important elements which evokes tension is conflict. The play of force and counterforce evokes tension in the viewer, simply because the viewer is involved in anticipating which force is going to prevail.

Conveying Information by Means of a Conflict

If you have to represent several matters of fact in an exposé, you could let two policemen exchange information so that the viewer learns these facts. This information may be conveyed in various fashions. You could arrange for a document to be read, after which one of the officers grabs his hat and rushes out to interrogate someone. But such a scene would have nothing more to it than giving certain information, which is scarcely interesting, and therefore we have to look for another way.

My solution to the problem of conveying information is to use a minor conflict. In order to recover certain facts, Thanner and Schimanski have to make inquiries in The Netherlands. Schimanski wants to go at once, but Thanner has a row with his girlfriend, having promised that he would spend the weekend with her. The facts that have to be conveyed in the exposé are carried by the conflict between Schimanski and Thanner. In this way, as writer,

you can always look within the main conflict for small frictions to enhance the fascination of individual scenes. For this reason I always try to give scenes their own inherent conflict.

In KUSCHELTIERE there is a scene in which Schimanski and Thanner have to get permission from Dijkhuis, an Amsterdam police commissioner, to search a house in The Netherlands. I do not let Dijkhuis then say, yes, of course they can search the house, but rather I make a conflict of it: Dijkhuis says no. And with this minor conflict with a contrary Amsterdam policeman I then couple a far greater conflict from the past. I let Dijkhuis refer subtly to the Second World War. He hopes Thanner and Schimanski will not mis-understand him, but that for two German policemen to search a Dutch house... In this way the conflict is immediately inflated, far beyond the small incident that actually took place. Of course you should not harp on such an allusion too long, since if it becomes too lengthy it will have to be cut out again. But these small injections serve to underpin the characters of the Dutchman and the two Germans.

In this way I look for an inner conflict in every scene I make, lest it become a kind of information dramaturgy that does nothing but hand out information.

Functions of a Conflict

In a thriller, for example, you can build conflicts into scenes that have a variety of functions. I think that many American scriptwriters would have seized on such a scene as I have cited in order to throw up new obstacles: yet another problem for the detectives. But I use such a scene in order simultaneously to introduce a new theme. Of course, I then make the investigation more difficult, but there is an essential difference. In American thrillers the investigation is intensified by more technical affairs, whereas in a TATORT episode I actually try also to introduce powerful human affairs into the script.

After Dijkhuis' refusal, their investigation is stuck. Thanner wants to return home, but Schimanski won't give up, and here also a conflict is exploited to convey information.

When Schimanski has the idea of cunningly gaining access to the office where illegal adoptions are settled, by presenting himself as someone looking for a child to adopt, Thanner points out to him that it would surely

look odd for two men to be adopting a child. 'Nonsense' says Schimanski: 'We're in Amsterdam!' 'But we're Germans' says Thanner. 'You'd do much better to take a woman with you.' And so Schimanski goes off in search of a woman in order to present themselves as a couple badly wanting to adopt a child. But where can you find a woman so quickly? Thereupon, Schimanski gets up and approaches a woman in the restaurant and says that he needs a woman. She replies 'Immediately, or can I first finish my meal?' A little romance is simultaneously introduced that again evokes a tension and makes the viewer curious for further developments.

In summary, we can say that the function of the conflict is essential. This conflict is at work on different levels, from the major basic conflict that provides the foundation for the main line of the plot, to the smaller conflicts within the scenes. Social conflicts, conflicts between characters and individual inner conflicts not only provide suspense and interest to the viewer, they form the driving force and play a most important role in the construction of the screenplay.

III.5 Construction of a Screenplay

Classical Construction

In a screenplay anything is possible: you can tell a story from front to back, from back to front, with flashbacks and flashforwards. Yet you have to have a good pedigree before you can let go of the classical structure. I am therefore not so keen on flashbacks where these are used to explain something that actually ought to be handled in the dialogue.

On the other hand, if flashbacks are used the way they were in Dennis Potter's THE SINGING DETECTIVE, that is fine. The flashbacks there are motivated by the main character who is confined to a hospital bed by illness. In this state his thoughts involuntarily take him back to the past. Through this you realize in THE SINGING DETECTIVE that this form is deliberately chosen, and not something incidental, used to introduce material the writer forgot to put in his script. If the flashback is a principle of form and is organically handled in the script, then, of course it can work very well.

Nevertheless, I find it important that a screenwriter understands the classical construction of a screenplay before risking excursions away from

such knowledge and skills into more experimental forms. For this reason perhaps, I now lay special emphasis on the more classically oriented construction.

I want to use ONCE UPON A TIME IN THE WEST to indicate how a screenplay is constructed in a classical way, so that you will very clearly understand that the whole film revolves around the hunt for 'Henry Fonda'. To do something like that well, you have to begin with an *action* that *motivates* the hunt. In ONCE UPON A TIME IN THE WEST this is the scene in which the brother stands on the shoulders of the younger brother, and when the latter collapses, the brother is hanged. This is so well written – a less friendly person would say skillfully – that you understand *why* such a man would dedicate his life to taking revenge on 'Fonda'.

From Exposé via Conflict Stage toward Climax and Resolution

How, in broad lines, is a classical screenplay constructed? After the exposé, in which you have been introduced to everyone, there must come the start of a conflict. The working out of the conflict, or of the story, takes place in this central part of the script, which I call 'the conflict stage'. What has been set in motion in the exposé has to be worked out in the conflict, after which the climax and the resolution follow.

Where several plotlines cross each other, the exposé of the first plotline may already have present the conflict of the second plotline. As the structure becomes more complex, the different stages pass through each other, yet each plotline should have its own exposé, conflict stage, climax and resolution. You must, however, pay attention with this sort of interweaving of different narrative structures, since it can easily create a contrived impression. I would rather you took a simple line and became exceptionally inventive within the circles of exposé, conflict, climax and resolution.

I now want to work out further the stages that I mentioned above.

The Exposé

In an exposé of a screenplay one makes acquaintance with the characters, their motives and the story, and in addition, the first impulse for conflict is given.

Take for example the first film from the RAMBO cycle, FIRST BLOOD. In the exposé, two sentences tell who the man is. Rambo is a Vietnam veteran

and actually a good guy. He is on his way to visit the mother of his dead friend and bring her a photo of her son. He is accosted by the police and, because he has long hair, is roughly handled. He is locked up and beaten up in such an extremely unpleasant and fascistic fashion that everybody sitting in the cinema is angered by the police officers. The viewer sits for fifteen or twenty minutes watching a glaring injustice. As a result, everyone is subsequently content to watch the man massacre an entire village with a bazooka. This is justified, since the viewer has been able to see in the exposé that he has been most unjustifiably and unpleasantly treated. If this had not been first introduced in this way, then everyone would have been repelled watching this film. Rambo himself refers back to the exposé toward the end when he says: 'They took first blood'. It is a technique that is used superbly by the scriptwriters of RAMBO.

In the earlier cited film, ONCE UPON A TIME IN THE WEST, the exposé is also very cleverly set up, introducing a number of elements. The hunt for 'Henry Fonda', round which the entire film turns, is motivated by a deed through which the audience understands why anyone should dedicate his entire life to getting revenge. Three elements are necessary for the exposé. First, it is clear that the character played by Henry Fonda is a villain. Secondly, it is also clear that someone is hunting him, and thirdly, it is clear why he is being hunted. In short, in an exposé, the beginning of the story, the writer has to lift the corner of the veil to provide an introduction into the background of the characters.

The information in the exposé must be wrapped up as imaginatively as possible. In many cheaply made television series, where there is little money available to work things out at leisure, you can see that the exposé is designed with little imagination. In fact, the exposé then degenerates into a radio play with pictures: there is something to say, but nothing to act. This is where what I call information dramaturgy comes from, a succession of statements.

In an exposé, an impulse for the conflict must be given. The exposé must be written so that the viewer is curious to see how it will develop further. Unfortunately, with 95% of scripts the problem is that they remain exposés without broaching any conflict.

An exposé can only originate from a story. The exposé is employed in order to tell the viewer something, and in this context it is important to

emphasize that 'serious' is not the same thing as 'dramatic'. 'Serious' is a war on television. The suffering that you see is 'serious', but I do not enter far into it emotionally, given that I neither know these people nor where they come from. An event touches the viewer precisely when the people concerned are known to him. For this reason you must take care in an exposé to show people to whom the problems relate, so that you don't need to come up with some gigantic problem, like AIDS or cancer, in order to give something dramatic form. In the first place, it is particularly difficult and calls for enormous skill to give dramatic form to such enormous issues as AIDS. Secondly, the issue can be so 'serious' that you no longer know, for example in a series, what you can do with it. It no longer affects you. It is 'serious', but not dramatic. An exposé in which such grave matters are introduced is like a coat that immediately falls off the coat rack. You cannot do anything with it.

A recurrent problem in writing an exposé is the question of how to give it form in an arresting manner. The point is that as scriptwriter you want to reveal a number of things without it becoming solely a matter of imparting information. How to make such an introduction in an exciting and fluent fashion?

It is especially important that you avoid giving an artificially constructed character to an introduction. If you, as scriptwriter, want to reveal a number of things, you can use a moving camera for this purpose. This immediately raises the question: who is this camera? A character from the story can lead the camera, and the public with him, and in this way you achieve a less artificial journey among the other characters and locations, and in an unforced manner you convey the information that you want.

If an exposé is divided between several locations, leaps through time can be accomodated, and moreover, the exposé acquires richer colour.

I once had to write a film that took place in Venice, in which a man and a woman had to tell each other a number of things. The problem was that this lasted rather long, about ten pages of talking, and I wondered if I could situate this scene in a gondola; but although you would have seen a great deal of Venice this way, it would not really have given the film any 'action'. In the end, I chose to split the conversation among several different situations and locations. Each new situation was introduced by other characters. For example, a conversation in a gondola is interrupted. The following shot cuts to a waiter who leads the viewer to a table where the man and woman are

sitting, and meanwhile the conversation between the two carries on. The essence of the composition of such a scene is that you do not cut directly from the gondola to the restaurant table. That would be tedious. You get to the currants in the cake by using other angles of approach.

When you have a big exposé, part of it can always be allowed to fall into the conflict phase. In the exposé, the building blocks must be laid ready to set up the conflict, which carries and feeds the exposé.

The Conflict Stage

The conflict stage is central in the construction of a screenplay, and for a good reason, too. The conflict that is to be worked out and slowly brought to a head, forms on several fronts the very essence of the screenplay. I have already spoken generally about the role the conflict plays in a screenplay, so I'll limit myself here to annotating the conflict stage.

The first initiations of conflict introduced in the exposé are further worked out and deepened in the conflict stage. The antitheses are heightened, and as a result the conflict gains in intensity and the tension increases. This mounting tension can be realized on several levels, using various techniques which have already emerged in the discussion of the conflict.

The interests at stake can be further increased by making a solution inevitable. For example, urgency can be enhanced by introducing a time limit. In THE KENNY CASE the pressure is increased because within the foreseeable future a second 'Kenny' will be walking about the world, and because of this publication must take place within a time limit. A time pressure like this sharpens the conflict stage. The scriptwriter in this way can let the conflict between characters escalate further.

Alternatively, the dilemma in which a character finds him or herself, as a result of some event, can become critical. The inner conflict, for example of a character in KUSCHELTIERE who doubts whether or not she should admit having adopted a child illegally, is intensified the moment the child develops typhus. In the conflict stage, one is looking for ways of accentuating and intensifying the conflict already set out, so that the tension mounts and a climax becomes inevitable.

The Climax

The lines of tension that are set out in the conflict stage are drawn together in the climax, and the conflict erupts. The climax is the resolution of the conflict. Escalation takes place and the bomb explodes. It can also happen that a murderer is found, or a crucial choice is made.

The resolution of the screenplay follows the conflict.

The Resolution

In the resolution it becomes clear how people are going to continue with their lives. The way the screenplay is resolved, however, depends on the foundation on which it is based.

In most police or crime series, the script ends with the solution of the case. DERRICK always ends with a close-up of Derrick or his assistant, their eyes radiating satisfaction at the fact that they've done it again, but in my episodes of TATORT I tried something else. With the ending of KUSCHELTIERE we see the conflict between a case that is, in police terms, solved but in a human sense remains absolutely unsolved, which is the reason for the final image of Schimanski walking through an archway with the adopted child. He now has to deal with the problem himself. In this TATORT episode, the case is solved but not the circumstances. An ending like this is closely linked to the theme that lies anchored in the foundation.

Foundation and Resolution

I was once asked to read the script of APOCALYPSE NOW before the film was shot. I thought it a magnificent script, but when I saw the film I noticed that they had changed the end, because the producers probably would not take the risk of the original ending.

In the original script a young man goes on a mission to kill 'Brando'. Almost the entire film is taken up with finding him. He finally has a philo-sophical conversation with this man, only then to slaughter him like a bull. At the moment that he steps outside, one sees all the followers painted and ready to worship him like a god. He is the new god, since he has slain the old god. In the original story, he makes a gesture to indicate that he is the new leader and takes 'Brando's' place. He also is adverse to power and stays in the jungle. Everything remains as it was, and another agent turns up seeking to slaughter him in his turn.

This is not a readymade resolution, but rather a brilliant invention that harks back to the foundation of the film. The script of APOCALYPSE NOW is in fact about people who cannot handle power. This seems to me the starting point for a film which rises above a mere war film with a secret agent commissioned to kill a soldier who has gone off the rails. In the filmed version, on the contrary, the young man simply walks through the crowd and goes home, having done away with an evil man, his mission complete.

The filmed version misses the angle that was so strong in the script, and with this altered, approved ending, it seems to me to have become merely a well made 'James Bond': a man goes on a job and comes back again. The original ending was far more interesting in the way it underlined the starting point of the film: the wielding of power.

III.6 The Dialogue

Spoken Language versus Written Language

When writing a dialogue in a script you have to realize that this is always language to be *spoken*. Written language is not the same as spoken language. I see many scripts where written language is employed, and it always imparts a literary, artificial character to the script, whose people never manage to get off the paper and become flesh and blood. If he is going to create people who will come to life, the scriptwriter must put words in the characters' mouths that are spoken language.

Information Dramaturgy

If two persons in a single space are having a dialogue, and something actually occurs between them, then when the scene is over, something has to have happened to them. For example, there must be a change in someone's frame of mind. People's behaviour must have consequences. If someone gets drunk, then this has to have consequences. If nothing has happened, and these two people remain exactly the same as before the scene, then the scene itself has little meaning, and in such a case, we can speak of what I call 'information dramaturgy', which does not go beyond saying exactly what happened, a dramaturgy with a dialogue that carries no real conflict, and is not rooted in real emotion. In my view, dialogues must consist of more

than spoken information. Unfortunately, recent times have produced a very great deal of information dramaturgy.

Action versus Dialogue

A related point is that not everything has to be articulated in words. You must give the actors in a dialogue the chance to construct a 'mise-en-scène' first, and then to act it out. The actors' performance during a dialogue can dispense with a good deal of speech. The actions must be detached from the text, so that characters do not say what they are doing, nor act what they are saying in a merely illustrative way.

Ideas in a Screenplay

You do not write thoughts in a screenplay. Thoughts cannot be filmed. You cannot present people thinking. By definition I want to see what's happening and not what a person thinks. Otherwise, the thinking must be so thoroughly worked into your script that you make a voice-over out of it, but I am not enthusiastic about this technique. I find it objectionable to have to hear ferreting about in the background. If one has to use voice-overs for thoughts, that seems to me an admission of failure. Whilst this may be appropriate enough in a literary work, in a film scene, when for example, someone looks at me and I can hear what he thinks, the effect is enfeebling, tedious; whereas guessing what he is thinking about is fascinating. Of course you can present thinking people, and that in itself can be very interesting, but then you have to devise a visible or audible way out of that thinking, which could be speech, or a drawing or a gesture.

Bringing on a Speaking Dog

If a man in a film scene goes on mumbling to himself without any obvious reason, I call this 'bringing on a speaking dog'. The man says to the dog: 'Hey, where is your master going then?' Or: 'Now look, isn't that the undertaker?' Talking to a dog like this in order to let a person utter his thoughts or his inner perceptions, as can often arise with monologues, is a problem you have to make sure you avoid. Keep as far as possible from bringing on a speaking dog. Introduce a character next to the protagonist so that they can lead a dialogue, and thoughts can be expressed, thoughts that can once more elicit a reaction.

Dialogue versus Monologue

As we have seen above, the monologue is a problematic form which often comes across as artificially. You can undercut this problem by bringing on someone for the character to speak to, and there is the further point that dialogue can represent the struggle that otherwise remains purely internal. You have a way of directly unravelling the problem posed, since the inner conflict is expressed and it becomes both visible and audible. And that is what you must always look for in scriptwriting: to show rather than to tell.

Obscene Language

Obscene language does not work dramatically, and neither does it make a character stronger nor more interesting. Moreover, if obscene language is used excessively you don't even hear it anymore. It simply makes the person coarser, and that is unnecessary. You should rely on the situation and the characters.

Aspects of a Dialogue

The dialogue occupies a central place in a screenplay. Apart from short descriptions of what happens when, the dialogue takes the lion's share of the script. Summarizing, the following aspects of the dialogue are important.

Dialogue carries the characters and their motives and translates the conflict. Precisely on account of this essential function, in writing dialogue you must take into account the points identified and recapitulated below.

A dialogue must be written in speech. A dialogue must do more than merely convey information and, moreover, must not carry in speech what is already evident in action. That works merely as illustration. A dialogue should have to stimulate the imagination and not function as explanation. I also advise against allowing the expression of ideas. Presenting dogs to speak to, or the use of a voice-over or a monologue, I consider as admissions of failure. They convey an artificial impression. A dialogue works more strongly than a monologue. Introducing another character always works more naturally and furthermore offers the possibility of unravelling a character's inner conflict.

Characters and what they say, the dialogue, are inextricably bound up with each other.

The Characters

Constructing a Character

Giving shape to a character consists of more than just putting words in his or her mouth. A character's background, the action, the conflict in which a character finds him or herself, the possibility of identification and the details that give that individual actual character, even the surrounding characters, all play a part in delineating that character. I shall now go further into the factors that are significant in bringing an interesting character to life.

Backgrounds of a Character

The better the background of a character is portrayed, the more interesting the intrigues become. A character's background can provide the motive for his actions. A crucial event in a person's life can form the driving force of the drama. In this context, I earlier cited the example from ONCE UPON A TIME IN THE WEST.

It is important to look especially to those aspects of the background that are relevant to the dramatic development. When people send me scripts, I usually get long-winded descriptions of characters. 'Xander has social problems, has difficulty making contact with women, has a love/hate relationship with his mother etc. etc.' When you see these characters on paper like this, you think: what interesting people these are – until you go on to read the script and from all these promising descriptions you recover little or nothing at all. The point therefore is that such an interesting character must be given actual shape as well.

Characters in Conflict

Character backgrounds are easy enough to invent, but it is important – and more difficult – to work out a conflict involving these characters. You must look for the conflict and its outcome. With no conflict, you finish up with information dramaturgy. You must always look for those points in your figures that will make the scene deeper and more interesting, and this you can do by making the characters play off each other. It is through conflict that the characters come to life, and crawl out of their shells, or on the contrary creep back in.

Characters in Action

The scriptwriter must write in an action the actor can feel at ease with, otherwise he will invent it himself. Before you know it, you once again get a doctor who sits pondering and chewing on the ends of his spectacles, or a secretary who sits filing her nails. A scriptwriter is responsible for creating a situation and an action in which the actor is challenged to put such cliches aside.

Crystallizing Characters in the Script

One usually reads an enormous elaboration of the characters in a synopsis, descriptions of how interesting a character is, and so on, but when it comes to the concrete behaviour of the characters in the scenes, often you never see these portraits again; whereas in fact a character only acquires shape through what he says and does in a scene. As a writer you must therefore search for things that will carry a character forward by what he says and does.

KUSCHELTIERE is an episode from TATORT that we recorded in 1982. In the writing I was determined to deepen the characters and so make the script more interesting instead of adding yet more special effects. Schimanski,

Schimanski (Götz George) and Hänschen (Chiem van Houweninge) in TATORT

Thanner and Hänschen form the three main figures. Schimanski is a 'Dirty Harry-figure', an 'Einzelgänger', a man with a parka and a moustache, a stout fellow with a rather black and white sense of justice. Thanner is somewhat meticulous, an authority, a policeman, a neat and respectable man. Hänschen is a likeable Dutchman, a friendly man who likes to eat well and frequently has his finger on the pulse of the crime but from a different angle. When I have to write a scene about them, I try to give form to these characteristics. In the first instance I had a scene in which the lads were visiting Dijkhuis, written in rather a dry manner. They go to Amsterdam, look up the commissioner Dijkhuis and ask permission to search through the travel agency, which Dijkhuis refuses. This is a useful, but hardly stirring scene.

Subsequently I tried in a second version to make this scene more interesting than the simple dry fare that had to be told. At such a moment I look for humour. Like a sculptor, I build onto to the bald framework of this scene a number of elements that allow the characters to show their colours. First I let Commissioner Dijkhuis serve them herring in honour of their visit. When confronted with these Thanner does not dare say no, since out of politeness he cannot decline such a friendly gesture. Hänschen, as a Dutchman who likes good food, finds herring delicious and asks if he may have some, while Schimanski, an ordinary bourgeois man at heart who does not find eating raw fish to his taste, bluntly refuses it. By means of this small addition of the herring in the scene, the characters and their individual peculiarities are brought to the fore, and meanwhile the exposé is moved along.

After this scene a switch was needed, from the police office to the Hotel Americain. This transition was too dry in the first version, and demanded the introduction of more imagination to bring the scene to life. We had two hours of shooting time left, and the director decided he wanted to shoot something interesting that would improve the transition. While we were standing on the set, I saw a traffic police tow truck drive by and thought it would perhaps be rather nice if the car belonging to the two German policemen was towed away. This scene, however, had to be properly introduced, since otherwise it would come out of nowhere. And so we added another scene in which we see Thanner having parking problems, and where they are warned, furthermore, while trying to park, that they should not leave their car there.

After Dijkhuis' refusal and the affair with the tow truck they are sitting in the Hotel Americain demoralized, with Thanner and Schimanski

running down Holland. Then Hänschen remarks that he too had never understood why the Germans found it necessary to occupy The Netherlands in the war. A silence follows, after which Thanner thumps the table and shouts 'Zahlen', an action which serves to underline his character. It is this kind of detail that gives the scene something special, and gives shape to the characters.

In brief, if you have written a scene, you are not finished once you have got the information across loud and clear. This is the moment that requires the introduction of a moulding process, with lots of sharp, humorous flashes that will flesh out the characters and give them colour. Only then does the actor have enough material with which he can act. If you are writing a script, you must bring all your imagination to the task of finding elements that will properly allow the character portrait to emerge *in* the script.

Details as Building Blocks of a Character

In continuation of this, I would like to go into the small details that make a film character especially interesting.

In my very first film script, THE BURGLAR (DE INBREKER), directed by Frans Weisz, we had to create a sympathetic burglar (the 'inbreker'). He couldn't be a thug, since sympathy has to remain with 'Glimmie' throughout the film. We had in mind a clever housebreaker but no villain. I had written a nice dialogue between the burglar and his mate to establish this, taking place during a burglary at a villa where the residents were away on holiday. But Frans Weisz wanted something essential to take place and put his pencil through all my efforts. What should happen now? Frans remarked that his old teacher in Rome had always said this to him: 'If you want to show a scoundrel, a really vicious scoundrel, even though he appears outwardly to be a sugar daddy, then have him kick a dog in the very first scene; he'll never overcome that for the rest of the film, even if he gives millions to good causes. And conversely, if you allow someone who has massacred an entire city to have a dog as a best friend, and in the first scene have him doing friendly things with the animal, then everyone will say that all things considered he's a good lad.' Frans then came up with the brilliant idea for THE BURGLAR of putting a bowl of goldfish in the villa to be burgled. The housebreaker comes across the goldfish bowl, takes the box with fish food and – tik, tik, tik – he gives the hungry fish something to eat. From that moment he has the public sympathy with him. It's a principle that operates in many entertainment films. It is an example

that demonstrates how essential small details are in giving form to a character.

The great difficulty in writing a screenplay is not the invention of a character, but how to show with small details what the character of a person looks like. In ONCE UPON A TIME IN THE WEST Henry Fonda chews tobacco, and he spits out the juice in a manner that would make your hair curl. The way he spits speaks contempt for his fellow men, it's a spitting that gives his character enormous support. It may seem a small detail, but it is esssential, and it's through details like this, in my view, that the film really takes off. The details see to it that these are not cardboard characters, but people. Of course, an actor himself will also often find similar details, but it is largely the script-writer's responsibility.

On the way from the conceptual world of the invented character to the real person lie the building blocks for the actor. An actor must find building blocks to enable him to build up a role, and these are what a good scriptwriter has to supply. The worse the script, the more a director and an actor have to invent themselves. The worse the story, and the poorer the details, the more cars have to be sent flying through the air in order to maintain pace in the story.

Identification with a Character

The details cited above can evoke either sympathy or antipathy in the viewer. Henry Fonda's spitting increased antipathy, whereas feeding the goldfish in THE BURGLAR, on the other hand, evoked sympathy. This sympathy can lead the viewer to identify with a character, and it is precisely this identification process that is so important for the viewers' involvement with a character and with the film.

In Coppola's DRACULA, in my view, the script commits a cardinal error by beginning with the main character going to Dracula's castle, where he is sucked empty by three young women, vampires. Subsequently I hear nothing more for half an hour of this main character, and when at last he reappears I no longer identify with him in the least. As a result, there remains a beautifully made film which, however, says little to me; and this is at least partly due to the fact that the viewer loses the main figure with whom the film begins, for a good half hour. As a result, the viewer is unable to identify with the main character and the film loses its power of expression.

Identification with a character is a basic condition for a powerful film. Furthermore the scriptwriter must take care that this identification is not

interrupted for too long a period, or the bond between spectator and character will be broken.

Characterisation by Means of Surrounding Cast

What is frequently overlooked is the role played by supporting persons in determining the character of an individual. A film where this happens in a fascinating way is RAISE THE RED LANTERN, which impressed me enormously. Technically, in the script, one thing struck me especially. The man who holds the power, and before whom everybody flees, is hidden. I think this is brilliantly envisaged by the director, Zhang Yimou, that the man with absolute power in that house, about whom everybody talks, should be concealed. As a result, his power is not shown through his presence, by setting him out as a really powerful figure, but rather emerges simply by letting everyone around him act out the fact that the man is a powerful figure.

In the time when I was still acting a lot myself, I once had to play a king in a Shakespearian play. Whenever it is discussed how you should play a king, it's always said that you must walk upright, look down on everyone, and more of that kind of eyewash; but there is one thing that is actually important. You can never play that king; it is the people around you who act out that you are the king, and that works. This is the same principle as applied in the construction of a script like RAISE THE RED LANTERN. You see that this man becomes a strange phantom of power, although in his own being he is a weak figure. Nevertheless in the first instance he simply doesn't appear in the script and you don't see him as a mighty figure on horseback.

Characters in Single Plays and in Series

An important difference between a single film and a series is the way in which the characters are delineated. In a single film, the main character can go through an essential development. The major conflict this character wrestles with can bring about a real change. A pleasant man can turn into a murderer, or a shy young girl emerge as a self-assured woman.

In a series like TATORT, on the other hand, you have to work with characters who stay more or less constant throughout different episodes, so that there is less room for diversion from the characterizations of these personae for a basic conflict. The basic conflict of the series is the police versus injustice. But although the characters move within this frame, the

stories are different every time, and consequently, writing a series, although different from writing a one-off film, often comes down to the same thing. When writing episodes for a series, just as in writing a single play, the foundation is always different, and as a result the plot varies too. However, there are a number of building blocks that are already familiar: the principal characters. The nice thing about writing a series is that you get to know the characters better and better. The longer I know Schimanski, Thanner and Hänschen, the better I know them. If you know the characters, then your obligation as script-writer is to look for a foundation, or theme, and to create a story in which the characters can grow.

Schimanski is an unusual policeman, and therefore he gets unusual cases to solve. Tracking down the murderer of an aunt, whose nephew gets the inheritance and the niece wants the pearl necklace, is not exactly the sort of case that needs a police commissioner such as Schimanski. You would do better to leave Derrick or Der Alte to solve that. For Schimanski and the others, we had to look for human cases that were rooted in social circumstances.

The great space which you as scriptwriter have to play with in the creation of such a character, this freedom in which for example, you can let a character undergo extensive development, would seem to be the antithesis of the more fixed patterns to which characters in a series are bound. And yet within the limits of that pattern, as scriptwriter, you do have considerable freedom. Precisely because you know the characters inside out, the imagination is stimulated to let them experience something extraordinary.

Giving Form to a Character

Summarizing then, to create interesting film characters the following elements are important. The backgrounds of the characters provide the motives for their actions. The scriptwriter should make sure that these backgrounds are also worked into the script in a concrete way. It is precisely the visible details that bring a person's character to life and can make that person either sympathetic (feeding the fish in THE BURGLAR) or unsympathetic (the contemptuous spitting in ONCE UPON A TIME IN THE WEST). The sympathy evoked can facilitate the process of identification, an essential process in relation to the involvement of the viewer with a character; but in order not to lose that identification, a character should not be allowed to remain out of sight too long. The conflict once again plays a central role as well as giving

form to a character, ensuring that a character is drawn out and brought to life.

Apart from the behaviour of a character himself, the surrounding cast also play an important role in setting a person's character. And finally there is the difference between characters in a one-off play and in a television series. In a single play the characters can undergo considerable development, tied to the basic conflict; whereas in a series the characters remain more or less constant.

III.8 The Screenplay in Scenes

The Writing of a Scene
Up until now, the most essential elements that serve as building blocks for a script have each been given a turn. The foundation, the plot, the building up of the script in stages from the exposé via the conflict stage to the climax, the resolution, the writing of dialogue and giving form to a character; these have all been extensively discussed.

Although I have already given a number of examples at the level of both scene and detail, I nevertheless want once more to elucidate the way I try to sharpen and improve a scene step by step. I often compare the writing of a scene with modelling, where you take off bits of clay and introduce other bits in order finally to get to what you had in your head.

The Quintessence of a Scene
If you reread a script, it helps to summarize each scene with a single sentence, taking the quintessence of the scene and identifying it in one sentence. I do this with my own scripts too. If this does not work, then I know something is wrong somewhere. Also, if you ever have to judge a script, this is of great assistance, since you can rapidly see how well the script fits together.

The Function of a Location in a Scene
If you are busy with a TATORT and you have set up a scene and then discover that within this scene there are too few building blocks or details present, then you have to mobilize the imagination and see to it that more building blocks are introduced. This is very often done by giving the scene a more interesting setting.

A location can have a dramatic function too, where the location accentuates the situation, as a result of which the conflict becomes inevitable. A location is used like this in many films to precipitate the confrontation between characters, as for example when a chase comes to an end in a cul-de-sac, bringing the protagonists eyeball to eyeball. Locations can also function as a way of making scenes from the exposé more interesting, as in the example I cited earlier, the exposé played in Venice where a dialogue was divided up between different locations.

The Construction of a Scene

The scene you write should begin with a handle for the director and cameraman, so that the reader, and in the end the viewer, knows just where you are. If you don't want to indicate that, it must be a very deliberate omission. Just as you must have a beginning for a scene, you must also have an end, which is to say that a scene must be directed toward the cut. Make sure then that the scene does not remain hanging in a vacuum, since in that case the following scene also begins with a vacuum.

You should make every scene, including those surrounding the exposé, as interesting as possible from beginning to end. There must be more than mere statement. If the statement, the exposé, is long, then try to ensure that it is distributed among several locations in as interesting a manner as possible, or is communicated by means of an interesting action, so that the director and the cameraman both get the opportunity to create an interesting 'mise-en-scène' and arresting images.

An exposé can be made interesting in two ways; the first is by appending a discovery to the exposé; the second is to let the scene be carried by an emotion. This need not necessarily be a struggle of life and death, but there should be something in it that comes from within.

The Script in the Scene

You should be able to look at every scene by itself; it should be interesting in itself. What this means is that what I have said about entire scripts is equally valid for each separate scene alone.

In the first place the premise, the theme from the foundation, should be echoed in the scene. Secondly, there must be development during a scene that leads to a change. It could be a change in the situation,

or an emotional change in one of the characters.

What I have said about giving shape to characters and dialogue is also of importance in specific scenes. The main line of the script should come alive precisely within the separate scenes and in the small details within a scene, in an exciting and surprising manner.

As for construction, here too, there is a considerable degree of correspondence with the construction of the whole script. Within the scene there should be a question of exposé, a conflict stage in which a part-conflict is produced. Likewise there is a temporary climax and resolution of the part-conflict, unless there is some question of different plotlines, in which case the scene is broken off at some tense point by means of a kind of cliffhanger.

III.9　Technique and Imagination

Technique
In my opinion there are two important pillars on which a good screenplay is built. The first is the technique of scriptwriting, and I have comprehensively dealt with this in my lectures on scriptwriting. How do you build a good script, how do you develop a plot, starting from the foundation and basic conflict? How do you give form to that plot, from the exposé via the conflict stage to the climax and resolution? How can you accentuate the conflict, sharpen the dialogue and make the characters interesting? Up to a certain level, you can make this technique your own through writing a great deal, and finally reach the point where you get the craft of writing in your fingers. That is difficult enough.

Imagination
The second major pillar is filling technique with imagination. It becomes even more fascinating when you are able to link this imagination with an emotion. The emotional involvement of the writer with a subject will ensure a strong foundation on which to build the screenplay.

If you manage successfully to integrate imagination and emotion with technique, this can result in a good, and even fascinating script. At this point, scriptwriting is no longer merely a craft, but perhaps becomes art.

Chiem van Houweninge

IV

BETWEEN THE GENRES

Drama, Comedy and Reality in an Episode from SAY AH

ROBERT KIEVIT

IV.1 Introduction

Three of the essential aspects discussed by Ernie Tee in his contribution to this volume, namely drama, comedy and reality, can be traced quite well in the following excerpt from THE PEARL FISHERS, an episode of SAY AH (ZEG 'NS AAA).[1] By way of introduction, I would like to make some brief comments on how these aspects interplay in this specific instance.

IV.2 Dramady

First of all, distinct notions of drama and comedy can be seen, since the excerpt in question relies on the interplay of two levels for its effect. The level of drama becomes tangible because we are confronted with a situation that has potential for dramatic conflict: Koos, married to Mien Dobbelsteen, finds out she is ironing the silk shirts of another man. However, this dramatic situation of marital strife, adultery, jealousy, violence is elaboratedin the comic rather than the tragic or melodramatic mode. More specifically, it is dealt with as a comedy of errors, including, of course, errors of language or malapropisms ('genitals' instead of 'initials'). Such intentional or unintentional double-entendres and other types of one-liners are integral parts of this particular comic mode. The combination of the serious aspects of the situation and its comic elaboration make the excerpt an example neither of drama, nor of comedy, but rather, illustrates a genre between the genres, which Chiem van Houweninge has dubbed 'dramady'. But 'dramady' is not just a hybrid form which integrates drama and comedy.

In Ernie Tee's essay, reference is made to the concept of 'dramady' as it applies to sitcoms such as SAY AH. According to Tee, 'dramady' in this context is not the result of a blending of essences, by mixing the tragic elements of drama with the laughter of comedy; nor is it a combined play of formulae in which the plot of drama is interwoven with the disruption of comedy. Rather, the transgression of boundaries shows itself in the pluralistic way in which the viewers are addressed, which is to say, its pluralism functions at different levels simultaneously. Since SAY AH represents not only the working class milieu, but also the well-to-do world of doctors, it appeals to a broad public. But the pluralistic appeal is not only active in respect to class: the shifts from drama to comedy serve to manipulate the degree of involvement of the public, ranging from superiority and distance vis-a-vis the characters when the comic aspects are more in evidence, to moving towards a closer emotional involvement when the drama is in the foreground. It is this kind of double appeal which distinguishes a series like SAY AH from the generally more unambiguous American sit-coms.

This specific character of Van Houweninge's work actually makes it difficult to locate it firmly not only within the boundaries of genres, but also within some of the boundaries of the television institution. The kinds of problems this can produce is illustrated in the anecdote Van Houweninge tells when asked how the term came about:

'In 1986/87 I was in England, trying to get the BBC to buy SAY AH. The Drama Department said: "We find it very interesting, but it contains too many jokes for drama. You should take it to Light Entertainment." So I did, but they said: "It's nice, but there aren't enough jokes in it. Why don't you show it to the Drama Department?" We got nowhere. That's when I decided that with SAY AH I was making *dramady*.'

IV.3 **Reality in Dramady**

The question remains: where does reality come in? Without going too deeply into what constitutes 'reality' in a television programme, there are nonetheless different modes, even within the category of fiction or drama. In the case of SAY AH the integration of reality is rather complex. Even in this

short excerpt, for instance, we can distinguish different levels. Representation of the social reality of class and status among the characters is related to the viewer by way of different milieus appearing in the series, which is recognized by and appeals to a broad public. Reality also enters this sit-com both as a form of intertextuality and as a network of references to everyday reality.

At the level of intertextuality, mention of other television series is made, which refer the viewer to television programming beyond and outside comedy and sit-coms. Koos' opinion about Italian men, for instance, has its origin in the television series OCTOPUS, a kind of docu-drama which deals with the mafia in Italy and its infiltration in the police force and the political establishment as well as the world of Italian high finance.

But reference is also made to the world outside television altogether, the factual or topical reality as represented or reported in the newspapers. Corruption scandals concerning the Vatican banks and allusions to 'mafia' cardinals were the subject of headlines in the papers at the time Van Houweninge was writing the script, and they 'anchor' this episode in a specific historical moment.

Yet, while this topical reality may go out of date and no longer constitute either news or a matter of public concern, the episode itself does not become dated. The generic form and the tight writing ensure that these parts of reality are integrated into the internal structure of the episode, allowing it to be re-shown in the various re-runs the series has enjoyed since it was first broadcast.

IV.4 **Drama, Comedy and Reality**

The way drama, comedy and reality are integrated gives SAY AH its special blend. In order to further identify the specific features of this sit-com and its particular appeal to national (in this case, Dutch and Flemish) audiences, it may be useful to contrast some of its procedures to those recurring in more typically American sit-coms.

We have already mentioned that the specific interaction of drama, comedy and reality is rarely found in an American sit-com, marking a significant difference. In the majority of U.S. sit-coms, generic conventions have been elaborated within the limits of the genre of comedy and continue to be quite

strictly adhered to. But an equally significant difference can be noted when one turns from the question of audience address and audience appeal, to the manner of writing itself. Chiem van Houweninge has himself characterized this divergence of approach as follows:

'There is also an essential difference between the sit-com writer in the United States and here in The Netherlands. Here, you write a series alone or with someone else, whereas in America, there are about twenty writers involved with a series like GOLDEN GIRLS. They allocate two men for the grandmother alone, who do nothing but invent the jokes for Grandma. So you get that kind of stream of one-liners, a list of wisecracks for Granny, which is, of course, something completely different from what I do. I sweat blood looking at series where every sentence plays off against every other sentence. It gives the interactions an extremely artificial air. The characters are not living people. That kind of thing is not fun to make, even if I were asked to. It is my view that people want to laugh at situations, and not just at verbal jokes. To make comedy, one needs more than one-liners and wise-cracks.'

The scene we have taken from the THE PEARL FISHERS episode illustrates quite well these differences, at the same time as it demonstrates more generally the way Van Houweninge gives shape and texture to his dramady. The excerpt starts with Mien Dobbelsteen ironing the shirts of an Italian called Paolo. Koos Dobbelsteen, just home from work and expecting his dinner, finds his wife at the ironing board...

Note

[1] Tee, E., 'Drama, Comedy, Reality: In Response to the Comedies of Chiem van Houweninge', in this volume, Chapter II.

V

SAY AH/ZEG 'NS AAA

Episode 129: THE PEARL FISHERS
A Fragment

CHIEM VAN HOUWENINGE AND
ALEXANDER POLA

LIVING ROOM OF KOOS AND MIEN

> *Mien is ironing Paolo's shirts.*
> *We hear Koos' shouting.*

KOOS
> *(off screen)*

Mien! Mien! Mien, where are you?

MIEN

Here! In the living room!

> *Koos comes in. He is astonished.*

KOOS

Are you still ironing my shirts? It is six o'clock, aren't you cooking?

MIEN

Six o'clock already? Oh, dear... I thought...it was much earlier.
Why are you so late?

KOOS

He who comes as a friend never arrives early, but always too late.

MIEN

You're not my friend, you're my husband.

KOOS

Yes, yes, I was trying to make it a bit more exciting.

> *He kisses her on her neck.*

MIEN

Oh, Koosie! No! Don't keep me from my work...I still have to cook...

Koos teases her with another kiss.

KOOS

(sultry)

How can you talk about food, when...

MIEN

Hold on, Koos, I have to concentrate.

This is pure silk and very difficult to iron.

KOOS

Silk? Do I have any silk shirts?

MIEN

You? Fancy that! These belong to Mr. Paolo.

KOOS

(perplexed)

Mr. Paolo?

MIEN

Beautiful, eh? He only wears shirts with his genitalias on it.

Look, here: P.P.

She mouthes the initials on the shirt

KOOS

Now! That is really going too far!

MIEN

Not at all! I think it's all the rage now!

KOOS

That's not what I meant! I mean I find it ridiculous that you iron this man's
shirts here at home!

MIEN

(picks up another shirt)

Oh, I didn't have enough time at the doctor's this afternoon, so I just took
them home. I'm glad to do it. They're such lovely shirts. I get something out
of this work and that's good for me.

KOOS

Get something out of it? When you cook for me, do you get something out of
that? I always eat everything up so nicely. Really! And...and...and now there is
nothing to eat, because you have to iron the mafioso's silk shirts in such a hurry.

MIEN

I don't want to hear that word ever again, Koos Dobbelsteen!
You're going to drive me around the bend with that one.

KOOS

Me?

MIEN

Yes, you. I dream about that every night now!
I wake up in a cold sweat again and again. Disgraceful!!

KOOS

Don't blame me for it.

MIEN

I certainly will. You tease me terribly! The mafia!
Mr. Paolo is actually a police expert.

KOOS

That doesn't mean anything in Italy.
Don't you remember Octopus?

MIEN

What do you mean?

KOOS

Well, you could see that the criminals had infiltrated everywhere,
even highest circles! In the law, in the government, in the police...

MIEN

Well, Octopus is only a film. That's not real.

KOOS

Ha. It's much worse in reality! Don't you read the papers?
They even have a Mafia cardinal in the Vatican.
You know, in the Vatican bank...

MIEN

Really? Lord help us...

KOOS

(laughing)

You may well say that...

MIEN

(notices that she's been had again)

No, no, no, no. You're not getting to me any more. I have learned my lesson.
Mr. Paolo has nothing to do with a cardinal in the Vatican bank.

KOOS

Before you say that so easily, you ought to first find out where he does his banking. And if it is the ... the... Amrozinia or Amroziniana, then I really would...

MIEN

I'm not finding out anything. I iron the man's shirt and that's it. Basta.

KOOS

Basta, basta. I wouldn't be so final about it, Mientje...

Since you are evidently wrong and since you are ironing his shirts,

you're actually a partner in crime!

MIEN
(frightened)

Partner in crime? You really are...you...are...

KOOS

A potato head! I know it and I'm proud of it.

A hundred times better to be a potato head than a spaghetti face...

By the way, what's for dinner?

MIEN

Spaghetti!

Chiem van Houweninge

VI

TRANSGRESSING THE BOUNDARIES OF THE DETECTIVE GENRE

Detective Story, Thriller and Comedy in TATORT

ROBERT KIEVIT

VI.1 Introduction

The transgression of genre boundaries in Van Houweninge's work is not limited to blending drama and comedy into 'dramady', as in SAY AH. By introducing humour, he has also effected a significant interweaving of genres in the German detective film, known as 'Krimi'. When 'Krimi' and comedy come together, Van Houweninge calls it 'Krimidy'.

Before going into the question of how this hybrid form is given shape, it may be useful to recall briefly some of the original characteristics of the crime film genre, its subgenres such as the detective film, and traditional ways of inserting elements from other genres.

Such a framework of generic conventions allows us to see how, for instance, the detective genre interacts with other subgenres, which is the case in TATORT. The genre's general characteristics may give us a better idea of the specific profile of Van Houweninge's contribution to TATORT, which in turn illuminates the series' position relative to other German TV-'Krimis'.

VI.2 Generic Conventions of the Detective Film

Basic Construction

The foundation of the detective film is, of course, a crime. Three questions surround it: Who did it? How did he do it? Why did he do it? This is what we mean by a 'whodunit'. In most cases a corpse is the first character to appear at the beginning of an episode. In this respect CUDDLIES (KUSCHELTIERE),

one of the episodes from TATORT written by Van Houweninge, is basically a detective story.[1] The body of a very young Thai girl is found, pointing to a crime which has to be solved by the investigators. The mystery, the question 'who did it?', dominates the way the screenplay is constructed. The viewer is stimulated into formulating retrospective hypotheses about the events leading up to this moment, and tension or suspense is derived from this anticipatory process: the viewer is anxious to discover the murderer and his or her motives. Often, the tension thus generated can be described as cerebral, comparable to the moves in a board game. Not surprisingly, then, detective series sometimes resort to metaphors drawn from chess in the opening credits. In their search for the solution to the mystery, the detectives – along with the viewers – are obstructed or misled in various ways. Deliberately deceptive trails ('red herrings') lead to false anticipation. As a result, several options are possible as to who might be the killer. Parallel to this narrative construction, the curve of tension surrounding the mystery is also governed by retrospective ('What has happened?') and cognitive ('Finding out by means of detection who did it') processes.

Retarding Strategies

One of the conventions of mystery and detective tales is that the solution, the answer to the three questions mentioned above, should not be given prematurely. It is only at the end of the causal chain that the criminal is identified and the consequences of the identification become clear.

To prevent the solution from being revealed too soon, retarding strategies intervene. The investigation is complicated by inserting material which defers progress. False leads, new crimes, key witnesses disappearing, flat tires, comatose victims, escaping suspects, clumsy policemen: every conceivable coincidence may and will obstruct the process of inquiry. Such bad luck forces the detective to use his skill and imagination in order to overcome the complications. In the excerpt from CUDDLIES reprinted below, the investigators Schimanski, Thanner and Hänschen want to obtain a search warrant for entering the office of a suspect in The Netherlands. Being policemen from Germany they are not given official permission, which means they will have to find an alternative way to continue their search. The legal obstacle acts as a retardatory strategy, functioning at its most basic level by enhancing our curiosity or suspense.

Withholding Information

According to narratologist David Bordwell, one of the fundamental characteristics of the detective tale is that the way it is told means that it must withhold from the audience crucial events occurring in the 'crime' portion of the plot.[2] The story telling conceals the cause of the crime, or the commission of the crime by just showing the corpse, or by focusing on another aspect concerning the crime. The unfolding of the story closely mirrors the progress of the detective's investigations, making sure that we pick up plot information from no other source than keeping track of the detective's inquiry. In this way, narration manipulates the viewer's access to knowledge by limiting it. The viewer discovers only what the detective finds out, and when the detective finds it out.[3] The viewer's identification with the protagonist of a detective film is thus created mainly by this tight restriction of the flow of information, making us identify with him because we depend on him. During the detective's investigation the viewer shares or is encouraged to form a set of hypotheses, as well as a set of suspects, utilizing as best as possible the information gathered from watching the detective at work. This active process of anticipating is possible precisely because vital causal material concerning the crime is missing or being withheld. Generic convention, on the other hand, dictates that the most essential causal material, necessary for the reconstruction of the crime, only emerges gradually, often near the very end of the film or episode in a detective series.

VI.3 # Transgressing the Boundaries of the Detective Genre

Manipulating the Flow of Information, Causing Shifts from Curiosity to Secret, Suspense and Surprise

Even though restricting the viewer's knowledge to that possessed by the detective may be predominant and according to some writers of crime stories even obligatory[4], it is not always applied consistently. The rule of 'fair play' is sometimes broken. The tension, on which the *curiosity* of viewers concerning past events is based, changes to other kinds of tension. How exactly is this tension changed as result of a change in the information revealed to the viewer?[5]

Sometimes the detective is ahead of the viewer. The detective spots something which is only revealed to the viewer in a new shot. On other occasions, the detective may possess information to which the viewer doesn't have access. Near the end of the story the more than brilliant detective reveals the solution, basing it on clues the viewer could only guess at. In these cases, the detective has a *secret*, based on information withheld in the narration.[6]

On the other hand, there are occasions when the viewer has a slight edge over the detective. In a moment of omniscient narration the viewer is given a glimpse of what the detective could not have seen. In an episode of TATORT, for example, Schimanski may leave the room. Although the detective has already closed the door behind him, the camera stays, giving us the expression on the face of a suspect, and thus information from which Schimanski is excluded.

In a suspense structure the principal character will be in danger in the very near future. The viewer in most cases is aware of this threat, whereas the protagonist is not. Frequently the viewer sees the gun pointing at the detective before the detective notices the threat himself. At such moments, restricted narration alternates with omniscient narration. As a result the overall curiosity/mystery structure is interrupted temporarily by another structure of anticipation, which is called *suspense*. In suspense sequences not only the retrospective question is raised, but also the prospective question of what will happen next is foregrounded.

The tension generated by this suspense can be intensified in various ways. Apart from the division of information, other strategies are utilized to heighten the degree of suspense. For instance, the introduction of a temporal limit is one of the most common ways of enhancing suspense, for example by means of a count-down situation. A threatening device like a time bomb is depicted long before the characters involved become aware of the danger. By introducing a deadline, for example by showing the viewer that the bomb will explode at one 'o clock precisely, high levels of suspense can be reached, especially when the clock is repeatedly shown to the viewer. Hitchcock uses this example to emphasize the importance of supplying information to the viewer and to show the impact of a deadline.[7] In TATORT such a time lock is also sometimes used, for example in SLIPSTREAM (KIELWASSER), a TATORT episode in which a polluting ship has to be caught redhanded within a limited time.

Another essential strategy often used is temporal retardation: 'One of the prime means of creating suspense consists in the author's temporarily impeding ("suspending") the natural progression of the action, especially its onward rush toward some expected climax, by the interposition of more or less extraneous matter.'[8] In CUDDLIES the process of inquiry is seriously impeded by the refusal of the Dutch authorities to cooperate, and the interposition of a love story. Both these elements cause retardation.

Apart from these temporal strategies, spatial strategies are also used. The detective, victim and criminal may be locked up in a 'Closed Room Mystery', in which an isolated setting like an island, a deserted castle on the moors or the Orient Express serve as a way to ensure a climax with no possibility of escape.[9] The setting of the polluting boat in SLIPSTREAM could serve as such a spatially enclosed location.

According to Pfister[10], Borringo[11] and others the identification process is one of the most essential ways to induce suspense. They state that the degree of identification determines to a great extent the degree of suspense. The process of identification is stimulated in TATORT by means of different strategies, for example the introduction of the love story in CUDDLIES and Schimanski's moral outrage in SLIPSTREAM.

Another way to enhance suspense is to make sure there is some-thing desirable at stake. More generally something of crucial importance should be at stake, preferably the protagonist's life, but if not his life, then at least his reputation.[12] In CUDDLIES Schimanski's reputation is at stake. Since, strictly speaking, he is breaking Dutch law, there is the possibility that if the plan misfires, he will be sacked or at least reprimanded.

Furthermore the chances of a happy end should be slim: 'If high levels of suspense are desired the formula appears to be: an extremely likable protagonist in utmost peril with an extremely slim chance for survival.'[13] Pfister agrees with this, stating that the potential for tension is determined by the risk involved.[14] Although this strategy is not driven to extremes in TATORT, such risks as Schimanski is willing to take are always present in the background. The risk he takes in CUDDLIES in bypassing Dutch law generates additional suspense.

In almost every case, a suspenseful situation is determined by conflict and contrast.[15] The counterforces opposing the protaganist's striving should be strong. Schimanski does not only go through an inner conflict

because he feels morally concerned, he also has to confront external counter-forces. Among them we have to count Thanner, for instance, who needs a lot of persuading before he agrees to go to Amsterdam, as well as Dutch law which does not grant German policemen search warrants in The Netherlands. These counterforces need to be neutralized, which again contributes to increasing suspense.

As we have seen, curiosity, secret and suspense are all distinct ways of involving the viewer and making the audience active participants. Van Houweninge utilizes them as a matter of course, confirming his technical mastery of the crime film as form and genre.

There exists, however, another possibility of manipulating the flow of information, which functions neither in the absence of the protagonist's knowing *(suspense)* nor in the absence of the viewer's knowing *(secret)*, but when something happens suddenly, without any introduction whatsoever. This is called *surprise*, a form of viewer manipulation valued less highly by a 'master of suspense' such as Hitchock. In a situation of surprise, the anticipation is, so to speak, negative because the initiating moment leading up to an explosion, for instance, is not shown. Because of the sudden character of such a surprise, it does not initiate tension of any kind, and instead, produces a sometimes thrilling shock, different from a carefully planned and sustained tension in a suspense sequence. According to Hitchcock the viewer should, whenever possible, be informed, because surprise only works for a few seconds, whereas suspense lasts longer and is for that reason more efficient.[16] In SLIPSTREAM, for instance, a small plastic bag of heroin is found to be in the possession of Thanner, without any kind of warning. Given that no one expects Thanner to be a drug pusher, the discovery causes shock. It is also a surprise to the audience because we have neither seen him use heroin himself, nor had we noticed that a fleeing suspect had slipped him the parcel during the drug bust.

Integrating the Curiosity Structure of the Detective Genre and the Suspense Structure of the Thriller

The combination of a mystery structure and a suspense structure may become clear in the following example. Suppose the murderer did not only kill once, but is still at large, stalking other victims. In this case, the question 'whodunit?' is linked to the question 'who is going to get killed

next?' In suspense sequences the profile of tension changes from interest being aroused, as in a good game of chess, to the situation becoming thrilling, signifying a higher degree of danger and risk. Although the spectator does not directly 'identify'[17] with the victim, and will always be a witness[18], he or she does experience a 'link'[19] or special bond with the person in peril, anticipating the future, menacing events to come. Even though the characters 'belong to a heightened reality that we know to be unreal,'[20] the viewer is entangled in the fictional world in a state between fear and desire which causes the thrill, according to Roloff and Seesslen.[21]

Because of this intensified emotional involvement the profile of tension in thrillers differs from the tension typical in the detective genre. The more cerebral tension, derived from curiosity concerning past events which in a mystery genre invite the viewer to formulate several options or hypotheses about 'who did it', is replaced in the suspense genre by hypotheses about future, threatening events. In the suspense sequence the viewer can anticipate only two possible outcomes: a happy ending (survival) or an unhappy ending (death). However, the integration of these two genres in terms of their tension structure is a frequent phenomenon, since mystery and suspense complement each other, and are situated on a continuum, rather than being mutually exclusive, especially when viewed under the aspect of retardation (bifurcation of options/intensification) or temporality (retrospective/prospective).

Nevertheless, there is a difference between a thriller and a detective film, which may be worth mentioning in passing. According to Roloff and Seesslen a detective story can be distinguished from a thriller by the fact that in a detective story the detective is the central figure in the constellation of characters,[22] while in the thriller, both detective and murderer become equally the focus of attention and involvement. Even if a suspense structure is involved, in a detective story the process of detection is the master principle both for the investigator and the viewer,[23] while a thriller usually reveals the identity of the murderer, and thus provides the spectator with at least two sources of information (which may, of course, still be inadequate or misleading).

As indicated, however, in most detective stories, the mystery structure and the suspense structure are interlocked, which is one of the reasons why the genre often goes by different names: we can speak of a police thriller, a mystery thriller, a detective thriller, etc. Generally the structure of

narrative mastery or who controls the flow of information determines whether the more appropriate label is 'police thriller' or 'detective story'. A 'Krimi', the genre's German label, names only the 'crime' element and does not as such exclude the kinds of combinations of subgenres indicated above.

Positioning TATORT within the Crime Genre

In order to give our generic definition of TATORT an extra dimension, it is useful to briefly compare it to other crime series produced by and for German television during the same period. In this respect, the most obvious examples of other 'Krimis' would be series such as DERRICK and DER ALTE, also quite popular and long-running, though perhaps not altogether enjoying the cult status of TATORT. What is striking is that in DERRICK and DER ALTE the classical mystery-construction is dominant: similar to crime stories from the days of Sherlock Holmes, we find at the centre an investigator, who is not only superior in the knowledge to which he has access, but also very often outsmarts the viewer. Assisted by his deputy, who is a stand-in for the viewer's ignorance or faltering grasp of the clues, the detective solves the case by reconstructing the facts through interrogation, investigation and deduction.

Although this reconstruction-mode of the mystery genre is also apparent in the TATORT series, the other component, that of suspense, is also introduced, often at several levels. As a result, the quality of emotional involvement with the principal character, the police detective Schimanski, is of a different order and scale of intensity. He is not just a coolly rational, detached investigator, but gets himself (morally and emotionally) entangled in the cases he is trying to solve. In the excerpt chosen from CUDDLIES Schimanski is planning to infiltrate an organisation which masterminds illegal adoptions. Needing a pretext to enter the organisation's premises, he poses as someone intending to adopt a child, but in order to play the part of the anxious parent convincingly, he has to find a woman willing to pretend to be his wife. Two elements of suspense are introduced and intertwined: 'will there be a romance?' and 'will his plan succeed?'

If one compares both DERRICK and TATORT to the 'bible' of detective-story writers, written by S.S. van Dine, we can see that TATORT seems to violate several golden rules.[24] One of Van Dine's instructions explicitly states that there should be no love story involving the detective. And, to be sure, one has, at least up until now, never seen Derrick fall in love. Schimanski, on the

other hand, does have a heart, as can be seen from the excerpt, where it takes only a few pages before a romantic theme is introduced. Emotional involvement of the detective is, according to the rules, not allowed, because it interferes with the purity of the detection process. While DERRICK remains 'pure', Schimanski gets involved, not only at a romantic level, but also at the heart of the matter: by the end of CUDDLIES, he walks off, hand in hand with a little girl, victim of an illegal adoption. The crime itself may have been solved, but the problem has not gone away.

VI.4 The Insertion of Comedy in the Crime Genre

Apart from blending different types within the crime genre, and even 'breaking the rules' when it helps to deepen the story, Van Houweninge adds the element of comedy to the characteristics of the 'Krimi'. Although he is not the only writer or filmmaker to have done so (one thinks again of Hitchcock), Van Houweninge has clearly thought about the issue of the two genres at length:

'A thriller is one of the most difficult forms you can choose in order to tell a story because it is so easy to check out whether it works, and this also goes for comedy. If a comedy is not funny, and produces no laughs, then it's no good. If a thriller is not exciting, then it too is no good. By contrast, in a more indefinite or psychological story, there is always room for discussion of whether you have seen this properly, or whether this or that character was well acted. Everything in a thriller, however, must fit clearly. Moreover, you must serve up a cast iron story to the viewer, with excitement, where you ensure that everything that has to be seen is in fact seen, and where the characters must be clearly painted. If you can take such a good story and also depict really good characters, then you create one of the very best thrillers.'[25]

This raises the question why Van Houweninge would want to integrate comedy-elements into a 'Krimi' like TATORT. Is he only interested in combining the essences of these two genres, the thrill of the detective thriller with the disruption and laughter of comedy? Just as in SAY AH, in the first instance this is not what he is after. Van Houweninge himself puts forward

two reasons for integrating humour into a detective thriller. In the first place, he points to the special position that a series like TATORT occupies in relation to other German police series, such as DER ALTE and DERRICK. Objecting to the deadly serious tone that results from having only automatons, he wanted to inject some 'life' into the business of crime investigation, by creating characters of flesh-and-blood. The second reason follows from the first, for it is humour which ensures that characters become lifelike:

'By bringing humour into the German 'Krimi' the characters become real people instead of case-solving machines. Someone like Derrick never laughs, and is never irritated if he has to get up in the middle of the night to investigate a murder. Derrick always sets off cheerfully to solve the case, even if it is the middle of the night. The man walks in a serious way, interrogates in a serious way, always wears a serious face. That is what is produced as a 'Krimi' lacking all life and humour. In TATORT it is different. In SLIPSTREAM, an episode which I wrote, Schimanski and Thanner get a telephone call saying that a transvestite, somewhere in an attic, has taken an overdose. When Thanner and Schimanski see the body, Schimanski says something Derrick would never say: "Why do these bastards always manage to O.D. at night? Can't they do it during daytime?" Thanner, kneeling close by the body, says: "God, I still cannot get used to this." Schimanski: "Nor me. I need six hours' sleep." This black humour in such a situation is the humour of police officers who are called up continually to go out at night. If Derrick had seen a body like this, he would have put on his pathetic face and said "Oh dear, oh dear, oh dear. What can you say?" And although I have considerable respect for series such as DERRICK and DER ALTE and that kind of 'Case for Two', they are to my mind always made in the same pattern, and as a result they don't hold any surprise. Apart from giving life to the characters, integrating humour also creates far more viewer involvement.'

In the script extract from CUDDLIES, humour is introduced by means of herring, served by the Amsterdam chief inspector in honour of his foreign guests. The individualized reactions to the sight of raw fish both builds up the characters and adds a comic touch. Here, not just the flow of information is important, but the way it is transmitted to the viewer. Another striking example, also from CUDDLIES, is Schimanski's discovery that the child who

died was one of a pair of twins. Puzzling over a set of apparently incompatible data, Schimanski does not hit upon the solution out of the blue. Rather, watching two identical Pekinese dogs, he suddenly makes a connection where, strictly speaking, there is none, and thereby solves the mystery. In this instance, comedy does not necessarily make the characters more lifelike, but it certainly makes the detection process more appealing.

VI.5 **Mediating Detective Story, Thriller and Comedy in** TATORT

If DERRICK and DER ALTE seem to be constructed strictly according to the rules of generic conventions of the detective tale with the mystery tale overlaying the entire construction, in TATORT the mystery tale is interrupted by the injection of other elements, transgressing the boundaries of the detective genre in several directions. While DERRICK and DER ALTE stimulate curiosity concerning past events, and engage a detection process which appeals mainly to the viewers' cognitive involvement, excluding any emotional bond with the series' central protagonist, in TATORT the appeal made to the viewer shifts from cognitive appeal at moments in which the detective mode is in the foreground, to a mild laugh when the comic mode is inserted, all the way to a more emotional appeal during moments of suspense, or moments where the viewer witnesses despair, anger or romance in the eyes of Schimanski.

Shifting from the curiosity of the detective story to the suspense of a thriller and to the comic mode implies a constant change in the viewer's attitude during the disclosure process of the episode. One may wonder whether this multiple appeal does not confuse or disturb the viewer. However, in order to promote different states of involvement Van Houweninge does not interrupt one state by another, but tries to intertwine them. Thus, the appearance of the two Pekinese gives Schimanski an associative clue about the possibility of a twin sister being involved, yet it is the humouristic element (the performance of the Pekinese) which makes it more than a clue in the detection-process, while not detracting from it, and instead, drawing attention to it. As Van Houweninge himself has pointed out frequently, he is not interested in just giving the information needed for following the action, but tries to work out how the information can be presented in the most engaging way.

Although purists may argue this interweaving of elements of detective, thriller and comedy obscures the pure process of detection in the mind of the viewer, one could also argue that the addition of other motives and elements intensifies and enriches the investigation process. The integration of the detection process and suspense suggests *detective thriller* could be an appropiate classification for TATORT. But the insertion of comedy elements makes TATORT mutate into a third genre, one in which the boundaries are no longer that strict, precisely the genre of 'krimidy'.

In recent years, there has been a general tendency for traditional generic conventions to merge and blend with other genres. Exponents of this developments can be found especially in television series. Inspired by Dennis Potter's THE SINGING DETECTIVE, Steve Bochko, the creator of the 'realistic' HILL STREET BLUES, made COP-ROCK in which realistic events were interwoven with rock songs, performed by the characters as if they were in a musical. Similarly, in TWIN PEAKS the question 'Who killed Laura Palmer?' was not the overture to a conventional detective story, but gave rise to a strange mixture of genres including thriller, soap and horror, along with hallucinatory sequences more properly belonging to the fantastic. Although the viewer was able to keep track of the inquiries conducted by investigator Dale Cooper, there was a suspicion that these other genre elements were meant to interfere with the detective story. Although the interweaving of genres in Van Houweninge's TATORT scripts is not nearly as radical as it is in these examples, his innovations can nonetheless be usefully situated within these developments.

VI.6 ## Detective Story, Thriller, Comedy and Reality in CUDDLIES

Reality in TATORT
Apart from the dialogue among the genres in TATORT, an element already discussed in connection with SAY AH also needs to be mentioned in Van Houweninge's TATORT: the relation between fiction and reality. The TATORT episodes Van Houweninge wrote are clearly rooted in social and political reality. Topical issues form the basis for both CUDDLIES, where the issue is illegal adoption, and SLIPSTREAM, where the issue is environmental pollution.

Detective Story, Thriller, Comedy and Reality in TATORT

Hopefully, the following excerpt from one of Van Houweninge's episodes for TATORT, written in 1983, will illustrate how the story's foundation in a specific social reality is shaped into a detective story with thriller as well as comedy elements. A brief introduction to the story so far: the body of a young Thai girl is found. The autopsy shows that she died of typhus, a disease which must be reported to the authorities. No doctor, however, appears to have filed an official report, which obliges the police to treat the girl's death as a case of culpable homicide. There is suspicion of illegal adoption. The trail leads to The Netherlands, where such adoptions are as yet not a punishable offence. Schimanski, Thanner and Hänschen leave for Amsterdam to investigate.

Notes

1 In the contribution of Robert Kievit, 'Chiem van Houweninge: The Writer at Work', printed in this volume (Chapter III), Van Houweninge looks more closely at the script of CUDDLIES.
2 Bordwell, D., *Narration in the Fiction Film*, London: Routledge, 1988, p. 64.
3 Bordwell, D., *Narration in the Fiction Film*, p. 65.
4 See for example S. S. van Dine, cited in: Roloff, B. and Seesslen, G., *Mord im Kino: Geschichte und Mythologie des Detektiv-Films*, Reinbek bei Hamburg: Rowohlt, 1981, p. 18.
5 See also Kievit, R., *Spanning in de Speelfilm: Narratie en Stijl en hun Wissel-werking in het Genereren van Spanning*, University of Amsterdam, 1992.
6 *Ibid.*, p. 34.
7 Truffaut, F., *Hitchcock / Truffaut*, New York: Simon and Schuster, 1967, p. 52.
8 Sternberg, M., *Expositional Modes and Temporal Ordering in Fiction*, Baltimore: John Hopkins University Press, 1978, p. 159.
9 Roloff, B., and Seesslen, G., *Mord im Kino: Geschichte und Mythologie des Detektiv-Films*, p. 17.
10 'Je stärker diese Identifikation ist, um so engagierter wird der Rezipient der Pläne, Alternativen und Risiken mitverfolgen und umso stärker wird er auf die folgenden Handlungssequenzen gespannt sein.' See Pfister, M., *Das Drama: Theorie und Analyse*, München: W. Fink Verlag, 1982, p. 144.

11 'Durch Identifikation mit der Angst (des Helden) und dem Grad der
 Intensität, mit der der Rezipient sich mit der Person, die in Gefahr
 schwebt, identifizeren kann, kulminiert auch das Gefühl von Furcht und
 Hoffnung im Rezipienten.' See Borringo, H. L., *Spannung in Text und Film:
 Spannung und Suspense als Textverarbeitungskategorien*, Düsseldorf:
 Pädagogischer Verlag Schwann, 1980, p. 46.
12 Caroll, N., 'Toward a Theory of Film Suspense', in: *Persistence of Vision*,
 nr. 1, 1984, pp. 65-89.
13 Comisky, P. and Bryant, J., 'Factors Involved in Generating Suspense',
 in: *Human Communication Research*, vol. 9, nr. 1, 1982, p. 57.
14 Pfister, M., *Das Drama: Theorie und Analyse*, München: W. Fink Verlag,
 1982, p. 144. '(...) das Spannungspotential [wächst] mit der Größe des
 involvierten Risikos.'
15 'There is a evident contrast between project and resistance [...].
 What fills the gap between points of contrast is tension, derived from the
 Latin *tensus*, meaning stretched. Tension suggests the invisible lines of
 force between two contrasting poles [...]. Tension [...] is induced by our
 perception of contrast'. See Beckerman, B., *Dynamics of Drama:
 Theory and Method of Analysis*, New York: A. A. Knopf, 1970, p. 48.
16 Truffaut, F., *Hitchcock / Truffaut*, New York: Simon and Schuster,
 1967, p. 52.
17 According to Zillmann the spectator is always a witness. As a result the
 viewer cannot in fact identify or 'feel with' (emphathize with) a character
 but only 'feel for' (symthathize with) a character. See Zillmann, D.,
 'Anatomy of Suspense', in Tannenbaum, P. H., (ed.), *The Entertainment
 Functions of Television*, Hillsdale: N. J. Erlbaum, 1982, pp. 141-143.
18 *Ibid.*, pp. 141-143.
19 Barthes, R., *A Lover's Discourse: Fragments*, London: Penguin,
 1978, p. 131. ('I cling to the image of the lover ...').
 See also Barthes, R., *S / Z*, Paris: Seuil, 1970. Barthes states that
 identification is a structural and not a psychological process. According to
 him the viewer is looking for a point of view or position which would be
 the viewer's if he were part of the fictional world.
20 Priestley, J. B., *The Art of The Dramatist*, London, 1957, p. 68.
21 Roloff, B. and Seesslen, G., *Kino der Angst: Geschichte und Mythologie des
 Film-Thrillers*, Reinbek bei Hamburg: Rowohlt, 1980, pp. 13-39.

[22] Roloff, B. and Seesslen, G., *Mord im Kino: Geschichte und Mythologie des Detectiv-Films*, Reinbek bei Hamburg: Rowohlt, 1981, p. 10.

[23] *Ibid.*, p. 10.

[24] *Ibid.*, pp. 18-20.

[25] This statement was made by Chiem van Houweninge during his seminar on scriptwriting at Film and Television Studies at The University of Amsterdam, 1993.

TATORT

Episode: CUDDLIES/KUSCHELTIERE
A Fragment

CHIEM VAN HOUWENINGE

POLICE STATION/DIJKHUIS' OFFICE – INTERIOR/DAY

When the German criminal investigators enter the room,
Dijkhuis gets up and welcomes them warmly.

DIJKHUIS
The name is Dijkhuis. Pleased to meet you. Did you have a pleasant journey?
Have a seat, make yourselves comfortable...
> *As a welcoming gesture Dijkhuis offers them some raw*
> *herring.*

DIJKHUIS
May I offer you some Dutch herring, gentlemen?

HÄNSCHEN
What a pleasant welcome, yes, I'd love one.
> *He grabs a herring by the tail end and swallows it whole in*
> *the Dutch fashion. Schimanski doesn't like raw fish.*

SCHIMANSKI
No, no, not for me, thank you. My stomach contains no salt walter
– the critter wouldn't be too happy there.
> *Thanner tries to imitate Hänschen, but he fails miserably*
> *and Dijkhuis and Hänschen burst out laughing.*
> *Meanwhile Dijkhuis has taken out a file.*

DIJKHUIS
Well, gentlemen, this is a difficult problem. We looked at the file once again
after you rang... eh, but...this is a rather complex case.

SCHIMANSKI

Why? What's the problem? All we want to do is to take a quick look at the
agency's files – of course one of your colleagues will be with us the whole
time... What is so difficult about that, if I may ask?

DIJKHUIS

Well, the agency has committed no punishable offences?

THANNER

No criminal offences? Trading in human beings is no offence?

DIJKHUIS

(somewhat embarrassed)

Yes...yes...I understand your point of view but we can't take any measures
against the agency... at least not yet... there is a law against their activities
pending but it has not been ratified by parliament yet. We could only get at
them if they had falsified records.

SCHIMANSKI

But...these people smuggled a child with typhoid fever across the border!

DIJKHUIS

Who?

THANNER

That's exactly what we need to find out. That's where the files come in.

DIJKHUIS

I understand... but two stuffed toys cannot be used as evidence in any
criminal wrongdoings of the agency.
We have no evidence to bring against them in a court case. And the state
prosecutor does not have enough reason to justify a house search – much to
his regret as he says.

SCHIMANSKI

All this damned paperwork. Same old routine everywhere.
Can't we work out something?

DIJKHUIS

(smiles)

I fear there is nothing we can do. I am truly sorry, gentlemen.

DIJKHUIS

(in Dutch)

Two German police officers searching a house in The Netherlands, don't
misunderstand me, but...

THANNER

Yes, yes, we understand you only too well...

Dijkhuis closes the file. Thanner sniffs his thumb and index
finger which he used for eating the herring.

SCHIMANSKI

Scheiße.

HÄNSCHEN

(translates from the German into Dutch)

Klote ?

DIJKHUIS

Thank you.

He makes a gesture to indicate that he can't help the
situation.

IN FRONT OF THE POLICE STATION – EXTERIOR/DAY

As the policemen leave the building, their car is being
towed away by the traffic wardens. Hänschen jumps on
the car and tries to stop them.

RESTAURANT – INTERIOR/DAY

Schimanski, Thanner and Hänschen are seated at a table
waiting for their food.

SCHIMANSKI

I have no intention of quitting. I didn't drive all this way just to have a meal in Amsterdam!

THANNER

I don't understand all this. Trade in human beings is in fact going on and the Dutch police have 'no incriminating evidence'? I can't accept that nothing can be done. What kind of country is this anyway?

Hänschen sighs and shrugs his shoulders.

HÄNSCHEN

Yes, I really don't understand why the Germans wanted to occupy Holland, all those years ago.

THANNER

Could we have our bill, please?

> *He gets up from the table.*

SCHIMANSKI

Thanner! I've got it! We'll adopt a child!

> *Thanner thinks Schimanski is joking.*

THANNER

Horst, don't make such stupid jokes...

SCHIMANSKI

Listen to me! We are going to make an appointment with the agency and pretend we are normal Germans who want to adopt a child. Then we can look around a bit, perhaps we'll discover something.
That's it! We've got to do something, after all!

HÄNSCHEN:

Not a bad idea! Except that you and Thanner don't look like a very convincing gay couple who want to adopt a child. These people won't buy it. They'll become suspicious in no time. If I were you I'd use a woman instead.

SCHIMANSKI

I can't find a woman just like that...

THANNER

That *is* a problem.

> *Schimanski takes a look around the restaurant.*
> *He discovers a lovely lady at a nearby table. She is eating*
> *her lunch alone. It is Marijke. He jumps up and walks*
> *towards her. Thanner and Hänschen are astonished.*

SCHIMANSKI

Excuse me, Madam... do you speak German?

MARIJKE

> *(surprised)*

Yes, I do.

SCHIMANSKI

I need a wife.

MARIJKE

> *(amused)*

Do you? Right now or may first finish my lunch?

> *Schimanski uses all his available charm on her.*

SCHIMANSKI

May I sit down? Please, let me explain. My name is Schimanski.
I am a criminal investigator with the German police.

MARIJKE

Go on.

> *He sits down and starts to explain. Thanner and*
> *Hänschen oberve them from afar. We see Schimanski*
> *continually talking to the woman. Hänschen and*
> *Thanner are being served their food. Shortly thereafter,*
> *Schimanski gets up and returns to their table.*
> *Marijke accompanies him.*

THANNER

I don't believe it. He did it! Are all women as easy as that in this town?

HÄNSCHEN

We are a helpful nation.

SCHIMANSKI

May I introduce.. Christian Thanner...Hänschen...
This is Marijke Sch..gg..

MARIJKE

Marijke Scherpenzeel. Pleased to meet you.

SCHIMANSKI

She is willing to help us.

THANNER

Wonderful.

HÄNSCHEN

Great.

> *Suddenly, all three men jump up to get a chair for Marijke*
> *She is amused by all this attention and sits down.*

SCHIMANSKI

Would you like a drink?

MARIJKE

A dry sherry, please.

AT THE AGENCY – INTERIOR/DAY

> *The office looks friendly and bright, user-friendly for*
> *children. In one corner there is a play pen with lots of toys.*
> *On the wall there are large posters with appeals for the*
> *Third World; another poster shows a white, happy couple*
> *with a small brown child. On the shelves are many*
> *familiar cuddly toys. A charming and elegant woman*
> *takes a file card out of a box. She speaks excellent*
> *German with a slight Dutch accent.*

WOMAN

May I ask why you chose our agency?

> *In front of her: Schimanski and Marijke are seated in*
> *two comfortable chairs.*

SCHIMANSKI

A friend referred us. Your agency must have a very good reputation.

WOMAN

Of course. Just as it should have. May I take down your names and address, please?

SCHIMANSKI

Schimanski.

> *The woman asks no further and repeats:*

WOMAN

Mr. and Mrs. Schimanski.

Chiem van Houweninge

VIII

BETWEEN WRITING AND FILMING

A Discussion

EDITED BY ROBERT KIEVIT AND JAN SIMONS

VIII.1 Introduction

On June 18th, 1993, a colloquium was organized by the Department
of Film and Television Studies of the University of Amsterdam, entitled 'Television,
Comedy, Script'. The key figure of this colloquium was Chiem van Houweninge
who discussed ideas on crucial aspects of writing for the screen with colleagues:
fellow-scriptwriters and a television director.

The discussion focused on the position of the scriptwriter and the
areas of tension within which he has to operate. Between script and programme
the producer, script editor, director, actors and occasionally other, sometimes
unexpected persons are influential. What is their role, and what is the relation
between scriptwriter and director, between scriptwriter and producer? What are
the positive and negative contributions of all those involved in the preparation of
a programme? Is it the writer, the director or the producer who makes the ultimate
decisions? What is the function of a script editor in this power game?

Of course, the commissioning agency, usually a television broadcasting
company, also plays an important role. How far does its interests, such as reaching
as wide a viewing public as possible, or alternatively a more specific audience
determine the form and content of a script? Does it make a fundamental difference
whether one is working for a public or for a commercial network (in The Nether-
lands for example, Hilversum versus RTL4 and RTL5)? Do networks prefer success-
ful foreign series or would they rather adapt the 'formats' of popular foreign series
to Dutch scenarios instead of taking a risk with original Dutch series? Do Dutch
television series also stand a chance abroad ?

These questions are taken up by a number of scriptwriters of, in
particular, long-running comedy series:

Chiem van Houweninge, writer of many television series, including SAY AH (ZEG 'NS AAA), EACH TO EACH (IEDER Z'N DEEL), CASSATA, *and* DOUBLE TROUBLE (OPPASSEN!!!), *but also the writer of several episodes of* TATORT.

Peter Römer, scriptwriter of THE BREAKERS (DE BREKERS) *and* CHICKEN AND EGG (KIP EN EI) *plus a number of other programmes.*

Jack Gadellaa began as director and later worked with Peter Römer as scriptwriter on STRANGE PRACTICES (VREEMDE PRAKTIJKEN) *and* CAN IT BE A LITTLE MORE (MAG HET IETS MEER ZIJN).

Haye van der Heyden, writer of the long-running series IN THE FLEMISH POT (IN DE VLAAMSCHE POT) *and more recently the series* SATURDAY NIGHT CAFE (ZATERDAG AVOND CAFE).

Finally, Nico Knapper took part in the debate as an experienced television director. He has often worked as director with Chiem van Houweninge on SAY AH *and* DOUBLE TROUBLE, *and has subsequently also worked on* HI DAD! (HA DIE PA!).

The discussion as reproduced here has been edited along thematic lines.

VIII.2 Between Writing and Directing

> *The scriptwriter produces a script to be turned into a film or (episode of) a television series. The latter is mainly the job of a director, who has to translate the written text into images, and who wants to bring his own ideas to bear on the material he is given. What is the relation between the scriptwriter and the director?*

CHIEM VAN HOUWENINGE

It is a delicate one, and also depends on the production you are working on. To my view, making a film is teamwork, and on TATORT we had a very strong team. The script provides the backbone of a film. If there were no script there would be no film to discuss, but the moment there is a script, everybody immediately feels free to discuss it. The scriptwriter is like an outlaw, anyone can take a potshot at him. Once the script is delivered, everybody thinks they are allowed to give an opinion, even the girl in catering. Of course I'm interested to hear what other people think; but as scriptwriter you have to

be very careful not to allow everyone's opinion to affect your script. Otherwise you'll end up with a homogenized hotchpotch. When you have written a cast-iron story that everyone finds damn good, one the actors want to have a part in and that the director likes, it will be strictly followed. But, if during shooting the director discovers that something doesn't fit, that the story's wrenched, that it won't run smoothly, all the actors on the set will push and pull at the script. Before you know it, the actors and the director will be making the film, while the writer is sitting at home all worked up with a terrible headache, angry, because there's nothing left of his script.

Writing a script also includes a bit of directing. As the writer you have to indicate very clearly how you want something to be played. You can steer the director, the re-creative artist. Indeed, you should avoid all discussions with a director along the lines of, 'Listen, that's not what I intended.' You must write in such a way that these discussions never arise. But it is a precarious balance. You should not write too much in order not to encroach on the director's territory. You don't write in the cuts and the camera movements. That is the director's job. But you can certainly describe a scene in such a way as to suggest how the camera should be placed. Suppose there is a scene with a sleeping child in a huge dormitory. If you want the spectator to see only the child at the beginning of the scene, and not the rest of the dormitory, you could write, for example, that the child's bed is situated underneath the window and that the rest of the room is in darkness. That's another way of saying: 'the camera is concentrated on....' In subtle ways like this you can communicate your wishes to the director. The writer and the director each have their own responsibilities. Fortunately, so far I have never suffered from a difficult working relationship with a director, but I would certainly have trouble if I was given back a script that a number of people including the director had been messing around with. If the script is written as was agreed, then it should also be shot that way.

But do you find that a director can add something to the script, since it still has to make the transition from paper into images, into scenes ?

CHIEM VAN HOUWENINGE

Well yes, that's his job. I always say: a script is two-thirds created on the writer's desk, and the creativity of the actors and the director supply the rest on the set. That's why I think it's very useful that someone else directs my work. I am only too pleased if the creativity of the director and actors is added. But they must be on the same track as the writer.

A scriptwriter is the only real outlaw in the film and television industry. Anyone involved in the production can take the script and say, 'That doesn't work', and the director will say: 'He says this won't work, could we have a look at it?' Since everybody thinks he or she can read a script, as a writer you must be extremely careful to choose only people whose opinions you hold in esteem. That way you might miss a few useful remarks but you protect yourself against a whole lot of useless comment.

HAYE VAN DER HEYDEN

For me, there's only one thing that counts: a script must be the best possible. If the catering girl has a good suggestion, you should use it. I couldn't care less whether it's a director or a script editor, as long as they help to improve the script. That is all.

PETER RÖMER

True, but I have been to script read-throughs where the director only had to say: 'Good morning', and the next thing you heard was six times click, click – those were the pens of the actors and actresses. No question of any useful suggestions about the script. What do you expect? Actors usually start immediately to read their own parts, crossing out and adding bits. Reading a script is extremely difficult, often too difficult for the actor. Most – not all – actors only read their own part. Such an actor can never have a picture of the whole script. I agree with Chiem, I find it intolerable that an actor can go hacking and chopping away at a script.

JACK GADELLAA

There is this other phenomenon that regularly happens in the studio. After the second reading, the first run-through and the rehearsal, when everybody has said his or her lines three times, a fireman passes by and shouts something which strikes people as funny. Of course his joke was in my first version, too,

since it's usually something obvious. But the moment the fireman makes the joke, it seems very original and refreshing, so everyone says: 'Yes, let's add it'. But, no, it shouldn't be added, we'll do just what's written. There ought to be a law against people who by chance happen to be television tycoons, or script editors or whatever, that forbids them from having a pen and messing around with other people's scripts. If they want to set people on another track or inspire them to something else, they should do so by sheer force of conviction. This co-writing by people who think they know better than I do drives me crazy.

HAYE VAN DER HEYDEN

This is beginning to sound a bit like the frustrated mutterings of the boys who won't let go of their scripts. I think we have to be strong and stick to the final editing. Anyone can say whatever he wants to say, but it's us who must say: 'Okay, either I'll do it or I won't'. End of story.

I have written into my contract with John de Mol (one of the major Dutch television producers, ed.) that from the moment the script is approved, by de Mol or whoever, no single letter of the script can be changed. Any changes have to be notified two weeks before the shooting, otherwise the shooting must be postponed.

PETER RÖMER

But when the script is taken over by the director and the actors, a strong director must protect the writer.

NICO KNAPPER

In the end there's only one captain on board, whether it is the director or someone else. That person has to see to it that everyone can do his own job properly. This person should ask the writer: 'Are you happy with it?' or say to the director: 'Can you do something with this script?' All these frustrations arise when there is no one who sees to it that everybody is given the full range of their responsibilities. Some years ago a research team from the University of Utrecht tried to discover the reason for SAY AH being such a long-running success. Luckily they didn't discover it, since otherwise anyone could now make such a series. All they could say was that there must have been a fortunate combination of writer, director and actors. I might have come to the same conclusion myself! But according to those researchers, it was very important

that there should be one captain on the ship who keeps all the various facets and elements in balance, and – certainly in a long-running series – who keeps everyone motivated, and who keeps a sharp eye on the quality of the series. Modesty obliges me to suggest that this figure does not always have to be the director. An enlightened producer could also fulfill the role. Even an enlightened executive producer or broadcasting director could, although it would be more difficult for such figures, because they operate too far removed from the working floor. Chiem as a writer and I as a director have agreed that I don't have to go to him for approval of small changes, an arrangement based on built-in mutual trust. If the change is too great to undertake on my own initiative, then it will be automatically submitted to the writer. He is the final judge.

VIII.3 Between Writing and Producing

The director is, of course, not the only person to 'interfere' with the script. A film or a television series is also the responsibility of a producer who may himself have ideas about what is desirable or feasible, or what the intended public wants or does not want to see. What is the relation between the scriptwriter and the producer? What is the area of tension between these two?

CHIEM VAN HOUWENINGE

The greatest dilemmas with which you are confronted as a scriptwriter occur when you are dealing with a powerful producer who wants to tell you what to write. It's always the producer, alone or together with the director, who decides whether what you have written is any good or not. A strong director also has his contribution to make. Here a distinction should be drawn between film and television. In the cinema, it is the director and the producer who decide about the film. In long-running series for television, the producer and the writer form the most important team – and this is not only how I see it, I have read this somewhere. A strong producer will tell you what's good and what's bad. I have often experienced how a lot of things from other people came into the script when things weren't going well. In such cases, various

theories were let loose on the poor scriptwriter, who had to change things. Only then the script was filmed. If in the end the script was totally different from what I, the scriptwriter intended, I had only one choice: to have my name removed from the credits. There came a time when I had had enough of such dilemmas and became a producer myself. People so often wanted things changed while I knew for certain that they were absolutely wrong. But if you're not the producer there is no chance to prove you are right. Usually the script is taken out of your hands and changed. Another difficult situation occurs when a producer judges a script on false grounds (good producers excepted). Then you start asking yourself whether he's right or not. You start to doubt.

Now that I am a producer myself, I have another dilemna. I cannot simply assume that everything I create is good, and I have to make sure that I surround myself with some good critics. I became a producer myself because I want to be involved with the entire process, and be able to say at every moment: I don't like this, we shouldn't do that. I am the artistic manager of my company, and besides me there is a commercial manager. I very much like creating something in cooperation with other people as long as it's me who takes the decisions. Since I am not only the writer but also the producer, this is possible. Nico Knapper and I have worked together with great pleasure because Nico also discusses production matters with me. We have become a team. Normally the opinion of the director is subordinated to the wishes of the producer and writer. I don't know whether this is good or bad, but television directors all over the world have to live with it.

NICO KNAPPER

This is only possible in a small company like ours, not in a large production company like John de Mol's. He has to make sure he has the right colleagues to carry out his policy. He needs someone who knows the trade. But in every unit someone has to be the central figure. It is simply an authoritarian business, and it has to be made very clear who has the authority. One of our frustrations is that so many people take advantage of our authority without even realizing it. Or they don't accept your authority and overrule you because they just happen to be in a position where they think they have the say.

Between Writer and Script Editor

Another profession figures in this power game between
scriptwriter, director and producer, that of the script editor.
What is the function of a script editor and what is the
working relationship between scriptwriter and script
editor?

NICO KNAPPER

Most TV companies where directors used to be responsible for the preparation
of the work as well as the work itself, have now appointed script editors. This
script editor is an ambiguous figure, since he's part critic, part creator. He is
mostly detested, since in the end he is always the messenger who brings the
bad news: 'This isn't good, this will have to be altered....' It is his critical
function. His judgement can be refreshing, stimulating, even if at first you
don't agree. But the script editor is also involved in the creative process, and
there is the rub. The script editor is never actually selected because of his strong
artistic involvement with the programme makers (writer and director) but
assigned to the production by the TV company to make sure the identity of
the company is respected. In the worst case he becomes a kind of KGB agent,
with so much power that he is able to subordinate various working practices
to his own pet notions, none of which has ever been proven to be successful.

I don't want to go into examples here of good cooperation, which
undoubtedly exist, but I do want script editors to consider for a moment the
somewhat twisted power position from which they speak. The TV bosses
much too thoughtlessly put them in a position where, through this double
function, they get to wear two hats. Script editors themselves should take
care not to end up in a position that no longer has anything to do with the
dramaturge's original function in the theatre, where his or her collaboration
with the director sometimes is an essential part of the success. In television,
the script editor has all too often become just a company employee, who gets
in the way between writer and director.

CHIEM VAN HOUWENINGE

In television you are obliged to work first of all with script editors, and there
are only a very few really good script editors who know the trade. People with

a firm opinion. Most script editors don't know how to deal with good writers. Eli Asser, one of the grand old men of Dutch comedy, once said that there are many people in the TV companies who understand humour, but have no sense of it.

PETER RÖMER
All their theoretical knowledge has never produced a single joke.

MARJA TUTERT (script editor, ed.)
But that is not what a script editor's analysis is for. Of course no one writes with scriptwriting outlines and models in his, her head. The first reading of a script editor too is intuitive. Only when you feel that something is wrong, do you start to use your theoretical facilities in order to find the fault. The moment the product is being broadcast, and audience research is done, the public's opinion comes into play. Sometimes things need some correction, and that's where the script editor with his theoretical training comes in.

HAYE VAN DER HEYDEN
I have learned from script editors what a term like *peripeteia* means. Now I find that a grasp of such technical things is useful when I'm writing.

JACK GADELLAA
Talking with a script editor makes me feel safe, since I know that if necessary he, she will press the right button, explain to me what 'narrativity' is or that the second plot must be allotted so much percentage of the script, or what-ever. But I don't have to know all those things myself.

MARJA TUTERT
But that is also a biased view of the way a script editor works. I first ask the writer what point he, she wants to make, and I try to put myself in his, her position. There are no standard ways of doing that, since the only standard is what the writer wants. And of course, eventually I must take the wishes of the TV company into account. Most of the time I just try to get a writer afloat again when he, she has run aground. I'm just a sounding board.

JACK GADELLAA

That's what I meant. When I discuss things with an understanding script editor, I suspect there's a great pile of theory and college notes behind this person, but I don't have to know that stuff myself. It can be most useful to have someone as a sounding board, someone who is used to thinking along these lines and who will ask you occasionally: 'Now what is your premise?' Then I'm really pressed to think, and it could happen that I might think: 'The premise is friendship above all, now that I think of it', even though the word 'friendship' doesn't occur in the script at all.

HAYE VAN DER HEYDEN

You are 100% right. And you must go on writing new versions until you get there, until you have found your premise and have cleaned up your script, shall I say. But people who are really able to help are very scarce. And I have not yet met one coming from academic studies.

CHIEM VAN HOUWENINGE

Film and television studies is, of course, a very young academic discipline, which still has to make its name. I believe that nobody has trouble anymore with art historians, except perhaps painters and sculptors.

My experience with script editors on the whole has been very good. You can work famously with a well-trained script editor. But you can never be sure whether the script will become a hit. This is sometimes confused with the quality of the script. We keep talking about writing a hit, and not, for example, about writing a fine single play. Whether cooperation with a script editor will produce an 18% viewer share, nobody can say.

Between Writer, TV Company and Television Viewer

Here a new party enters the picture: the commissioning agency or television broadcasting company. What is the assignment they give to a scriptwriter and their watchdog, the script editor? Does it produce quality or does it produce a hit, if these are mutually exclusive categories?

HAYE VAN DER HEYDEN

Nobody ever asked me for a hit. Recently my producer, John de Mol literally said to me: 'I want a series with a viewer share of 12 to 13 percent.' That was the only thing he asked for. No topics or themes were mentioned. I said, 'You'll get it from me.' Done. I don't know why I gave that answer; it doesn't matter. But 12 to 13 percent is not a hit. He simply said, 'I don't need a hit, I just want enough people to watch.'

JACK GADELLAA

In The Netherlands nowadays 12 to 13 percent is a hit, and it would be a semi-hit in the rest of the world.

HAYE VAN DER HEYDEN

No, 12 to 13 percent isn't a hit. 18 percent is a hit.

NICO KNAPPER

If you can guarantee a public broadcaster 12 to 13 percent viewing share, you certainly will get your commission on your way out of here right now.

No one of course can guarantee a hit, as Chiem van Houweninge earlier remarked. But don't TV companies demand that you take into account what the 'general public' wants? No plots that are too difficult, no stylistic tours de force, etc.?

NICO KNAPPER

Television is by definition a mass medium. In the theatre you can easily confuse the 'good guys' and the 'bad guys', since there it would be very well appreciated as an intellectual idea. But you cannot do it on television because most people will just switch off. There you must stick to the iron-clad roles of 'good guys' and 'bad guys'.

But is it possible to write for something so abstract as the 'general public'? Or do you in fact write for a specific public? I am thinking particularly here of a public that is much more selective, and prefers another sort of humour, intellectual humour?

PETER RÖMER

That is not a problem at all, since you can write for all sorts of audiences. You can write a sketch for greengrocers or something really intellectual. Of course I want to have my work bought, but in the end I write for myself. How my work gets appreciated, whether it will be consumed by small groups of intellectuals or by a mass audience on RTL4 (a commercial TV company, ed.) comes second. I have to like it myself. I would never write one sentence just because it would ensure success if I myself thought it was a poor sentence.

JACK GADELLAA

There are several things you must keep separate. You can also find your own way within the boundaries of a genre. This year I have been approached countless times by TV people who would like to have a provocative late-night comedy. Of course you can manage that. Of course, I would have to step over some threshold and give rein to my own coarse sentiments. Things can always be tougher, more juicy, and so on, but this would be a comedy for a specific group. Or you can say: 'It's for VERONICA, so, it's for a rather young audience.' We're familiar with this kind of target group broadcasting. Of course you can do that. But I'm not so sure about writing specifically for a VPRO-public as target group... Working for television means working for a mass medium, and that means you are aiming at a large audience. Now I know that measured in terms of football stadiums even the smallest VPRO programme has a pretty

large audience, but that's no standard. A comedy that gets a viewing share of four percent has to be taken off the air, I think.

HAYE VAN DER HEYDEN

I would like to make a comment here. Today, producers don't talk about viewing numbers, but about the demographic composition of the audience. It can be calculated that at a certain moment, all Volvo drivers watch a certain programme. So, if you make a comedy for Volvo drivers only 4 percent of the total public will watch it, but 70 percent out of those four percent drive a Volvo. In spite of its rather low score, it can certainly be functional, if only it reaches its designated target group.

NICO KNAPPER

This actually is the problem of commercial companies. If they want highly educated and highly paid viewers as their target groups, they will ask you to make such programmes.

JACK GADELLAA

Of course, public TV companies are looking for an audience, whereas the commercial companies go looking for a public in order to sell it to an advertiser. That difference will always remain, and become only more marked in the future. Then Van der Heyden's story will only apply to the commercial side. In which case, of course, he is right.

CHIEM VAN HOUWENINGE

Then I'm finished because I can honestly say: when I sit down to write, I never think of the audience, never. I am only concerned with the characters I am creating. Of course I know that an episode has to be half an hour, that is the standard I'm working with. I know nothing about target groups. I always stick closely to what I am creating and that's the way I like it. Of course, it's wonderful when it turns out that a whole lot of other people like it too. Recently I was shown a list of the ten favorite programs among intellectuals, and number two was SAY AH. We would never have expected it.

But rating figures are originally just sociological information that nowadays is used in an absolutely unscientific way. Rating figures always have to do with what programmes come before and what programmes come after, with what is on the other network, and God knows what else. A top ten of the most popular programmes is absolute nonsense. It's always nice when yours is in the top ten of course, but ultimately this has to do with how many football matches were on that week.

VIII.6 Between Foreign Format and Original Script

> *For the TV company in any case, rating figures are of importance. Not only in The Netherlands but also in the surrounding countries, one sees an irresistible increase in foreign formats that are bought in and reworked for use in the home country. The question this raises is whether this is a tendency that stands out because television producers imagine they can ensure success for themselves through buying foreign shows or whether this tendency is a consequence of the dearth in quantity or quality of original scripts?*

NICO KNAPPER

Everybody wants to have a long-running comedy format. The ratio of popularity and production costs is the best. What a company manager would like most is to get hold of a script that he knows for sure would bring success. But such scripts don't exist. Reading a script is very difficult. Without actors, one doesn't see faces, one cannot hear how the lines will be spoken. There are no exciting descriptions of actions and states of mind that engage the reader and evoke an image in the mind as in a novel. Only a director, or some exceptionally gifted person is able to visualize the intended result when reading a script, like Michelangelo who already saw his sculpture in an unworked block of marble, and only had to chip away the irrelevant bits of stone. Since they lack this skill, company directors become nervous and would rather buy foreign series and have them adapted for The Netherlands. At least

they have the reassurance of the foreign example. Subsequently, they must be adapted, translated, and sometimes reworked for the Dutch situation. But it seems to be less of a risk than starting with something entirely new.

It is with intense and malicious pleasure then, that I can state that the adaptation of a foreign example does not by definition produce good results. An exception which proves the rule: the Dutch adaptation of FRIENDS FOR LIFE (VRIENDEN VOOR HET LEVEN) has been more successful than the original. Other examples, however, are just as much proof of wrong decisions. The tycoons who are more interested in wheeling and dealing, of course, keep promoting this approach and broadcast managers walk blindly into the trap.

JACK GADELLAA

I absolutely agree with Nico. It's a disease of the 1990s to stick to this sacred belief in formula shows on the basis of a single successful example, while conveniently overlooking the failures. I have some experience with it myself now. For the writer it is a disaster, since it takes far more work to rework someone else's script, and adapt it to the Dutch situation than to write an original script. So I really don't see the advantage. The broadcast manager in charge will think that continuity is guaranteed because there are 120 scripts waiting for adaptation, and maybe he thinks success is certain because it was a hit in New Zealand as well. This line of argument has led more than once to mistakes like, 'Let's do HONEYMOONERS with Gerard Cox as Jackie Gleason'. That is something completely different. One forgets that the script and the main actors of a foreign series have their roots in another society. They can't be simply transplanted. Foreign formats are absolutely no guarantee for success, and demand at least as much work as writing a new script. As Berend Boudewijn (a Dutch director, ed.) once said: 'Foreigners may be extremely good, and world famous. But they have no idea of the flavour of red cabbage with apple.'

CHIEM VAN HOUWENINGE

I don't want to take bread out of anyone's mouth, but if you are so strongly against imported formats and believe another solution should be found, you have to say: 'I don't do adaptations, but here is what I've got to offer. This is what I've been working at for my whole life.'

PETER RÖMER

But that won't work, of course, because the man from the TV company isn't interested in what you have to offer. And of course not every foreign format is bad. The archetype of STEPTOE AND SON (STIEFBEEN EN ZOON) was a great success, a milestone in the history of black and white television. That was a fine example of how a foreign format could be accurately translated into a Dutch product. Under the right conditions it's certainly feasible. And the time is past where all kinds of foreign series were bought, translated, and then abandoned after 13 episodes.

CHIEM VAN HOUWENINGE

Yes, that's my impression too. Another problem is that nowadays television all over the world is extremely greedy. Anyone with the slightest talent for scriptwriting immediately gets an assignment as co-writer of a series, in order to create one series after another for some tycoon. Few have had the chance, as I have – and I have been very lucky in this respect – to develop their talent quietly, by creating and making things. Nowadays, people are immediately assigned to write this or translate that. If it doesn't work out, you never hear of these people again. And that, of course, is a disaster.

HAYE VAN DER HEYDEN

I still want to say something in favour of the formats. The most difficult thing in comedy is, I think – and this the maestro, Chiem himself, told me a long time ago – the plot. The great advantage of buying a format is that you already have a plot. For people who are not yet fully masters of their trade, it could be a sound training to work on such a format for a while. Maybe you should make free adaptations as Peter Lösse does, for example, with FRIENDS FOR LIFE. Not all formats are bad.

> But if a foreign format does not guarantee success, and it costs the same amount of work to translate a format into your own culture as to write an original script, are the TV companies purchasing more formats at the moment simply because they are being offered too few original scripts?

ZEG 'NS AAA: *cast (Dutch version)*

CHIEM VAN HOUWENINGE

Indeed. I do believe that the Dutch TV companies are offered too little choice.
I believe we have to build a tradition of writing in The Netherlands. Dutch
talent should be allowed to work for television and be supervised. But television
is too greedy to be satisfied by the potential of Dutch writers. That's why the
TV companies go abroad. I had the same experience, but the other way round.
Germany bought the format of SAY AH, the scripts were translated and adapted
by Germans, with another director and another cast, but they build it on sand
with no foundation. Then you have to lean back calmly and try to find out why
it doesn't work. I said at the time that there was one essential thing missing
in the German SAY AH: charm. A few months ago, Georg Veil, the director of
BAVARIA, the television company that produced SAY AH, said: 'We now realize
that the adaptation of a foreign format requires just as good a writer as an
original German script.' It's pointless to have such a series adapted by some-
one who knows German reasonably well and has some feeling for dialogue.
No, you need someone who is thoroughly acquainted with the German way
of acting and being and who has a real talent to write the series. Someone
who can't create a series on his own will not be able to make a well written,
decent adaptation of a foreign format. When as a writer you look for a format
you would like to adapt yourself, you'll come up with STEPTOE AND SON
(STIEFBEEN EN ZOON) and perhaps occasianally something else. But you'll
certainly not come up with THE BILL COSBY SHOW, because the American way
of educating children is completely different from the Dutch. So I would
never choose that. People have told me in the past that they went to TV
companies to ask what kind of comedy they would be interested in, and the
answer was SAY AH. What they really wanted, of course, was a success like
SAY AH. But you will not find such a thing lying around waiting to be picked
up. You have to be able to create such a series yourself, if you want to be a
successful adapter of something from abroad.

PETER RÖMER

It's my job to foster Dutch television drama. A lot of the things I have in mind
will have to wait for a while until this wave of foreign formats has passed and
my boss will say: 'Well, if you've got something original in your drawer that's
any good, show it to me.' I have a number of promising projects, projects
that I find more promising than foreign models, because they're about our

SAG MAL AAH: *cast (German version)*

problems and way of life, and for that reason they're more authentic.

Everywere in the word people think it's funny to see someone slip on a banana peel. A sit-com however, has to appeal to the everyday experience of the viewer. It's very important that people can recognize themselves in comedy, even in SAY AH.

CHIEM VAN HOUWENINGE

But to my mind, 60 to 70 percent of scripts can be transposed to other countries and other languages. Of course you have to work with an art direction and a director from that other country. Specific puns of course can't be translated that easily. Recently there was a request from Munich, for a pilot of DOUBLE TROUBLE (OPPASSEN!!!) They asked me to send them three translated scripts. One of the scripts was called the CONDOM FOR WOMEN (HET VROUWENCONDOOM). We got it back with the comment that there are no condoms for women in Germany. So you cannot do that in Germany.

OPPASSEN: *cast (Dutch version)*

PETER RÖMER

There is a great difference in they way foreign comic series and domestic comic series are appreciated. In Germany for example, RTL-plus recently broadcast MARRIED WITH CHILDREN around six o'clock in the evening. It was the original American version which is an enormous success over there, one of the pillars of the channel. Two hours later they came up with the premiere of the German version, the German adaptation of MARRIED WITH CHILDREN, called HILFE MEINE FAMILIE PFEIFT, as a title itself already a hit. They had the same set, as is obligatory with American series, the same tune, the same opening sequence with a man feeding money to a dog. These people were desperately imitating the American actors. The programme was taken off almost immediately, because the viewers just would not accept it. They'll accept it subtitled, or dubbed, but as soon as it is carried over into their own situation and is not done well enough, then even a hit will be immediately rejected.

NICO KNAPPER

In this respect, we did an interesting experiment. We made an English version of the very first episode of DOUBLE TROUBLE as well as a Dutch version. Most of the English actors were excellent, and we were all very pleased with the result. There was nothing wrong with it, but we didn't sell it, probably because the

DOUBLE TROUBLE: *cast (English version)*

English eventually always think they can do these things better.

And perhaps they can. But the crazy thing is that I directed both episodes and I myself thought that the English version was more subtle, more sensitive. Ours was a bit coarser, if I dare say so, though in a Dutch way it was just as good. You have to be honest in these matters. The Dutch ambience is different from the English, and maybe in Germany you have to give it a bit more 'Spaß'.

CHIEM VAN HOUWENINGE

I went to London, after Nico and I had done the English version. Maybe the English actors also played more subtly than the Dutch. We had a lot of discussions, and one deadly remark was made: the English thought the two children were terrible. Whereas for us they were amusing.

NICO KNAPPER

It's only fair to say that we were not in a position to do the casting ourselves. We simply accepted what was offered to us, and in this respect, it was not too good. That's why I do not agree that an English format could not be succesful in The Netherlands. It just depends on all these small decisions that follow one from another, the casting, how to adapt it to the Dutch situation in a very

technical sense, and so on. That's where mistakes can be made, and these mistakes mostly determine why it isn't a success.

CHIEM VAN HOUWENINGE
I once participated in an English-language workshop. First we showed a subtitled episode of SAY AH and then an episode without subtitles. We then had a terrible discussion with which I shall not bore you. But every time I had the impression my jokes fell flat, the Americans thought they were probably typically European. I found this rather touching, since I understood well enough this was a polite way of saying that it wasn't much of joke. But the jokes I liked myself got really warm laughs. Of course, Peter is right. If you commit the error of buying the format of FAWLTY TOWERS and forget to take John Cleese under contract, you'll be caught with your pants down, you'll have nothing. I certainly believe we can laugh at English humour. Sometimes I think it's terribly funny and even if I translate it into Dutch it still can work wonderfully. I don't laugh at every joke in THE GOLDEN GIRLS and I certainly don't share the humour of every English joke. You always have to be careful in your choices. You can't take and adapt an English format just like that. If you take an English language format which contains nothing but one-liners, you're certainly in for trouble. You must transpose the situation, and you have to work and discuss it with English writers. And you yourself have be extremely creative. Only then, I think, could you get DOUBLE TROUBLE across to an audience in Germany or England.

Chiem van Houweninge

IX

LAUGHTER IN SITUATION COMEDY

Some Reflections on Three Sit-Coms by Chiem van Houweninge and Alexander Pola

CLARA OVERDUIN

IX.1 The Comic Mode: Introduction

Is comedy a genre with its own specific narrative structures?
This question can be approached from different angles. In his monograph
Genre Stephen Neale conceives comedy as an independent genre with indeed
inherent narrative structures.[1] Neale claims that in all genres the beginning
of a narrative contains a disruption at the expense of an equilibrium which
in turn causes clashes between various discourses in the 'text'.[2] Comedy is
different from other genres in that this disruption takes place in the discourses
themselves. In the following I will demonstrate that this occurs on a number
of levels.

Neale and Krutnik are less interested in specific properties contained
in the narrative structure of comedy but instead focus on those elements
most frequently present in comedy in its many guises.[3] Authors such as Terry
Lovell and Jerry Palmer take this even further.[4] They claim that comedy is not
a genre at all and that it therefore possesses no inherent structure. Lovell
proposes to speak of a story 'in the comic mode'[5] and Palmer is concerned
with what he calls the smallest element of comedy, the jokes.[6] He investigates
how jokes function and to him this explains the success or failure of comedy.
The relevant starting point in Palmer's theory is 'comic surprise'. Palmer
describes how this causes laughter in the audience. Firstly, a specific expectation
will be raised for the audience. This expectation will be disappointed in a later
phase, whereby comic surprise is created. Previously obtained knowledge
lets the audience arrive at the conclusion that events are both plausible and
implausible. According to Palmer plausibility and implausibility must balance

each other, otherwise jokes will not work. Without this balance, jokes will fail to be funny.[7]

The intention of this article is not to discuss which jokes do or don't work, but instead to investigate (with the help of Palmer's concepts) the narrative structures of a number of sit-coms written by Chiem van Houweninge and Alexander Pola. Before embarking on this task, I propose to examine the theoretical framework within which sit-coms are located. As already stated, the primary cause of laughter is the disappointment of expectations which are, however, not raised exclusively by the narrative. The scriptwriter also knows how to rely on the audience's knowledge located, as it were, off-screen. If a character acts differently than is expected of him, her, then this may induce laughter. These expectations have to do with social interaction, the knowledge of general norms and values in society, the knowledge of how people ought to behave properly in certain situations, etc. In addition, a scriptwriter makes use of the knowledge which audiences have about the codes of a specific genre. This is the raison d'être for programmes which turn the sit-com's conventions upside down.

Furthermore, language itself offers a wide range of possible jokes. Ambigious remarks create slightly different meanings without sacrificing recognition of the original. Finally, the narrative is told in such a way that the audience receives information which is contradicted at a later point. Comic surprise thus occurs on several levels: on the level of language and code in relation to the social reality of the audience, and on the level of content in relation to the plot.

IX.2 **Narrative Development in Comedy**

The happy ending, according to Neale and Krutnik, is a second characteristic of comedy which is of consequence to the narrative structure. Although this feature does not exclusively belong to comedy – one only has to think of classical Hollywood film, for instance – Neale and Krutnik nevertheless consider it characteristic of comedy.[8] The very definition of sit-com demands a happy ending: at the start of a short narrative the equilibrium is disturbed; at the end it is once again restored. I should add here that it is not required for the happy end to occur in the episode itself. Deferred happy

endings occur frequently. The narrative structure of FAWLTY TOWERS, for instance, illustrates this point. Each episode ends in a disaster for Basil Fawlty. Over the course of an episode, chaos has inevitably increased and everything has turned against him. At the end, there is not the slightest evidence of restored order and it is only in the following episode that calmness is seen to have prevailed. Consequently, the audience does not witness the process of 'regulating' the situation.

Neale and Krutnik seem to imply here a similarity between the structure of the sit-com and classic narrative structure.[9] In the latter a given situation will normally be disrupted and towards the end a new situation will have developed. The characters usually have undergone a learning process or have experienced an event which changed their lives. In sit-coms, per definition individuals learn very little from their mistakes and will be tripped up by the same obstacle time and time again. Their approach to a problem never varies and the events of a previous episode will already be forgotten by the next episode. Only the present time exists. According to Mick Eaton only slight variations are needed for the sake of dramatic realism.

On the other hand, individuals must learn something from the past even if the episodes form closed units.[10] In each instalment, a number of characters appear which are more or less stereotyped. Their attributes and a range of reactions are soon well-known to and recognized by the audience. Medhurst and Tuck see this as a consequence of time restrictions: sit-com scriptwriters have at their disposal only 30 or 40 minutes, a limit which hardly allows the authors to build up a character extensively.[11]

IX.3 **The Basic Situation**

The above outlines much of what is typical about sit-coms: the existence of a basic situation. The latter is made up of the characters themselves, their way of acting and their reactions towards events. Another point of interest is the individuals' living arrangements. The objective is to negotiate these and get along with other group members. In most (sit-com) cases, the framework is a family or work situation.[12]

The interaction and mutual relations between characters are at the centre of each episode. Both influence each other and keep each other in

check.[13] Furthermore, all situations are set in limited locations. The style of narrative demands this, moreover, and producers are thus able to use the same decor year after year while audiences appreciate the recognition factor.

IX.4 ## Comedy of Social Disruption

The function of chance is the third point of interest in the debate. According to Neale and Krutnik there is a lot of room in comedy for chance, luck, fate or the intervention of supernatural powers.[14] However much that may be the case, though, chance events must nevertheless be properly motivated. If events seem overly accidental, then, according to Palmer, the audience will not laugh because it is too implausible.

Lovell discusses in further detail the cause and effect relationship (and therefore the logic of motivations).[15] She makes a differentiation between non-realist and realist comedies of social disruption. In realist comedy of social disruption there are causal connections. In the non-realist comedy of social disruption there is more room for chance and 'Murphy's law' ('anything that can happen, will happen'). Although no improbable events occur, there is nevertheless room for the exceptional. In realist comedy of social disruption, laughter is created in a much more natural manner. Characters are often funny in spite of themselves. They do not try consciously to be funny, but they seem to be so naturally.

Realism in realist comedy of social disruption makes distinct references to the audience's reality. The audience compares the truth as it is presented in the narrative with the truth as it exists in everyday reality. This can happen on two levels: the normative order (how things ought to happen according to most people) and the typical order (how things really happen). Laughter is often created, according to Lovell, because the normative and the typical are set in contrast to each other. A lot of sit-coms are hybrids and feature characteristics of realist as well as non-realist comedy of social disruption.

In contrast to comedy of social disruption there is comedy of formal disruption.[16] In this form of comedy comic surprise is created mostly on the level of language or the code.

Three Comedy Series by Chiem van Houweninge and Alexander Pola

This brief introduction of the narrative structure of comedy in general and of sit-coms in particular enables me now to investigate three comedy series which were written by Chiem van Houweninge and Alexander Pola between 1975 and 1993. Before analysing these three series I will introduce them briefly.

EACH TO EACH (IEDER ZIJN DEEL) consists of 24 episodes and ran for three seasons between 1975 and 1978. A large house is shared by father Willem, mother Gaby, their son Hubert and daugher-in-law Bea. The father who used to own a factory making shoe polish has bid farewell to luxury and worldly goods to dedicate himself to living a simple and creative life: he has become a sculptor. Daughter-in-law Bea employs a housekeeper, Truus who in turn is married to Rinus, the postman who regularly delivers the mail.

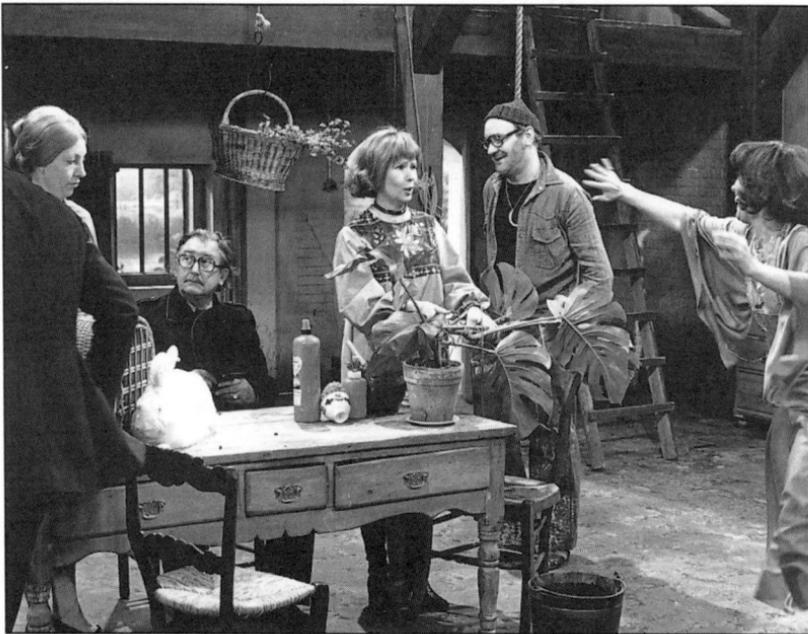

EACH TO EACH (IEDER ZIJN DEEL)

CASSATA

CASSATA consists of eight episodes and ran in the 1979-80 season. In this series we are introduced to an Italian immigrant family by the name of Paparo. The father, Guiseppe, is the owner of an ice cream shop and the mother, Lisa, manages an antique shop. Daughter Marina is a student.

SAY AH (ZEG 'NS AAA) consists of 212 episodes and has been shown during 12 seasons (1981-1993). It is the longest running sit-coms on Dutch television. General practitioner Lydie van der Ploeg is a widow. In the first instalment we also meet her future partner: surgeon Hans Lansberg. Lydie has two children: Gert-Jan and Nancy. In the course of the episodes her daughter Nancy moves to Africa and after some time, it so happens that her niece Wiep comes to live with her. Furthermore, there is Mrs Dobbelsteen who looks after

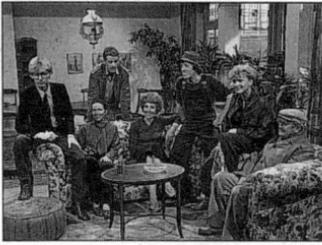

1980 1980

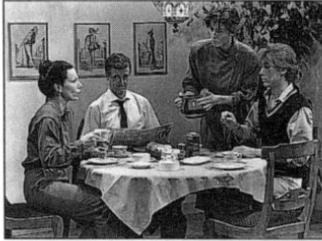

1983 1986

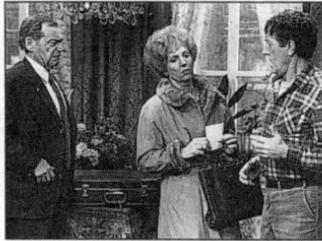

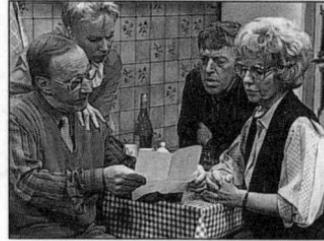

1986 1987

1989 1990

SAY AH *from its early development to 1990*

the house and is married to Koos. The audience is witness to her constant quarrels with Koos.

IX.6 **Narrative Structures**

Apart from investigating the three series and their formal similarities I should also like to highlight their narrative structure in relation to the narrative structure of comedies *sui generis* into which context the structure of sit-coms belong. My analysis, as far as it discusses narrative structures, is based on the published scripts of the comedies chosen.[17] I have not included information from the screened episodes, partly on the assumption that transmission, while obviously crucial in every other respect, did not alter the narrative structure to a significant degree.

In EACH TO EACH the audience is witness to the basic situation, in which to a certain extent two households are forced to be dependent on each other. The son is the father's 'dependent' in that everything he has achieved in life thus far was made possible through his father. He therefore puts up with his father's irritating habits, unlike his wife who is often at her wit's end. Indeed, both father and mother give their children a lot of reason for grief. The origin of all this irritation lies in the father's inconsequential behaviour. While he has forsaken all luxuries – theoretically at least – practically speaking he cannot do without them. For instance, while he does not want to have a telephone number nor a telephone, he is nevertheless constantly in need of one. So he makes regular use of his son's telephone.

No matter how much irritation Father causes for his children, to the audience he comes across as a very funny character. While giving the impression that he is not interested in financial matters nor cares for luxurious items, he always acts to the contrary. This makes the audience laugh. The first piece of information contradicts the second. On the other hand, the father's behaviour is quite understandable. I suspect that the audience probably compares the father's behaviour to what they themselves would have done. One telling example is his reaction to being sent his tax assessment. Before he opens the envelope he grandly announces that taxes must be paid and that it is only right that some have to pay more than others. But as soon as he looks at his tax bill, his mood changes and he is furious. A very recognizable

situation for the average viewer. Tax has to be paid, to be sure, but who would not rather it was his neighbour that pays the biggest share?

It becomes evident from this example that the level from which the laughter comes is not always clearly indicated. The scriptwriters here set a first bit of information (no more luxuries) against a second contradictory one (using the phone). This, in turn, is set against the background of the viewer's own reality. The latter's experience will indeed provide the necessary information to support the probability of the joke. It goes without saying that this reality is not the same for every viewer.

It is clear that the writers make use here of both the audience's knowledge of their own reality as well as their knowledge of the father, acquired in the course of the series. If we look at the structure of the series it becomes evident that this combination often occurs. Usually comic surprise is created when an expectation, raised at an earlier stage, is disappointed. The disillusionment happens on the level of content and social reality and is primarily used to sketch the atmosphere. I am reminded of the episode where father and mother took their love of nature a little too far. They looked after a philodendron plant as if it were a person. Not only did they talk to the plant, they also exposed it to special music. This attitude in itself would not normally cause continuous laughter in the audience but it was the very breeding ground for sarcastic comments and insightful observations by other characters.

In EACH TO EACH there exists a third family, Truus and her husband Rinus. The relationship between the couple and the Van Dierens is business-like. Although both appear regularly and always play a role in the events, the audience never learns much of their lives outside the Van Dieren household. Their actions and experiences function to support the events in the Van Dieren home rather than convey information about their own living arrangements. They remain anonymous.

Similarly, in the two other series, Van Houweninge and Pola create couples with an existence outside the primary household, but with whom there exists a work or business relationship. In CASSATA, Mien and Kees, the flower shop owners, hold that position. Guiseppe Paparo, an Italian macho type, sports very old-fashioned ideas regarding the proper place of a woman. He feels short-changed ever since his wife began running her own affairs. Neither wife nor daughter accept his rules. At home, he always gets the worst of it. It is only with Kees and Mien, who come to drink a cup of coffee every

day in his cafe, that he can air his grievances. They function as a kind of road-side emergency telephone. Just as in EACH TO EACH we learn nothing else of this couple or their own environment. Their conversations function primarily as support for Guiseppe's 'story'.

In SAY AH the couple who work for the family barely have a 'life' of their own. Dr Lydie van der Ploeg's household is always being chased about by housekeeper Mien Dobbelsteen. She feels connected to 'her' family and spends a lot of time there, but she also has her own life. The events in the Dobbelsteen family often form a side story which sometimes crosses over into the main plot, but more often develops a life of its own and becomes the main plot. In comparison to other series, SAY AH devotes much time to the children's adventures. In EACH TO EACH and CASSATA the events happen due to the individuals' personality traits. Since there are only a few characters, everyone is defined as a main character. In SAY AH all members of the sit-com family play a main role. The writers have worked out a variety of possible relationships between the characters. A range of subjects and problems is thus created providing ample material for ten years of TV shows.

The basic situation in SAY AH is the most extensive one, while at the same time, it leaves room for development. The children still live at home at the beginning of the series and in the course of the series go their own ways. The oldest son has a partner and a child and finally goes through a divorce. These events provide developments which were previously not part of the basic situation. The remaining relations stay quite stable.

IX.7 **From Chance to Realism**

In the three series discussed here a shift has occured in the realistic character of the narrative structure. Whereas in EACH TO EACH and CASSATA cause and effect were determined to a degree by Murphy's Law, in SAY AH there is a greater sense of probability. The first two series could – in Lovell's terms – be called non-realist comedies of social disruption and the latter a realist comedy of social disruption. This is not derived from the plot structure alone but also from the typecasting of the characters.

Over the course of the years, the plots have become increasingly coherent. In EACH TO EACH as well as in CASSATA the narratives changed to

straightforward main storylines, sometimes combined with a side plot, and episodes which consisted of amusing sequences of events, all of which were connected to each other through the characters and situations. It is only in SAY AH, however, that there exists a solid structure, and clearly distinguishable story lines are properly developed and brought full circle. In most cases, this happens at the end of each episode.

Although not every episode necessarily ends happily, partly because developments are not always advantageous for the characters, laughter nevertheless prevails. The situation thus appears much less serious and a happy atmosphere is maintained. Furthermore, bad luck does not hit the same person time and again. Instead, just as in real life, it could be any-one's turn. Problems are never insurmountable and a quiet word spoken in a friendly manner always restores order. This is a general characteristic of all of Van Houweninge and Pola's sit-coms. There is always humour and a wink and a nod in someone's eye. This does not mean, however, that there is not some-body who always gets the short end of the stick. I am referring to Guiseppe Paparo who is forever in combat with his daughter and his wife. She usually sides with the daughter whereby his old-fashioned values and authority are undermined. If he finds his daughter's dress vulgar, then his wife will judge it to be beautiful. Since his family constantly undermine his authority, he becomes the butt of many jokes. In one episode, for example, he is very shocked by the fact that his daughter's boyfriend has slept over. He expresses his displeasure but gets no sympathy from anybody. Only Mien can under-stand his position and spends time listening to him. This makes matters worse, since Guiseppe now appears to be having an affair with another woman.

In building up the character of Guiseppe, the writers rely primarily on contradictory expectations generated at the level of content and plot. These are the main sources of comic surprise for the audience. Again and again, the 'typical' is set against the normative and the result is laughter. It happens, for instance, when father and mother express their disagreement over matters of upbringing. According to the rules of normative order parents ought to be in agreement, but it is very typical indeed that this is not the case.

One consequence of placing a strong main character at the centre of attention results in Guiseppe's being more stereotyped than other characters. In general, Van Houweninge and Pola make use of stereotypes but characters are never limited to being stereotypes. The comic categories which

scholars have catalogued, where the social status of characters determines their characteristics: the doctor, the policeman, etc, do not occur in the three series under consideration. The characters have a number of recurring characteristics, but are also given a full personality, and therefore never become real stereotypes. But Guiseppe is an exception. Although he sometimes displays aspects of other personalities, he mostly fits the stereotype of the Italian. He has an ice-cream parlour (Italians always sell ice-cream or run a pizzeria) and considers his wife his property. Because Guiseppe's opinions are never affirmed, an implicit commentary about Guiseppe's attitude is given here. For Dutch viewers this is nevertheless done in a 'safe' manner. Do only Italians think like this? Although the two script writers criticise the rather old-fashioned morals of Guiseppe very indirectly, this critique remains somewhat hidden to the unsuspecting viewers.

This is characteristic for all three sit-coms. Without moralizing, EACH TO EACH declares rather slyly that a back-to-nature philosophy sounds great in theory, but is difficult to put into practice by people used to modern-day conveniences. In EACH TO EACH the message is packaged in an exaggerated love for nature and shamelessly inconsequential behaviour. In this way too, a mirror is held up to the audience, but the audience looks into a closed world in which they take no part.

As far as social consciousness is concerned, SAY AH qualifies emminently. No single subject is left untouched and each character has his or her own way of reacting. The role of Mien Dobbelsteen is especially interesting in this context. In the van der Ploeg household, which is her place of work, she often represents the more conservative point of view. At home she turns into a progressive person. She tells everything she has just heard at the van Ploeg's to Koos, her husband, who on these occasions often takes the more conservative position of the two.

IX.8 Conclusion

The shift from non-realist to realist comedy of social disruption shows itself in greater concern for plausibility on the level of narrative structure. The later series leave less room for chance, while the characters, although stereotyped by a number of characteristics, show increasingly more

individuality. The basic situations of these series do not fit easily into a pattern, since the series work with a greater range of looser relations.

The shift towards comedies of social disruption also shows itself in the content of the series. The link with contemporary social reality is especially clear in the last series I have looked at, SAY AH. Moving from the workings of 'Murphy's law' to a greater narrative coherence is parallelled by a growth in social concerns, apparent in the many themes of larger political and cultural concern that are treated directly or indirectly. A 'policy of humour' is often used to make indirect comments or even criticisms on broadly held opinions in society, by making the characters' behaviour or the consequences of their behaviour contradict their explicitly expressed point of views. The normative and the typical are thus comically contrasted with each other. In this 'policy of humour' the background knowledge and attitudes of the viewer are adressed, with the effect that the viewer's laughter is always indirectly also laughter at the spectator him or herself. Although of course in the many jokes, allusions, puns, and word games, humour is also created on a formal level, the series by Chiem van Houweninge and Alexander Pola do not engage themselves primarily in a play with the 'codes'. More and more they look for the comic in the normal, everyday lives of not so exceptional, 'real' or at least plausible characters, who live normal lives familiar to the viewer. Van Houweninge's and Pola's 'policy of humour' consists of pointing to the contradictions in everyday life, to 'make 'em laugh' about themselves. Calmly taking a distance from one's convictions and attitudes, isn't this what real humanist art aims at?

Notes

1 Neale, S., *Genre,* London: BFI, 1980, p. 20 ff.
2 *Ibid.,* p. 2.
3 Neale, S. & Krutnik, F., *Popular Film and Television Comedy,* London & New York, 1990, p. 2.
4 Lovell, T. 'A Genre of Social Disruption?', in: J. Cook (ed.), *Television Sit-com,* London: BFI, 1982. Palmer, J, *The Logic of the Absurd,* London: BFI, 1987.
5 Lovell, p. 21.

6 Palmer, p. 30.
7 Palmer, pp. 43, 44.
8 Neale, S. & Krutnik, F., pp. 25-31.
9 *Ibid.*, p. 235.
10 Eaton, M., 'Television Situation Comedy', in: Tony Bennet (ed.),
 Popular Television and Film, London: BFI, 1981, p. 33.
11 Medhurst, A. & Tuck, L., 'The Gender Game', in: J. Cook (ed.),
 Television Sit-com, London: BFI, 1982, p. 43.
12 Eaton, M., p. 37.
13 Swanson, G., 'Law and Disorder', in: J. Cook (ed.), *Television Sit-com*,
 London: BFI, 1982, p. 35.
14 Neale, S. & Krutnik, p. 31.
15 See Lovell, p. 20 ff.
16 Lovell, p. 20.
17 I decided to base the analysis on the published scripts, since the series as
 broadcast were not available to me.

Chiem van Houweninge

x

SAY AH

Some Remarks on Comic Identity

MARJA TUTERT[1]

X.1 Introduction

Why do people laugh? How does laughter get going and how is it sustained? Are there certain mechanisms that need to be present, and if so, in what combination do they produce comic effects? These are some of the questions I asked myself when trying to define the identity of a quintessentially comic television genre: the situation comedy. I started by looking up what had been written about 'comedy' and 'humour' in general, and about sit-coms in particular, before going on to apply my findings to an individual case, that of Dutch television's longest-running sit-com, SAY AH (ZEG 'NS AAA).

X.2 Comedy, Humour, Situation Comedy

Comedy

Many writers on comedy in the theatre not only point out the Greek origins of the word *koomooidia*, a contraction of *koomos* (parade) and *ooidè* (song), but also stress that what makes a play a comedy is its social character, which is to say that the action highlights human nature and social life. But this does not tell us very much, since tragedy, too, deals with human nature and the life of the community. In the final analysis, therefore, we may have to look for the crucial difference elsewhere; precisely, in the effect aimed at: laughter.

The question, then, is whether laughter is, so to speak, built into the structure of a play, or rather, happens between the staging of a play and the way it is received. It soon turns out that plot structures in themselves are not comic. Instead, it is the way the plot is worked out in a specific instance

which gives rise to laughter. Writers therefore often talk about a 'climate of comedy', meaning an ambiance or a setting which, as it were, signals to the audience that what is about to happen may be appreciated as comic. More generally, a comedy plot follows the model that once a problem is posed, a solution will be found, which – at least in the theatre – will almost always ensure a happy ending.

Humour

To forestall any misunderstanding, it is necessary to differentiate between comedy and humour. Strictly speaking, only that which is intentionally funny can be called comic, while humour is a quality which viewers attribute to an object or an event, even where no comic effect is implied or intended.

How does one discover whether something is funny or humorous? Can one speak of discovery at all? Most people do not know why they laugh, which is where different theories try to bring some enlightenment. Cognitive approaches to the issue have always been in search of the mental processes that enable us to recognize and evaluate humour, and since the 18th century, the discussion has regularly turned to two concepts which seem to name the same phenomenon and are nonetheless different: 'incongruity' and 'surprise'. Recent studies, too, have built on the notion of 'incongruity'. Nerhardt, for instance, regards humour as the result of the discrepancy between two mental representations, one of which is the expectation, and the other the perception which varies from that expectation. The bigger the surprise element in the difference between expectation and perception, the funnier the joke, that is, the experience of the 'humour-stimulus'.[2]

This has led cognitive psychologists, among them Jones, Schultz and Suls, to formulate the 'incongruity-resolution-theory' which they developed independently from each other. The theory states that 'humor results when the perceiver meets an incongruity (usually in the form of a punch line or a cartoon drawing) and is then motivated to resolve the incongruity either by retrieving the information from the joke or cartoon, or from his/her own stock of information. According to this account, humour results when the incongruity is resolved; that is, the punch line is seen at some level to make sense of the earlier information in the joke'.[3]

Given my earlier premise that humour is a quality which a subject

attributes to an object (nothing is funny in itself, but is perceived as funny), the resolution must be experienced as something which qualifies as a 'solution' (to a problem). Freud had already shown that one needs to get 'surplus value' from a joke in order to laugh at it. For the possibility exists that one recognizes the incongruity but does not laugh at the joke. One may realize that something is meant to be funny, and even to be able to identify the joke element and still not experience it as funny. In other words, for something to be experienced as funny, something needs to 'click', whereupon laughter follows. Laughter signifies that the joke has not only been recognized but also valued (for its humour). Thus, I would argue, when a joke is experienced as a joke, it is because the 'resolution' marks the 'incongruity' as merely apparent, providing a context in which the solution can be seen as 'logical' in some sense.

Jerry Palmer's theory of humour enters more deeply into what exactly happens when a joke 'clicks'. He first draws on the comparison between a metaphor and a joke. Every metaphor and every joke, whether verbal or visual, has two stages: the preparatory stage and the culmination stage. The first one he calls peripetia, or surprise; for the second he uses the term syllogism, or closure. In the preparatory stage of a joke or metaphor an expectation is created which in the second stage is countermanded or denied: this produces peripetia. Two kinds of peripetia can be distinguished: plausible and implausible.[4] However, faced with a metaphor, no one bursts into laughter, whereas with a joke, one does. It would appear that something like an 'emotional dispensation' exists which sees to it that, on certain occasions, one knows when not to take things too seriously. According to Palmer, the change in modality and register has to do with the relation between plausibility and implausibility. In the case of humour, the balance tips towards implausibility, though not all the way – for then one would be dealing with pure nonsense –, but rather, somewhat beyond the halfway mark.[5] If metaphors tend towards plausibility, then in a joke, it is the implausibility which dominates.

For Palmer, implausibility is the criterion for triggering laughter, but this is difficult to square with the incongruity-resolution-model, which posits that for laughter to occur a logical solution must be offered within a given context. Palmer stops at the point of incongruity. But it seems to me that incongruity can be equated with Palmer's implausibility and resolution

with his plausibility. Once one adds the term 'expectation', to characterize the climate necessary for the viewer to attribute humour to a state of affairs in the first place, then one arrives at the following model:

EXPECTATIONS - INCONGRUITY - RESOLUTION

In this model, the viewer who thinks something funny at first experiences incongruity/surprise/contrast (ie. a large amount of implausibility), and subsequently arrives at a satisfying, which is to say, logical resolution (plausibility is re-established). What, then, happens when the viewer thinks a joke falls flat? The expectation previously established is not fulfilled; no surprise/incongruity/contrast is generated, so that the resolution is not experienced as a logical solution. This can take several forms:

EXPECTATION – INCONGRUITY – RESOLUTION [JOKE 'WORKS']

EXPECTATION – INCONGRUITY – NO RESOLUTION [TOO IMPLAUSIBLE]

EXPECTATION – NO INCONGRUITY – NO RESOLUTION [TOO PLAUSIBLE]

What is important, therefore, is the simultaneous presence of implausibility *and* plausibility. However implausible something may strike one, there nonetheless has to be a level of plausibility in the implausibility, as it were, if one wants to 'follow' the story. And conversely, however plausible something is, there has to be a suggestion of implausibility in the plausibility: can there be anyone in reality who cracks as many jokes as a character in a situation comedy and to whom so many funny things happen each week?

Situation Comedy

This brings us to sit-coms. What are their typical features? The most obvious one is the *repetition-with-variation-principle*. This means that in each episode characters recur, as do the kinds of personal conflicts they have with each other; likewise, the locations repeat themselves, while the plots and subjects vary. Although the name stresses 'situation', the characters and their reactions are in fact the main source of the humour, while the situations only supply the necessary conditions which allows them to be as funny as possible.

Essential elements of each comedy figure are in my opinion both the stereo-
type which refers to role and function, as well as the uniquely different which
refers to the character and the individual.

There has been, over the years, a shift towards an ever more
solid narrative structure and realism, both regarding the situations and the
characters. However, the fact that sit-coms have become more realistic does
not preclude differences of styles among them. Terry Lovell, for instance,
distinguishes social-realist sit-coms, non-realistic sit-coms, and the 'mixed
type'. The social-realist genre refers to an externally existing world, and on
two levels: first, in the normative sense (referring to how it ought to be) and
in the sense of the typical social order (referring to how it is, and has always
been). The characters, too, have to represent common modes of behaviour
and naturalism. The comedy is wrapped up in the social-realist framework,
which is to say, characters do not have comic intentions or desires and
instead, comedy inheres in the 'human condition'.[6] Laughter arises,
according to Lovell, from the discrepancy between the ideal and the real:
'The emphasis remains on the told – a story of believable characters in
recognizable situations behaving in ways that are at the same time absurd
and characteristic'.[7]

Non-realistic sit-coms are constructed according to the principle of
cause and effect, with the emphasis falling on the exceptional rather than the
usual. It is not the degree of probability that stands at the centre but what
might be possible: 'The comedy is generated by surprise connections and
developments, and also by failures to connect.'[8] The third type of situation
comedy, a mixture of the other two is, according to Lovell, the most common
form on television: naturalistic, but non-realist.

With these distinctions in mind, where does SAY AH locate itself?
First of all, a brief reminder: SAY AH was first broadcast on Dutch television in
1980. Altogether, 212 episodes were recorded. The series lasted for more
than twelve seasons until 1993 and enjoyed considerable commercial success
as well as popular appeal. SAY AH is a typical family or domestic sit-com, which
draws on plausible and common situations within the family circle. As is often
the case in series of this kind, each episode of SAY AH features the same
characters, in the same relationships to each other, in situations which have
recognisable similarities to previous episodes. There are, however, also some
tendencies towards character and location development; some of the events

spanned the boundaries of individual episodes, and the characters were able to grow in the run of the series. This combination of the series form and the serial format is a trend also noticeable in US TV sit-coms like CHEERS and THE COSBY SHOW.

x.3 Narrative Structures of SAY AH

The Outlines of SAY AH

At the centre of each episode of SAY AH were the characters of Lydie van der Ploeg (Sjoukje Hooymaayer) – a GP –, her husband Hans Lansberg (Manfred de Graaf) – a surgeon –, their children and other relatives, and their housekeeper Mien Dobbelsteen (Carry Tefsen), her husband Koos (John Leddy), his friend Jopie (Herman Kortekaas) – the owner of a video-rental business – and his partner Annie, the sister of Mien Dobbelsteen. The mix of characters allowed for different combinations, both in the domestic/private and in the work/public sphere. Thus, family situations in the Lydie van der Ploeg/ Hans Lansberg household involved Lydie and Hans, their children, their niece Wiep (Kiki Claassen) – who lived with them for a time, as well as her boyfriend John (Kenneth Herdigein), along with the family doctor with whom Lydie is sharing her practice at home. Mien occasionally functioned as a source of family problems in the Lydie/Hans family circle as did several guests who at times mingled in the household, for example, Lydie's sister Canci and her Italian boyfriend, who temporarily stayed with the family.

The Dobbelsteen household, too, gave rise to its own family scenes, with Mien and Koos, Annie and Jopie and their – eventually deceased – father as the protagonists.

Work situations were centred around the three doctors and their patients, and the relationships between Lydie, Hans and John. Furthermore, work situations between Mien and Lydie as Mien's employer, between Koos and Lydie, Jopie and Koos and sometimes between Koos and his other employers often provided background for developments in the episodes. The emphasis was usually on one or more of the characters, which varied from episode to episode, although Mien and Lydie (and most of the time also Koos and Hans) were always the most important characters.

Relationships

In the series the relationships between Lydie, Hans, Mien and Koos formed the permanent background for the developments in the episodes. Lydie and Hans were married. She had a part-time job as a family doctor, while he was a surgeon with a full-time job. In their relationship love and friendship were more important than their professional occupations, special value being placed on honesty and openness. When Lydie had problems, in the private or working sphere, she would often ask Hans for help. The opposite case, with Hans asking Lydie for help, hardly ever happened. Socially, the two behaved like members of the upper middle class.

Koos and Mien were also married, with their relation based on fairness, although they quarrelled more often than did Lydie and Hans. In most cases, these quarrels centred on Jopie, Koos' friend, whom Mien did not like. Private and work matters were given equal importance as subjects of conversation between husband and wife. They lived on a relatively small income and belonged to the lower middle class. Koos thought that he was the one who made the decisions at home, but most of the time Mien got her way.

Lydie and Mien acted very friendly towards each other, but they were not friends. Their relationship was based on a regular employer-employee situation. They were not on familiar terms with one another. Lydie was called 'doctor' by Mien, and Mien was addressed as 'Mrs Dobbelsteen' by Lydie.

Lydie treated Koos, as husband of her housekeeper, politely but with a certain distance. In contrast to Mien, Koos was called by his first name by Lydie. Most of the time the contacts between Lydie and Koos were brought about by Mien's altruistic intentions; through her he had, not always with his approval, all kinds of odd-jobs thrust upon him. Mien addressed herself more to Lydie than to Hans, since Lydie was already Mien's employer when Hans came to live with Lydie.

Koos and Hans occasionally went out together, for example, to go fishing. Only the hobbies of the men were mentioned, not those of the women. Hans called Koos by his first name, but not the other way around. Their relationship was friendly, but also showed a certain detachment. In general, the relationship between the two couples was mainly determined by their employer-employee roles.

Individuals

The individual traits of the major characters of the series also constituted a constant framework for the series. Lydie van der Ploeg was characterised as an intelligent, more or less independent woman at middle age. She was impulsive, enthusiastic and more emotional than objective in her responses. Her distinguishing recurrent trait was her forgetfulness. Her husband Hans Lansberg was, in contrast to Lydie, a very rational person. His traits were control, reasonableness, decency and calmness. Typical of him were his (in his opinion, subtle) jokes.

Mien Dobbelsteen liked to talk, and did so a lot, often out of turn. She called a spade a spade, was short-tempered, emotional in her reactions and busy in her movements. She had a strong altruistic streak. Her recurrent character trait was her aversion to Jopie. Koos was depicted as ordinary and solid, characterised by the usual cliches: he loved his beer, liked to go fishing and cycle-racing. Most of the time he was good-tempered and good-natured, which sometimes resulted in his being too trusting and gullible. Repeatedly he was frustrated in his schemes (as in episode 144).

In SAY AH the characters were mainly constructed out of individual traits. Although there was a certain amount of stereotyping, Hans, Lydie, Mien and Koos were not outstanding prototypes of surgeon, family doctor, housekeeper and handyman. In fact, the comic effects of the series were to a certain extent based on the discrepancy between the roles the characters assume and their inability to perform them as expected.

Structures

The structure of the plot consisted of several lines of conflict, on the level of the series as a whole, and on the level of the separate episodes. Each episode in the series focused on a particular set of problems, most of which were solved at the end. The more fundamental conflicts, however, were never truly solved, and were always present in the background, to reappear in the next episode as fresh, concrete problems. The persistent conflicts were, among others, Mien's dislike of Jopie, the troubles between John and Wiep, and Lydie's forgetfulness in contrast with Hans' tidiness. The solution to the problems in one episode of the series were invariably superficial, concrete problems being solved for the time being, the better to keep the underlying conflicts going. In other words: the situation was not

liable to fundamentally change, but was frequently subject to processes of destabilization and restabilization.

Private Sphere and Workplace as Settings

The settings of SAY AH were readily recognisable, based as they were on the division of private sphere and work place. Recurring locations in the Hans and Lydie household were the living room, the kitchen, and the bedroom of Hans and Lydie (all of which were also work-places for Mien). Other locations were Wiep's room (former room of son Gert-Jan), the consulting and waiting room of Lydie and John, and Hans' consulting room in the hospital.

In Koos' and Mien's home there were also some rooms to which the action returned more often than to others: the kitchen, the living room and the bedroom, and, for Jopie, the video-rental shop. Sometimes the place of action was the street in front of the doctors' or the Dobbelsteen's house. In the first years of the series, only interior settings were used. The change of location was never introduced by adding shots of the fronts of the respective houses.

X.4 SAY AH and Social Realism

The type of sit-com represented by SAY AH clearly belongs to the social-realist genre, and its jokes never transgress the borders of the possible and plausible. The comic conflict arises out of the clash between the 'ideal' and the 'real'. For instance, in episode 144, Koos and Mien buy a boat. While Koos tries to get round the 10% commission he owes Jopie, Mien wants to launch the boat 'in style'... alas, in reality, things work out rather differently. Thus quite generally in SAY AH, it is not the situations that are comic, but the characters' reaction to them. The audience is left with the impression that similar situations and jokes could occur in their own domestic lives. The normality and verisimilitude of the characters are the centrepiece of the action. The jokes are based on daily problems and inconveniences that are very recognisable to the audience. In fact, recognisability is the main feature of the series. The creation of a plausible microcosm, based on common sense notions, with very developed but also stereotyped characters is one of the strengths of SAY AH.

X.5 Categories of Laughter

In order to determine the comic identity of the series more closely we need to look at the comic effect in relation to character, situation and structure. The comic effect can be further analyzed by studying the moments of laughter in the studio audience. SAY AH was always recorded in front of a live audience, so that the laugh track gives at least some empirical grounds on which to judge the effects and the efficacy of jokes and comic moments. For this, I shall make use of the categories of joke reactions elaborated by Hans van den Bergh in his 1972 study.[9] Based on the laugh reactions of an audience watching a theatre comedy, he isolated seven types of processes or categories among jokes. In principle, one category of jokes should correspond to each laugh reaction and it ought to be possible to determine what kinds of jokes the writers of SAY AH most commonly utilized. Here, then, briefly are Van den Bergh's categories:

The first is *indirect confirmation* whereby the writer confirms the moral value system of the audience by staging an assault on this value system in the play. The characters embody divergence from the norm, sometimes by showing how they fail to uphold their own ideal self-image.

The second is *breaking a taboo*. The audience laughs when subjects are alluded to on stage which (in ordinary life) belong to the sphere of the forbidden. Van den Bergh distinguishes five kinds of taboo; apart from sexual taboos, he mentions religious commandments, social codes, conventions of etiquette, and transgression of artistic forms.

The third category is *mechanisation*, which is a process of repetition, a well-established technical means in comedy which however, also has implications of content. The effect can be explained because of the automatisation of the characters' behaviour. The actor behaves as if he were a robot, either through deviant predisposition or the circumstances.

The fourth is *recognition*. Laughter is provoked by referring to the world outside. Familiarity with a situation or an utterance can be brought about by many different means: topical references, generally known names, commonplaces, easily identifiable emotions, clichés, put-downs, etc.

The fifth Van den Bergh's category is *contrast* (in the narrow sense). He is referring to the clash between contrasting elements present within the play, whereby the comic effect may be achieved via irony (contrast between

what characters say and what they intend), comparisons, misunderstandings, word play, puns, or by introducing a term which does not fit the situation (the 'context-contrast' category).

The sixth is *anticipated pleasure*, and the seventh *pay-off*. However, it seems to me that these more properly belong to category four, since they are variants of recognition.

In principle, each category can produce laughter by itself, but it is also possible that a laughter reaction is the result of several types being simultaneously present.

Bearing in mind Van den Bergh's categories, I approached the question of what kind of comic identity SAY AH represents by conducting an analysis (covering several episodes) in which matters of content with reference to the comic climate (character, situation, structure) were considered, and where I tabulated the comic effect, broken down according to intensity (how many moments of laughter), dosage (the distribution of the jokes), and category (according to Van den Bergh's typology). The results may give some indication of how my initial question could be answered.

x.6 Comic Effects of SAY AH

Quantitative Comic Effects of SAY AH

The number of comic moments differ from episode to episode. Thus, in episode 144 I counted 26 comic moments. However, the average number in each episode is closer to 43, which indicates a certain exceptional status for episode 144. In two of the SAY AH episodes I analyzed (broadcast by VARA television on November 24th, and on December 29th, 1988) the number of comic moments was as high as 54!

The dosage or distribution of comic moments does not appear to follow a fixed pattern, although one can assume that the comic mode should not be suspended for too long in any given period. Striking, however, is the tendency towards a decline in the number of comic moments halfway through the episodes. In some episodes the gap between laughs may be as long as two minutes. The shortest interval between two comic moments was 3 to 4 seconds. In the two episodes just mentioned, the average amount of comic moments during one minute was, respectively, 2.21 and 1.80.

Although periods and intervals are by definition not related to a specific character, there is a slight tendency for Wiep and John to score fewer laughs than most of the other characters. The number of jokes (absolute and in terms of percentage) connected to a character varies from episode to episode, because – as already indicated – the emphasis on the different characters has shifted periodically throughout the run of the series. In general, Mien's scores are the highest. Not altogether surprisingly for the best-known character in the series, she also gets the best laughs.

Qualitative Comic Effects of SAY AH

As indicated, the situations and themes treated in each episode of the series are not comic in themselves. They are invariably concerned with daily worries and arise from easily recognizable misunderstandings. What happens to the characters could happen to anyone, while the problems are never insuperable or of tragic consequence. The story structure usually consists of several plotlines which criss-cross each other, permitting the problems raised in each episode to be resolved by the end of the episode, even if not always to the satisfaction of everyone concerned, thus creating a gradient or gap which a subsequent episode can counterbalance.

Most of the jokes in SAY AH arise from verbal remarks and interchanges. Visual jokes are absent. The technical production of the series, which is recorded with a multiple camera set-up in the studio does not lend itself to special camera work or effects of framing. Staged on a wide, relatively shallow set, in front of a live audience, there is little or no postproduction editing, which also limits the use of cinematic techniques, putting the emphasis on 'theatrical' aspects, such as entries and exits. There are no intermissions or commercial breaks during the course of an episode, and the comic situations are strictly developed around or related to the characters.

x.7 The Characters

Mien Dobbelsteen

In order to identify the relation of the type of joke to the characters involved I return to the categories differentiated by Van den Bergh. I'll start with Mien, since she scores highest.

The source of laughter in Mien is most commonly the breaking of taboos or conventions, for she is always transgressing social customs, etiquette and polite language. This is partly due to Mien having to negotiate the difference in status between Lydie and herself, often by an inversion of hierarchies: she is the one giving orders to Lydie, instead of the other way around.

Mien also scores a lot of laughs in the category of recognition. The viewers recognize a familiar situation, referring not only to their own domestic lives, but also to their familiarity with the fictional situation depicted, based on the information gathered throughout the series.

The category of mechanisation is elaborated into a recurrent set of humorous remarks, impatient gestures, and typical ways of saying things as well as typical ways of responding to certain situations. This is recognized by the audience and again becomes a source of comic effects. Often she provokes laughter by her gestures alone, even when there is nothing funny in what she says. Furthermore, Mien is funny because of her use of stereotypical phrases, her Dutch pronunciation of foreign (English) words, and because of idiosyncratic use of syntax or sentence structure, proverbs, or figures of speech. In episode 144, for instance, she says: 'In that case, everything's all right, then; a boat's got to leak like a sieve'.

The most important scores Mien gets are in the fifth category – contrast – and refer to the subcategories 'errors of language' and 'context-contrast'. These moments of laughter are often caused by the funny way Mien choses her language, rooted as it is in Mien's character and not just made up by the authors in order to play with words, or show off wisecracks. Her lines are not interchangable with the lines of any other character. Much of Mien's humour is unintentional. Mien rarely sets out to make a joke in the moments when the audience laughs. We laugh at her because most of the time she is unaware of her own facetiousness.

Koos Dobbelsteen

Koos Dobbelsteen is both an intended and unintended source of humour. In the category of recognition and contrast his score of laughs is high. As a good-humoured man he likes to make jokes, and is intentionally comic. The style of his jokes is simple and blunt; he does not make indirect remarks. Sometimes we laugh at his caricatural thriftiness or his blind

confidence in Jopie, but most of the time we laugh at his jokes rather than at him, although his jokes may well be the trigger for other comic moments not originated by him.

Lydie van der Ploeg

Lydie van der Ploeg is often humorous without intending to be so, particularly in her emotional reactions, which are often just what one expects. In this respect, recognition is the category which dominates. Ironical or slightly sadistic remarks addressed to her are often apposite, although in the episodes I analyzed no such expressions did in fact occur. She is too rational and conventional a person for absurdist jokes (of the category 'context-contrast').

Hans Lansberg

Hans Lansberg is immediately recognisable as a man who acts as a joker. He often makes jokes, and other characters respond to them. If we laugh at him, it is usually thanks to an overtly constructed situation, like a misunderstanding, the origins of which fall entirely outside his responsibility. The situation is responsible for the comic moments. However, in most cases, Hans tries to give a comic twist to a situation.

Male and Female Characters

In general, the female characters are more often a source of unintended humour, while the male characters initiate the intended humour (this does not apply to the minor roles). It reflects a fairly stereotypical, widely shared division of gender, and is recognized as such by the audience, who often laugh *at* Mien and Lydie, and laugh *with* Hans and Koos. The (rare) sexual innuendos are restricted to the male characters; Mien is too naive, Lydie too proper to indulge in sexual banter or risk 'rude' remarks.

X.8 A Comparison Between SAY AH, CHEERS and EXECUTIVE STRESS

The Similarities

SAY AH, EXECUTIVE STRESS and CHEERS are all set in the present. Individual episodes of the three sit-coms have a comparable length, somewhere around 23 minutes, subdivided into ten, more or less self-contained units. All three have the structural characteristics of series: they are constructed as closed units, with problems solved within the duration of the episode, while the basic situations and conflicts are fixed and recur in each episode. In all the three sit-coms disruptions are solved by the end of the episode, although not always via solutions that are satisfactory to all main characters. A happy ending for each episode is not a necessary ingredient.

In all three series there is an equal number of male and female characters. The female characters are often stereotyped as women who are not in control of their lives, and who respond to problems in an emotional way. The male characters are pictured as men who can take charge of situations.

The Differences

The humour in both SAY AH and EXECUTIVE STRESS is very plausible, while in CHEERS plausibility is sometimes broken. The jokes in this sit-com regularly have a more absurd and extreme character. Therefore, it is the least 'social-realist' sit-com of the three.

The dialogues in CHEERS are different from those in the other series. They are generally made up of short remarks, one-liners, and the interval between the remarks and the come-back replies is also shorter. In general, the characters in CHEERS speak more and make more jokes than the characters in SAY AH and EXECUTIVE STRESS.

In CHEERS the exterior is never a place of action. Shots outside the familiar interior settings function only as a marker for the locations. SAY AH and EXECUTIVE STRESS have, in contrast to this, recurrent scenes set outside the characters' homes.

In EXECUTIVE STRESS the minor characters are less important than in CHEERS and SAY AH. It is unlikely that minor characters in EXECUTIVE STRESS dominate one of the episodes, a possibility not excluded in CHEERS and SAY AH.

CHEERS scores a remarkably higher number of laughs: an average of 98, compared to an average of 43 and 48.5 for SAY AH and EXECUTIVE STRESS. In CHEERS there are more than four jokes a minute, more than double the amount of jokes in EXECUTIVE STRESS and SAY AH.

SAY AH is, compared to the other shows, the most middle-of-the-road series; here the characters are the outstanding examples of ordinariness and verisimilitude. They are well-rounded, displaying a variety of small, individualized traits, which trigger the jokes. In CHEERS the characters are much 'bigger' in their stereotyped exaggeration, and show a much weaker link to the jokes they utter. In SAY AH, most of the jokes, especially the typical Mien Dobbelsteen expressions, are never interchangeable with those of the other characters.

By comparison with EXECUTIVE STRESS, the humour in SAY AH is utterly harmless. The comic disruptions of the easy-going lives of Lydie, Hans, Mien and Koos are predominantly light and innocuous. The typical SAY AH jokes are based on a subtle exaggeration of little domestic inconveniences, and the recognisable panics and blunders in dealing with actual day-to-day problems. EXECUTIVE STRESS is much more serious in its underlying conflicts.

In general, the similarities between SAY AH, CHEERS and EXECUTIVE STRESS are more striking than the differences. All three are examples of the regular family or domestic sit-com. In their duration, segmentation and pre-dominance of the plausible, they are very comparable, as they are in their aims and place in the schedule. They are the epitome of television programmes broadcast at the same time each week (or several times a week), inviting us to entertain ourselves with the lives and recurrent situations of what often become familiar characters. SAY AH and EXECUTIVE STRESS are more of the social-realistic type than CHEERS, while CHEERS is more driven by one-liners and sometimes slightly absurdist jokes. In SAY AH the Lydie-and-Hans, Mien-and-Koos family troubles dominate the series, nicely intertwined with guests, topical issues and universal human problems. The similarities of SAY AH and US sit-coms would indicate that family sit-coms are a tightly organized genre appreciated by audiences everywhere, and for much the same reasons: seeing others who are so much like oneself coping with the inconveniences arising in a modern household or in the course of trying to live in harmony with one's fellow human beings. Verbal humour, contrast and recognition are the chief comic procedures deployed in order to assure audiences of this recurrent pleasure.

X.9 Conclusion

I started by asking a very general question: why do people laugh? I am not sure I have been able to get much closer to answering it, except by detailing and describing some of the mechanisms that appear to be present when comic effects are achieved in such a widely-known and much-relished audio-visual experience as the family sit-com of the social-realist kind. Clearly, SAY AH is both a full member of this by now 'classical' genre, and at the same time rather unique in its enormous popularity among Dutch-speaking audiences.

Necessarily, this analysis aimed to establish the comic character and identity of the series and stressed universal traits and similarities with other sit-coms; it used SAY AH as an example and case-study to illustrate some underlying constants in a televisual form which so far has not been fully studied in all its aspects. Hopefully, outlining some of the structural and generic features will pave the way for studying, in series like SAY AH, the typically national feeling for humour. This may require other analytical tools, but it may also imply a shift away from comparing examples of the same genre from different countries, to looking at different genres from the same country – and, indeed, why not? – from the same broadcaster or writers. In this respect, both VARA and the work of Chiem van Houweninge, two of the driving forces behind SAY AH, offer plenty of possibilities to learn while laughing and to learn from laughing.

Notes

1 (Editors' note:) This text is based on Marja Tutert, 'Wat valt er te lachen in ZEG 'NS AAA', in: *Het Nederlands Scenario*, no. 5, June 1991 and Marja Tutert, *Make them Laugh: een onderzoek naar de komische identiteit van situation comedies* (M.A. thesis, Rijksuniversiteit Utrecht, 1989). It was translated, edited and revised by Thomas Elsaesser, with thanks to Sonja Snoek and Robert Kievit.

2 Quoted according to Jerry Suls, 'Cognitive processes in humor appreciation', in: Paul McGhee (ed.), *Handbook of Humour Research*, New York, 1983, p. 39ff.

3 *Ibid.*, p. 42.
4 Jerry Palmer, *The Logic of the Absurd: On Film and Television Comedy*, London: BFI, 1987, pp. 20-55.
5 *Ibid.*, p. 56.
6 Terry Lovell, 'A Genre of Social Disruption?', in: Jim Cook (ed.), *Television Sit-com*, London: BFI, 1982, p. 22.
7 *Ibid.*, p. 24.
8 *Ibid.*, p. 24.
9 Cf. Hans van den Bergh, *Konstanten in de Komedie*, Amsterdam, 1972.

ILLUSTRATED BIOGRAPHY AND FILMOGRAPHY

Chiem van Houweninge
born 20 November 1940 in The Hague

Education:

1963 - 65 Studies in Cultural Anthropology and Dramaturgy, University of Amsterdam

1965 - 69 Academy for Dramatic Arts 'De Toneelschool' in Amsterdam, graduated with diploma.

Acting for the following repertory companies in The Netherlands:

1969 Theaterprodukties Croiset

1969 - 71 Nieuw Rotterdams Toneel

1971 - 72 Amsterdams Toneel

1972 - 81 Publiekstheater Amsterdam
(Artistic director together with Hans Croiset and Ton Lutz)

Direction of stage plays

Various plays by Chekhov, Shakespeare, Pinter and Van Houweninge.

Plays

PACHACAMAC (1965)
Visser Neerlandiaprijs
This prize was awarded in the Knights' Hall in the Binnenhof in
The Hague. No locale is more awe–inspiring in which to receive a first
prize for the first time.

WAR OF THE ROSES (1969)
Adaptation of Shakespeare's 'Histories'
Theaterprodukties Croiset, The Netherlands
A somewhat reckless production where my love of Shakespeare
was much more inspired than my own youthful writing style.

THE LAST TRAIN/DE LAATSTE TREIN (1969)
Nieuw Rotterdams Toneel, The Netherlands (1969)
Noorder Compagnie, The Netherlands (1970/'71)
Saskatchewan, Canada (1973)
Sydney, Australia (1974)
Teatro D2, Rome, Italy (1984)
Sofia, Bulgaria (1985)
Oran, Algeria (1992)
My debut as playwright. Unfortunately I could not attend the
premiere since I was on stage in Den Haag that very evening
– acting in 'Two Gentlemen of Verona' (W. Shakespeare).

THE BIKINI SWINGERS/DE HIPPE VOGELS VAN BIKINI (1971)
Nieuw Rotterdams Toneel, The Netherlands (1971)
The first play in which I worked with a location setting. Unfortunately,
very few people knew that Bikini was an atoll where the first atomic
bomb was dropped. It was assumed that the play would feature girls
clad in the two-piece bathing costume of the same name.

The Press-ganging Dutchman/De Hollandse ronselaar (1972)

Publiekstheater, The Netherlands (1972)

Hoorn, The Netherlands (1980)

Leeuwarden, The Netherlands (1983)

Music hall piece, which included song and dance.

Single Lady at That Certain Age/Alleenstaande dame op leeftijd (1974)

B.T.W., Belgium (1974)

A revised edition of Pachacamac. During the première in Antwerp I felt for the first time that I was working abroad.

Old Toys/Oud speelgoed (1978)

City Theatre Sofia, Bulgaria (1984).

The invitation to the première reached me two months after.

Old Toys/Oud speelgoed – revised version (1987)

Nederlands Volkstoneel, The Netherlands (1988)

Carry Tefsen from the TV series SAY AH *starred in this production.*

The Kenny Case/De zaak Kenny (1989)

Rene Stokvis Produkties, The Netherlands (1989)

A piece about gene manipulation. During my research for this piece I became truly worried about the human race.

Television Plays and Series

COME CRY ON MY SHOULDER/HUIL MAAR EVEN BIJ ME UIT
VARA/BRT, Dutch-Belgium coproduction (1966)
I wrote this while still attending Drama School in Amsterdam.
Willy Pos, the director of the school at the time asked me to write a
piece for a TV project for the finalists' class.

BOBO AND BOBO/BOBO EN BOBO
AVRO, The Netherlands (1970)
With this production I learned how much effort it takes before a play
on paper can be realized on TV.

The Last Train/De laatste trein
AVRO, The Netherlands (1970)

The TV adaptation of this piece convinced me that, before I am commissioned to do another play, I should first work in the medium.

Furnished Room/Gemeubileerd
A television adaptation of 'PACHACAMAC'
AVRO/BRT, Dutch-Belgium co-production (1970)

I watched the broadcast with my wife and a friend. An exciting event since I saw very little of it. After two minutes the screen began to blurr, so I could only decipher my name. Then it began to 'snow' and we poured some stiff drinks to toast to a good result.

CROSS MY HEART/HARTEDIEF
AVRO/BRT, Dutch Belgium co-production (1970)
A TV film based on the story of the first heart transplant by Dr Barnard in 1967.

OLD TOYS/OUD SPEELGOED
A Television adaptation of the same play
AVRO, The Netherlands (1980)
With a sparkling performance by Ellen Vogel.

GOOD RIDDANCE TO BAD RUBBISH/OPGERUIMD STAAT NETJES
NOS, The Netherlands (1980)
A cynical thriller dealing with the issue of old people. I moulded the theme into a science fiction story, and hope it will always stay science fiction.

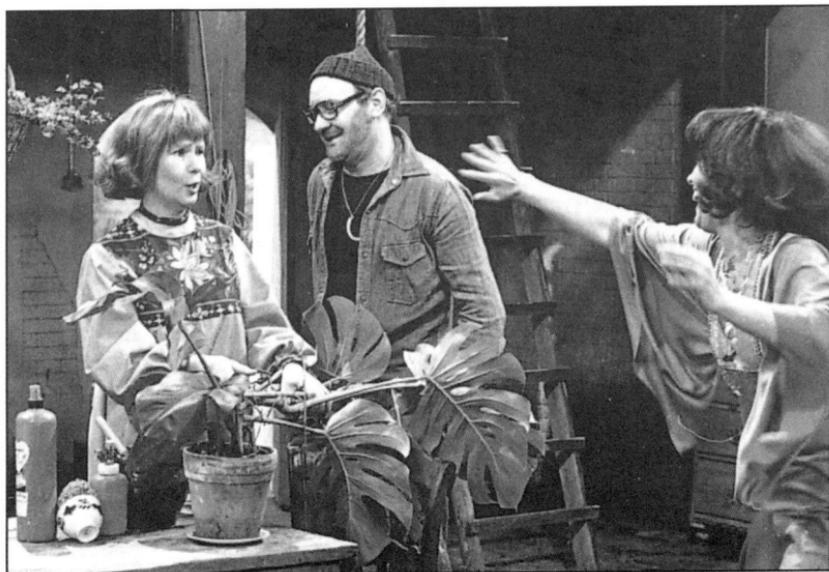

EACH TO EACH/IEDER ZIJN DEEL
in cooperation with Alexander Pola (24 episodes of 30 minutes)
VARA, The Netherlands (1976, 1977, 1978)
My first attempt along the 'comedy-path'. Not an unqualified success and VARA wanted to stop the series. Fortunately, one expert understood that 'those boys Chiem and Alexander learned a lot during the first eight episodes. This cost VARA plenty of money. Could we profit from another venture?' They stuck with us and consequently I wrote another 326 episodes. I learned a lot, that's for sure.

CASSATA
in cooperation with Alexander Pola (8 episodes of 30 minutes)
VARA, The Netherlands (1979)
After 24 episodes of EACH TO EACH the new head of entertainment at
VARA wanted something new. The result was a series about the joys
and woes of an Italian ice cream-man in The Netherlands.

Say Ah/Zeg 'ns aaa
in cooperation with Alexander Pola and Marina de Vos
(212 episodes of 25 minutes)
VARA, The Netherlands (1980-1993)
Broadcast in Belgium (BRTN), Australia (SBS Australia),
Spain (Servicios de Imagen, TVE), Canada, (MTV Toronto),
Greece (New Channel/Radio Tileoptike) and in Germany as a
remake (ARD). Also broadcast by Superchannel.

*After eight episodes of Cassata the ice cream had melted and we
had to find something new. We came up with a general practitioner:
Lydie van der Ploeg. A woman with a busy practice, two demanding
children and a calm friend. She has help from her housekeeper
Mien Dobbelsteen and Mien's moonlighting husband Koos.
When I discussed the German version with a dramaturgue he said:
'Chiem, there is one problem in this series. In Germany, we no
longer have housekeepers like Mien in* SAG MAL AAH.*'
'Neither do we in The Netherlands.' I answered. 'But everyone
would like to have one.' We have so far produced 212 episodes.*

SPADES ARE TRUMPS/SCHOPPEN TROEF
in cooperation with Alexander Pola (12 episodes of 30 minutes)
NCRV, The Netherlands (1983)
*A title difficult to translate. There are 'Schoppen'-Spades and
'Schoppen'- Kicks. For eight episodes we followed the ups and
downs of a small football club.*

ENGINEER ON A SIDE TRACK/MACHINIST OP DOOD SPOOR
(3 episodes of 60 minutes)
TROS, The Netherlands (1984)
This was a TV adaptation of the book 'Op dood spoor'
by W. Hartman.

CUDDLIES/KUSCHELTIERE,
episode of TATORT (90 minutes, 16 mm.)
WDR, Germany (1983)
My first 'Schimanski-Tatort' dealt with illegal adoption.
A foreign affair for a policeman with strange methods.

SLIPSTREAM/KIELWASSER,
episode of TATORT (90 minutes, 16 mm.)
WDR, Germany (1984)
Nomination for the 'Adolf Grimme Preis'
Public's Prize (Best programme of the month in March 1984
in Germany).
A Schimanski-Tatort where a polluter is taught a lesson.

THE TRADE-OFF/DER TAUSCH,
episode of TATORT – in cooperation with Hartmund Grund
WDR, Germany (1986)
A Schimanski-Tatort about the sale of nuclear weapons or parts
thereof to a country in the Middle East. Any resemblance to
persons living is entirely accidental.

WHAT A NIGHT/WAS FÜR EINE NACHT,

a special for Thekla Carola Wied
ZDF, Germany (1986)

ON HER OWN ACCOUNT/IM EIGENEN AUFTRAG,

a special for Thekla Carola Wied – in cooperation with Felix Huby
ZDF, Germany (1986)

Thekla Carola Wied was one of the most popular actresses in Germany in the eighties. She was the lead in DIE KROPP FAMILIE. The ZDF decided to dedicate a trilogy to her. I was very pleased they asked me to write two of the episodes.

WITCH-DOCTORS/MEDIZINMÄNNER,

episode of TATORT (90 minutes, 16 mm.)
WDR, Germany, 1989

A Schimanski-Tatort about the sale of the banned sleeping pill Secubarbitol to Togo in Africa. The effect of such a pill is that you 'get stoned like a shrimp.'

About 30 million pills manufactured for 1 cent each are sold for 1 US Dollar each in the Third World, a truly lucrative business. Until Schimanski, Thanner and Hänschen put an end to it.

IN IT UP TO MY NECK/BIS ZUM HALS IM DRECK,
episode of TATORT – in cooperation with Wolfgang Hesse
(90 minutes, 16 mm.)
WDR, Germany (1990)
A Schimanski-Tatort about illegal trading of hormones.

THE KENNY CASE/DE ZAAK KENNY
A television adaptation of the same play
AVRO, The Netherlands, (1990)
About 50,000 people saw this play in the theatre.
The TV adaptation was watched by 1.5 million people.
Much as I love the theatre, if I want to reach large numbers of
people, I have to work in TV.

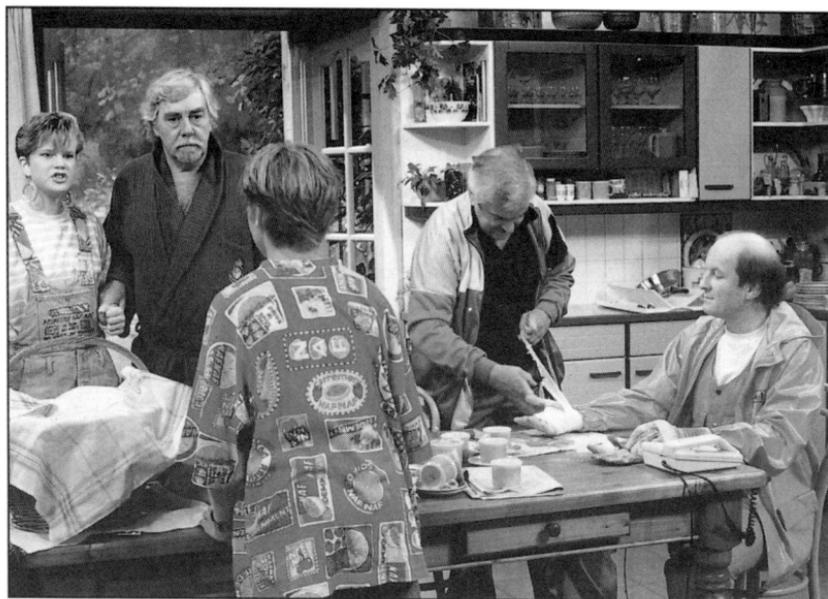

DOUBLE TROUBLE/OPPASSEN!!!

in cooperation with Marina de Vos, Nicolas van Pallandt
(72 episodes of 25 minutes)
VARA, The Netherlands (1991–1993)
Two grandfathers look after their two grandchildren while their
parents are busy with their careers. A generation gap with an
extra gap.

THE VICTORY/DE VICTORIE

based on a format by Chiem van Houweninge and Alexander Pola:
SPADES ARE TRUMPS/SCHOPPEN TROEF; script in cooperation with Lars
Boom (8 episodes of 25 minutes)
VARA, The Netherlands (1994)
A new situation comedy dealing with more ups and downs of a local
football club.

Feature Film Scripts

THE MAN WITH A THOUSAND TEETH/DE MAN MET
DUIZEND TANDEN
(1964)
*A film script written for a student of the Film Academy at the time I
studied drama with Professor Ben Hunningher. The victim of horror
was played by Miss Holland 1963.*

THE BURGLAR/DE INBREKER
after A. Defresne, directed by Frans Weisz, produced by Parkfilm
(35 mm. colour, 105 minutes, 1972)
*My first real film script, a clumsy job, if I may say so. Luckily, I received
a lot of support from Frans Weisz and Rob du Mee.*

SHERLOCK JONES/DE DWAZE LOTGEVALLEN VAN SHERLOCK JONES
directed by Nikolai van der Heijde, produced by Henk Bos
(35 mm. colour, 92 minutes, 1975)
A comedy by Piet Bambergen. The original script was written by a mysterious American and was adapted by me and many others. The best feature of this production was the interaction between Fred Benavente and one of the gangsters.

**SAD STORIES AT THE CENTRAL HEATING/ZWAARMOEDIGE
VERHALEN VOOR BIJ DE CENTRALE VERWARMING**
after H. Heeresma, episode A SHOPKEEPER WHO NEVER CAME BACK/
EEN WINKELIER KEERT NIET WEEROM
directed by Nouchka van Brakel, produced by Sigma, triptych
(35 mm. colour, 95 minutes, 1975)
*One of the films of this trilogy dealt with a shopkeeper who never
came back. A model of cooperation between two fantastic actors
and a good director, shaping the film together. I was very pleased
with the result.*

SUCH SWEET BOYS/LIEVE JONGENS
inspired by Gerard Reve, in cooperation with Paul de Lussanet,
directed by Paul de Lussanet, produced by Sigma
(35 mm. colour, 88 minutes,1980)
*The final version of the script was so different from my original that
I am still a bit disappointed when thinking about this production.*

TROUBLE IN PARADISE
in cooperation with Robbe de Hert, directed by Robbe de Hert,
produced by Three Lines Productions
(35mm. colour, 100 minutes, 1988)
'In the late eighties' should have been the title here.
A joy to work with a 'cinematographic beast' such as Robbe.

Translations

THE CHERRY ORCHARD/DE KERSENTUIN
THE SEAGULL/DE MEEUW
UNCLE VANYA/OOM WANJA
PLATONOV/PLATONOW
THE THREE SISTERS/DRIE ZUSTERS
All by Chekhov, translated from Russian, in cooperation with
director Ton Lutz, Publiekstheater, Amsterdam, The Netherlands
(1977 – 1979)

Film Roles

Played various bigger and smaller roles (guest appearances) in
feature films. Amongst others:

THE BURGLAR/DE INBREKER
SHERLOCK JONES/
 DE DWAZE LOTGEVALLEN VAN SHERLOCK JONES
TO CRAZY TO LET LOOSE/TE GEK OM LOS TE LOPEN
THE SHOPKEEPER WHO NEVER CAME BACK/
 ZWAARMOEDIGE VERHALEN VOOR BIJ DE CENTRALE
 VERWARMING

TV Roles

Played in a number of Dutch TV series and in German TV
productions:

SCHIMANSKI-TATORT
as detective Hänschen, (26 episodes)
THE OASIS/DIE OASE
as private detective Spoor, (6 episodes)
ENGINEER ON A SIDE TRACK/MACHINIST OP DOOD SPOOR
DARE TO LIVE/MENSCH DURF TE LEVEN
THE PRESS-GANGING DUTCHMAN/HOLLANDSE RONSELAAR
WOLFMAN/WOLFMAN

Publications

* THE LAST TRAIN/DE LAATSTE TREIN appeared in: *L'Avant Scène du Théâtre*,
 Paris, 1976; translation by Michel and Maryse Caillol. Nr. 30048
* Chekhov, A., *Een Meeuw, Oom Wanja, Drie Zusters, De Kersentuin*,
 translated by Chiem van Houweninge and Ton Lutz, Amsterdam:
 International Theatre & Film Books, 1989
* Chehkov, A., *Platonow*, translated by Chiem van Houweninge and
 Ton Lutz, Amsterdam: Publiekstheater, 1979
* Ab van Ieperen et al., ZEG 'NS AAA, *Het Nederlands Scenario*, no. 5, 1991.

Offices Held

1970 - 82	Advisor for Dutch feature films – *Tuschinski Film Distributions*
1984 - 92	Advisor in the Drama Department of VARA
1992 - 93	University of Amsterdam, Film and Television Studies: Visiting Professor
1992 - 93	Advisory Board Dutch Film Fund

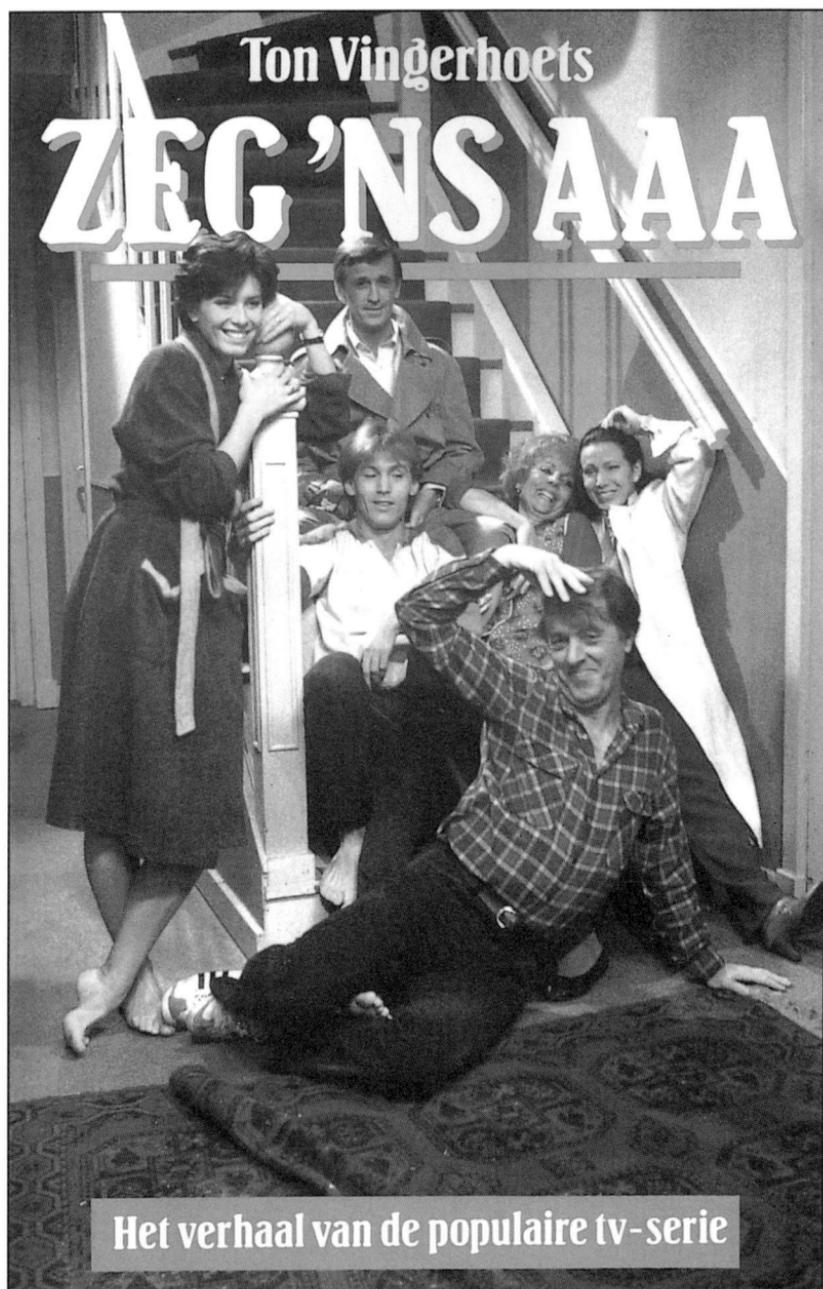

SAY AH: *the popular television series adapted as a novel*

SAY AH
SAY NINETY NINE

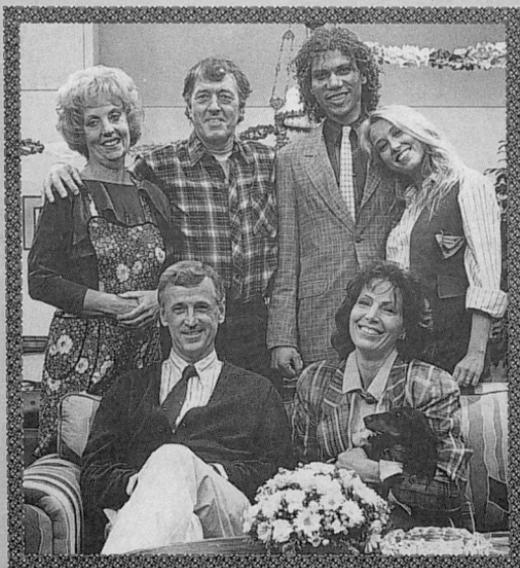

This season *Say Ah* begins its 10th year as the most successful comedy series on Dutch television. Following the life of the *Van der Ploeg-Lansberg* family, the show mixes gentle humor with personal and social issues-oriented situations to create sparkling entertainment.

The characters, of course Dutch, but somehow universal, revolve around a couple, the wife, *Lydie*, a medical doctor, her husband, *Hans*, a surgeon, and their household of children, a housekeeper and her husband, and assorted friends, and relatives. There is *Gert-Jan*, son of *Lydie* who is a medical student. There is also a daughter, who leaves to work for development aid in Kenya after episode 16. *Mien Dobbelsteen*, the zany housekeeper is the foil for most of the comic "bits" in the series, She and her husband/handyman, *Koos*, with their down-to-earth, working class outlook give a kind of "Upstairs Downstairs" flavor to the series, set in modern-day Holland. And like most such comedy series it is the amusing twists and turns of day-to-day life which give the programs their humor and also build audience loyalty.

Selling SAY AH

PHOTO AND ILLUSTRATION CREDITS

134	OPPASSEN: *cast (Dutch version)*
	Source: NOB-Photo Archives.
135	DOUBLE TROUBLE: *cast (English version)*
	Source: NOB-Photo Archives.
138	*Chiem van Houweninge*
	Source: private collection Chiem van Houweninge.
143	EACH TO EACH (IEDER ZIJN DEEL)
	Source: NOB-Photo Archives, Hilversum, The Netherlands.
144	CASSATA
	Source: NOB-Photo Archives, Hilversum, The Netherlands.
145	SAY AH *from its early development to 1990*
	Source: NOS-Programme Sales Department, Hilversum, The Netherlands.
154	*Chiem van Houweninge*
	Source: private collection Chiem van Houweninge.
177	COME CRY ON MY SHOULDER
	Source: unknown.
178	THE LAST TRAIN
	Source: NOB-Photo Archives, Hilversum, The Netherlands.
179	CROSS MY HEART
	Source: NOB-Photo Archives, Hilversum, The Netherlands.
179	OLD TOYS
	Source: NOB-Photo Archives, Hilversum, The Netherlands.
180	EACH TO EACH
	Source: NOB-Photo Archives, Hilversum, The Netherlands.
181	CASSATA
	Source: NOB-Photo Archives, Hilversum, The Netherlands.
182	SAY AH
	Source: NOB-Photo-Archives, Hilversum, The Netherlands.
183	SPADES ARE TRUMPS
	Source: NOB-Photo Archives, Hilversum, The Netherlands.
184	ENGINEER ON A SIDE TRACK
	Source: private collection Chiem van Houweninge.
185	WITCH-DOCTORS
	Source: private collection Chiem van Houweninge.

THE CONTRIBUTORS AND THE EDITORS

The Contributors

Ernie Tee has taught in Media Studies at the University of Amsterdam. Currently he teaches Film History and Film Theory at the Dutch Film and Television Academy in Amsterdam. He is on the Editorial Board of *Skrien*. He is editor of *What a Wonderful World: Music Videos in Architecture* (Groningen, 1990).

Clara Overduin graduated in Theatre Studies from the University of Utrecht where she currently teaches Film and Television History.

Marja Tutert graduated in Theatre Studies from the University of Utrecht. Since then she has been teaching there, while also working as script consultant at AVRO, a Dutch broadcasting company.

The Editors

Thomas Elsaesser is Professor at the University of Amsterdam and Chair of the Department of Film and Television Studies. Before coming to Amsterdam in 1991, he had been teaching Film and English Literature at the University of East Anglia since 1972. He is the author of *New German Cinema: A History* (BFI/MacMillan, 1989) and editor of *Early Cinema: Space Frame Narrative* (BFI: 1990).

Robert Kievit graduated in Theatre and Media Studies in the University of Amsterdam and currently teaches there in the Department of Film and Television Studies.

Jan Simons teaches theory and aesthetics of film in the Department of Film and Television Studies at the University of Amsterdam. Formerly the editor of the film journal *Skrien* and film critic of *De Groene Amsterdammer*, he is currently the editor of the film journal *Versus* and film critic of *Het Financiëele Dagblad*.

FILM CULTURE IN TRANSITION

On the Series

Film Culture in Transition is the name of a new series which addresses the debates around a new and exciting field of study. Never have movies been more popular or more ubiquitous, they meet us on television and in the home, at the videotheques, on posters and in advertising. Yet no consensus exists about how the cultural and historical role of the audio-visual media might be understood, and the contest for legitimation among the more established academic disciplines obliges those who teach and research in these fields constantly to question their intellectual foundations and aims.

Film Culture in Transition wants to set new accents, review the state of debates, explore the territory beyond the established topics, but also to consolidate what has been achieved. The focus is on work coming from Europe, continuing the dialogue between the continent's fascination with Hollywood and America's attraction to European aesthetic and critical thought. By trying to shape the debates among different intellectual traditions in Europe itself, the series provides a forum that respects each country's distinctive film and television culture, developed alongside and in competition with Hollywood.

The objective is not a general line, but to provoke reflexion and stimulate research, to give body and substance to the many transitions now centred on the audio-visual media. The elements are in place to make the case for *Film Culture in Transition*.

Thomas Elsaesser
General Editor